The Great Themes

Other Publications:

PLANET EARTH
COLLECTOR'S LIBRARY OF THE CIVIL WAR
LIBRARY OF HEALTH
CLASSICS OF THE OLD WEST
THE EPIC OF FLIGHT
THE GOOD COOK
THE SEAFARERS
THE ENCYCLOPEDIA OF COLLECTIBLES
THE GREAT CITIES
WORLD WAR II
HOME REPAIR AND IMPROVEMENT
THE WORLD'S WILD PLACES
THE TIME-LIFE LIBRARY OF BOATING
HUMAN BEHAVIOR
THE ART OF SEWING
THE OLD WEST
THE EMERGENCE OF MAN
THE AMERICAN WILDERNESS
THE TIME-LIFE ENCYCLOPEDIA OF GARDENING
THIS FABULOUS CENTURY
FOODS OF THE WORLD
TIME-LIFE LIBRARY OF AMERICA
TIME-LIFE LIBRARY OF ART
GREAT AGES OF MAN
LIFE SCIENCE LIBRARY
THE LIFE HISTORY OF THE UNITED STATES
TIME READING PROGRAM
LIFE NATURE LIBRARY
LIFE WORLD LIBRARY
FAMILY LIBRARY:
 HOW THINGS WORK IN YOUR HOME
 THE TIME-LIFE BOOK OF THE FAMILY CAR
 THE TIME-LIFE FAMILY LEGAL GUIDE
 THE TIME-LIFE BOOK OF FAMILY FINANCE

*This volume is one of a series devoted to the art and technology
of photography. The books present pictures by outstanding
photographers of today and the past, relate the history
of photography and provide practical instruction in the use of
equipment and materials.*

LIFE LIBRARY OF PHOTOGRAPHY

The Great Themes

Revised Edition

BY THE EDITORS OF TIME-LIFE BOOKS

TIME-LIFE BOOKS, ALEXANDRIA, VIRGINIA

For information about any
Time-Life book, please write:
Reader Information, Time-Life Books,
541 North Fairbanks Court,
Chicago, Illinois 60611.

TIME-LIFE is a trademark of
Time Incorporated U.S.A.

Library of Congress Cataloguing in Publication Data
Main entry under title:
The Great themes.
 (Life library of photography)
 Bibliography: p.
 Includes index.
 1. Photography, Artistic. I. Time-Life Books.
II. Series.
TR650.G733 1982 779 82-5530
ISBN 0-8094-4414-3 AACR2
ISBN 0-8094-4412-7 (retail ed.)
ISBN 0-8094-4413-5 (lib. bdg.)

ON THE COVER: Six pictures
encompass the great themes of
photography. The thematic procession,
clockwise from top left, shows the
nude—a color study by William Larson;
nature—a Japanese marten alert for
danger by Manabu Miyazaki; the human
condition—love of a child by David
Austen; portraiture—a young Cape Cod
vacationer by Joel Meyerowitz; still life—
succulent fruits by Olivia Parker; and
war—a U.S. Marine airlift into Khe Sanh,
South Vietnam, by Larry Burrows.

Contents

Time-Life Books Inc.
is a wholly owned subsidiary of

TIME INCORPORATED

FOUNDER: Henry R. Luce 1898-1967

Editor-in-Chief: Henry Anatole Grunwald
President: J. Richard Munro
Chairman of the Board: Ralph P. Davidson
Executive Vice President: Clifford J. Grum
Chairman, Executive Committee: James R. Shepley
Editorial Director: Ralph Graves
Group Vice President, Books: Joan D. Manley
Vice Chairman: Arthur Temple

TIME-LIFE BOOKS INC.

EDITOR: George Constable
Executive Editor: George Daniels
Board of Editors: Dale M. Brown,
Thomas H. Flaherty Jr., William Frankel,
Thomas A. Lewis, Martin Mann, Philip W. Payne,
John Paul Porter, Gerry Schremp, Gerald Simons,
Nakanori Tashiro, Kit van Tulleken
Art Director: Tom Suzuki
Assistant: Arnold C. Holeywell
Director of Administration: David L. Harrison
Director of Operations: Gennaro C. Esposito
Director of Research: Carolyn L. Sackett
Assistant: Phyllis K. Wise
Director of Photography: Dolores Allen Littles

President: Carl G. Jaeger
Executive Vice Presidents: John Steven Maxwell,
David J. Walsh
Vice Presidents: George Artandi, Stephen L. Bair,
Peter G. Barnes, Nicholas Benton, John L. Canova,
Beatrice T. Dobie, Carol Flaumenhaft,
James L. Mercer, Herbert Sorkin, Paul R. Stewart

LIFE LIBRARY OF PHOTOGRAPHY

EDITORIAL STAFF FOR
THE ORIGINAL EDITION OF
THE GREAT THEMES:
SERIES EDITOR: Richard L. Williams
Picture Editor: Carole Kismaric
Text Editor: Jay Brennan
Designer: Raymond Ripper
Assistant Designer: Herbert H. Quarmby
Staff Writers: John von Hartz, Bryce S. Walker
Chief Researcher: Peggy Bushong
Researchers: Sondra Albert, Jill Beasley,
Carol Caruso, Rosemarie Conefrey, Ellie Feltser,
Gail H. Mattox, Shirley Miller, Kathryn Ritchell,
Carolyn Stallworth
Art Assistant: Jean Held

EDITORIAL STAFF FOR
THE REVISED EDITION OF *THE GREAT THEMES:*
SENIOR EDITOR: Robert G. Mason
Designer: Sally Collins
Chief Researcher: Patti H. Cass
Picture Editor: Gretchen Wessels
Text Editor: Roberta R. Conlan
Researchers: Rhawn Anderson, Adrianne Goodman,
Molly McGhee
Assistant Designer: Kenneth E. Hancock
Copy Coordinator: Anne T. Connell
Picture Coordinator: Eric Godwin
Editorial Assistant: Jane Cody

Special Contributors:
Maitland A. Edey, John Neary, Charles Smith,
Gene Thornton, Robert Wallace

EDITORIAL OPERATIONS
Production Director: Feliciano Madrid
Assistants: Peter A. Inchauteguiz,
Karen A. Meyerson
Copy Processing: Gordon E. Buck
Quality Control Director: Robert L. Young
Assistant: James J. Cox
Associates: Daniel J. McSweeney,
Michael G. Wight
Art Coordinator: Anne B. Landry
Copy Room Director: Susan Galloway Goldberg
Assistants: Celia Beattie, Ricki Tarlow

CORRESPONDENTS:
Elisabeth Kraemer (Bonn); Margot Hapgood, Dorothy
Bacon (London); Susan Jonas, Lucy T. Voulgaris (New
York); Maria Vincenza Aloisi, Josephine du Brusle
(Paris); Ann Natanson (Rome). Valuable assistance
was also provided by: Lesley Coleman, Millicent
Trowbridge (London); Miriam Hsia, Christina
Lieberman (New York); Katsuko Yamazaki (Tokyo).

*The editors are indebted to the following individuals
of Time Inc.: George Karas, Chief, Time-Life Photo
Lab, New York City; Herbert Orth, Deputy Chief,
Time-Life Photo Lab, New York City; Melvin L. Scott,
Assistant Picture Editor, Life, New York City; Photo
Equipment Supervisor, Albert Schneider; Equipment
Technician, Mike Miller; Color Lab Supervisor, Peter
Christopoulos; Black and White Supervisor, Carmine
Ercolano; Color Lab Technician, Ron Trimarchi.*

In the century and a half since a bleary view of a barnyard in France became the first image captured by photography, millions of photographers have taken billions of photographs of everything from babies to lunar soil. However, the efforts of artist-photographers can be grouped generally into six great themes: portraits, still life, the nude, nature, war and the human condition.

Each theme presents a different challenge. To portray the human condition requires not only that the photographer be sensitive to the complexities of the way people feel and the way they live, but that all his camera techniques be second nature: When a scene occurs, there is no time to fuss about proper exposure settings. A photographer of still lifes, on the other hand, does have time—spending hours or days perfecting the details of a single shot, patiently seeking an arrangement of objects that is esthetically pleasing and also sparks the imagination.

Both sensitivity and patience are needed to achieve the dual goals of the portrait photographer: to realize on film both the subject's private personality and the photographer's statement about that personality—goals that come together most succinctly in the self-portrait.

Photographic style is an important consideration for both still-life and portrait artists, but it is in studies of the nude that the variety of photographic approaches is most apparent. Liberated from Victorian constraints, modern photographers give free rein to their visions, portraying the nude as a beautiful object, as a source of abstract design, as a real person, or as an expression of the photographer's own fantasy. Similarly, nature studies—once constrained by styles of composition that were dictated by 19th Century painters—now go beyond idyllic visual beauty to express the photographer's own reactions to the natural forces of the world. War is a far less accessible subject than nature. Yet men and women have continually risked their lives to record its horrors in pictures that often are as imaginative, as well composed and as artfully lighted as those made in more comfortable circumstances.

Whatever the subject—whether a bowl of fruit, an old woman's face or a helicopter hovering over a jungle—all who make successful photographs are driven by the same instinct: The work of art is imagined whole in the mind's eye before the shutter is tripped. A good photographer is not often surprised when the image comes up in the darkroom.

The Editors

The Human Condition 1

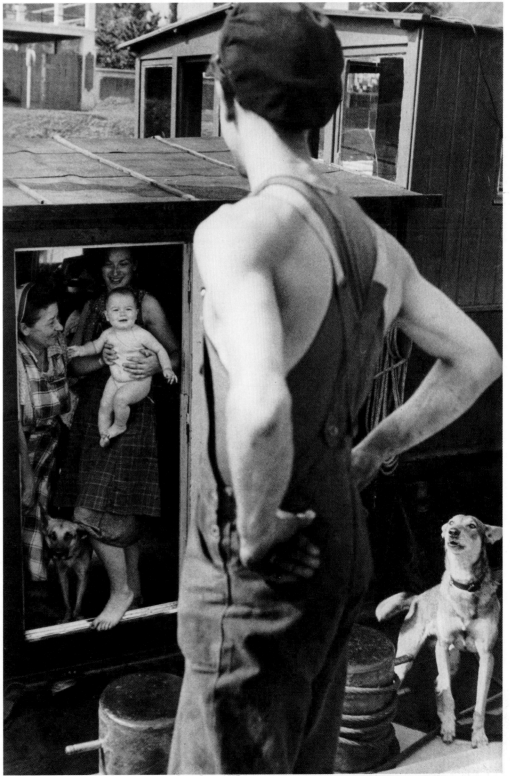

HENRI CARTIER-BRESSON: *Bargeman on the Seine River*, 1957

Life as the Camera Sees It

At first glance, *Bargeman on the Seine River (preceding page)* seems a casual snapshot. As the women look on proudly, the baby smiles at his father. The bargeman's face is hidden, but the viewer senses that he too is smiling — the indentation of his cheek profile, his tipped-back hat, the jaunty hands-on-hips pose, all convey his paternal delight at the sight of his son. Even the dogs mirror the warmth of the moment. The picture is a perfect entry for the family's photo album. Yet this picture is more than an album snapshot. So precisely does it define the affection between members of the family, so expert is its composition and its subtle revelations of mood and tone that it becomes a work of art. It was made by Henri Cartier-Bresson, who, together with the other photographers represented on the following pages, has found one of the classic themes of photography in natural views of ordinary people — pictures that uniquely convey the human condition.

The concern of these photographers is people and their interrelationships, as expressed in love and grief, anger and compassion, work and learning, birth and death. The whole sweep of human existence is their province, life itself their raw material. Thus their work has the broadest possible scope of all the themes of photography. Studies of the nude *(pages 131-176)*, portraits *(pages 89-128)* or still lifes *(pages 45-86)* are major areas of photographic endeavor, but each has obvious confines. Even war photography *(pages 203-240)*, which offers photographers a chance to record man at his most savage and heroic, portrays humanity at its extremes rather than across the broad spectrum of behavior.

From the first, the camera was trained on human beings in action. In the late 19th Century, John Thomson in England, Giuseppe Primoli in Italy and Ernst Höltzer in exotic Persia recorded the lives of the mighty and the lowly, hauling around with them not only clumsy cameras but wagonloads of equipment. This ponderous gear, however, limited the mobility of all but the most dedicated photographers. It was not until the 1930s that small cameras capable of dealing with an experienced photographer's complex needs became widely available. The German-made Leica set the pattern. Using small-sized, inexpensive film, it and similar little cameras permitted many pictures to be taken on one roll in rapid succession. Lenses did not need to be very large in diameter in relationship to the small negative size — this enabled them to be very fast, transmitting large proportions of the light available in dim natural illumination. The result was that the photographer was set free to mingle with people and take pictures almost anywhere without drawing notice.

Today, most photographers noted for their perceptive renderings of the human condition use small cameras and relatively simple accessories. Although a long-focal-length lens, for example, permits close-ups from a distance, some of the best pictures of people are made with the subjects fully aware they are

being photographed. What is necessary is an alertness to the telling moment in life, wherever and whenever it occurs.

Joanne Leonard looked no farther than her brother's backyard. Using her twin-lens Mamiyaflex with its normal 80mm lens, she caught the simple serenity and grace of her sister-in-law hanging up the wash on a sunny summer afternoon *(overleaf)*. David Austen, while on assignment in a small farming community on Taiwan, decided on the spur of the moment to photograph a group of townspeople who had gathered to watch a traveling theater troupe. As he moved through the relaxed crowd with his Nikon F camera equipped with a 105mm lens, he spied a crinkled old grandfather who was off to one side, squinting intently as he clutched the small grandson asleep in his arms. Shooting with color film, Austen captured a moment that linked old life and new in a secure embrace *(page 17)*.

Just as David Austen preferred to record the people attending a performance rather than the performance itself, so too did David Alan Harvey. Preparing to cover a revival meeting among the deeply religious Lummi Indians, who live on a tiny reservation north of Seattle, Washington, Harvey went to the church early with one of the elders of the tribe. When the man seated himself in an empty pew, Harvey shot the meditative, moody color photograph on pages 38-39. "Very often the 'non-event,' or things that happen before the event you have planned to photograph, provide better pictures than the event itself," Harvey says. He adds that being ready beforehand "often proves the key to getting good pictures."

Both Marcia Keegan in the slums of San Juan, Puerto Rico, and Raghubir Singh on a visit to his home state of Rajasthan in India were ready for the unexpected encounter. Keegan photographed a boy and his mother sharing a private moment of happiness unmarred by the rude wooden walls behind them *(page 18),* and Singh photographed the grief of a group of mourning women in the city of Bharatpur *(page 42)*. Alert to the manifold moods of humankind — gay, somber, animated, reflective, stoic, grieving — the photographer can capture on film pictures that touch every human being, simply by seeing the emotion and drama inherent in the apparently ordinary and by moving swiftly to record them. □

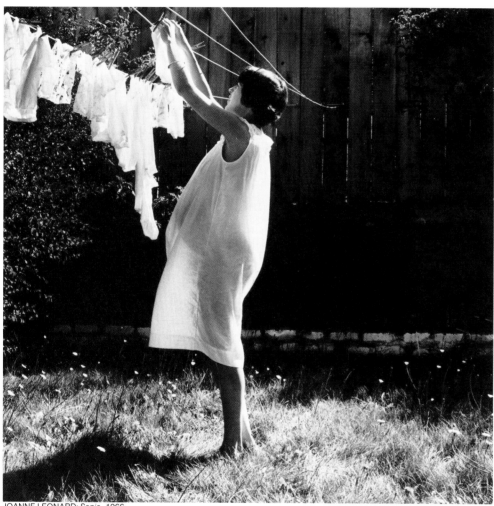

JOANNE LEONARD: *Sonia*, 1966

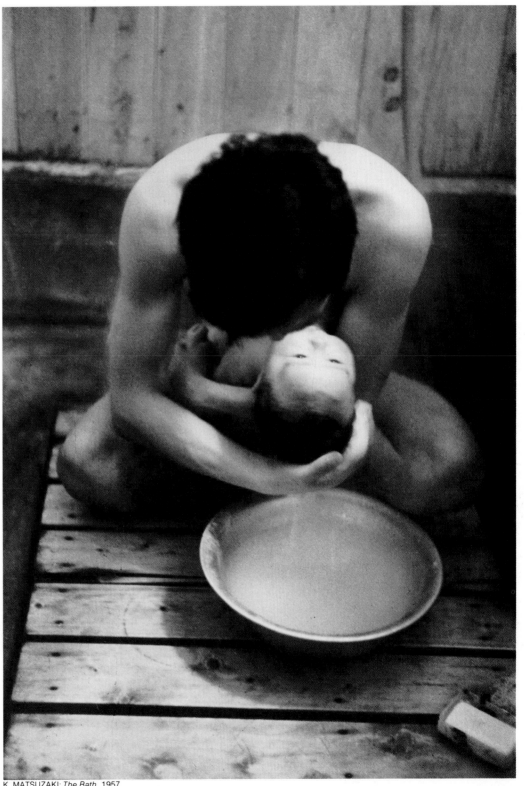

K. MATSUZAKI: *The Bath*, 1957

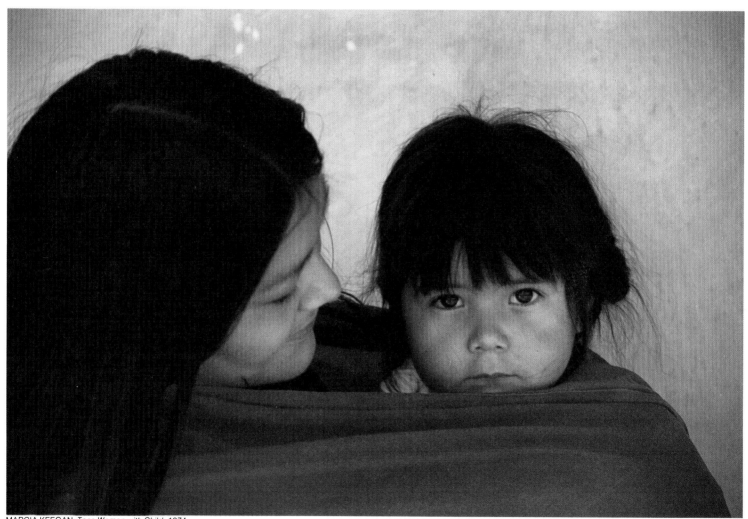

MARCIA KEEGAN: *Taos Woman with Child,* 1974

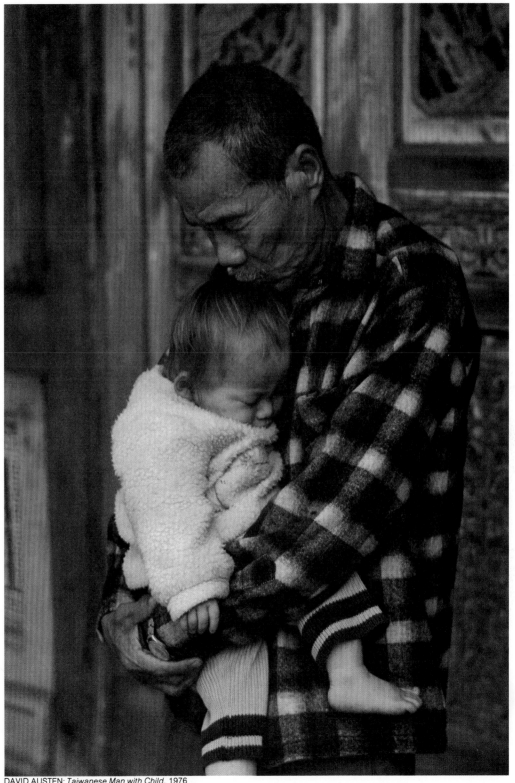

DAVID AUSTEN: *Taiwanese Man with Child,* 1976

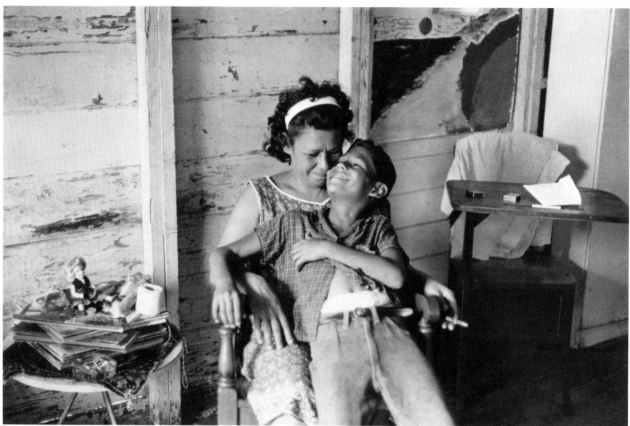

MARCIA KEEGAN: *Mother and Son,* 1968

LAURENCE FINK: *Mother and Daughters*, 1962

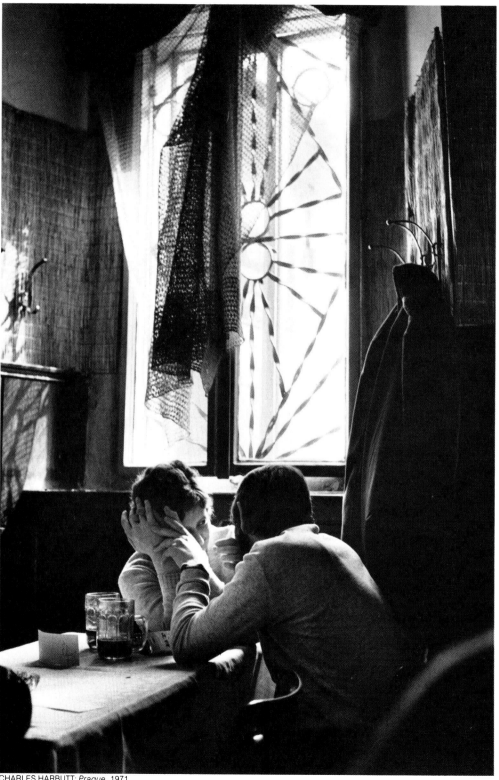

CHARLES HARBUTT: *Prague,* 1971

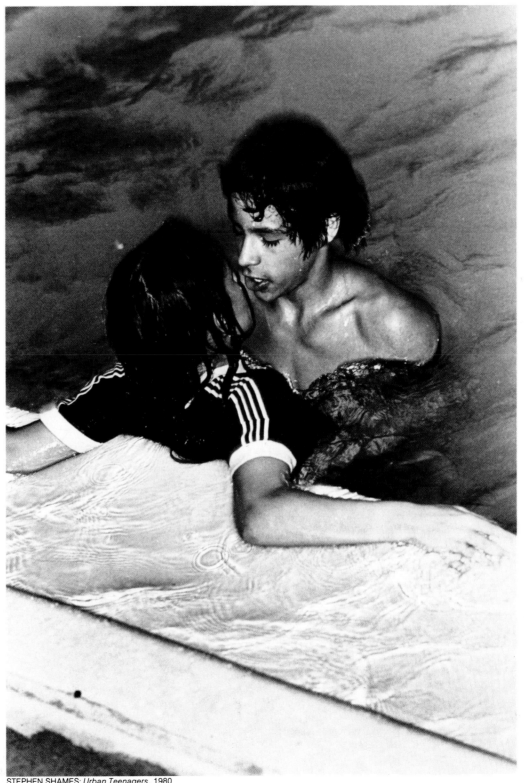

STEPHEN SHAMES: *Urban Teenagers,* 1980

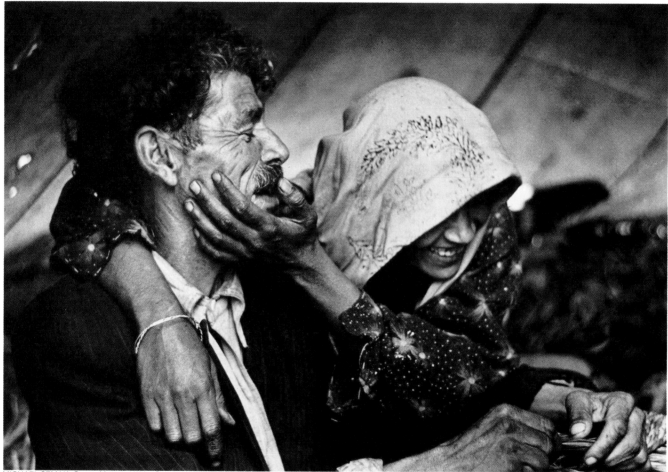

MICHAEL SEMAK: *Gypsy Man and Wife, Greece, 1962*

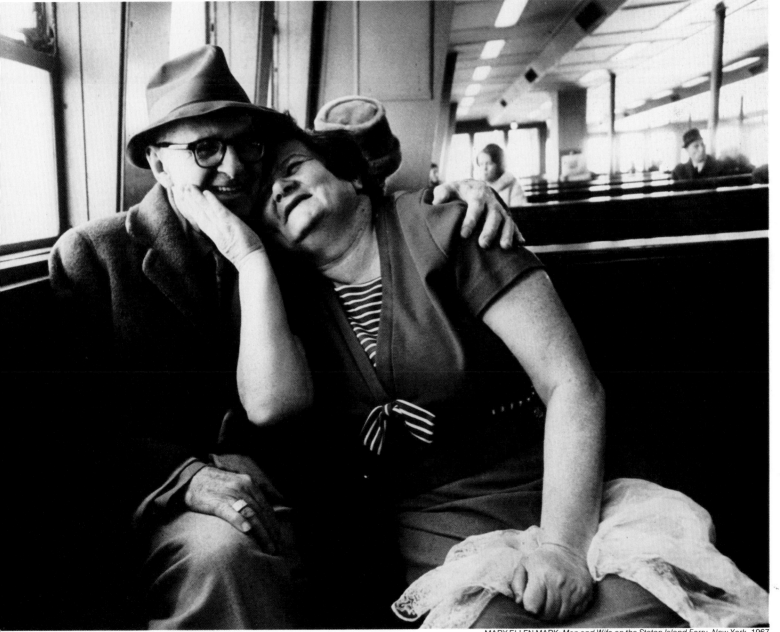

MARY ELLEN MARK: *Man and Wife on the Staten Island Ferry, New York,* 1967

Shifting Emotions

LEONARD FREED: *The Argument*, 1965

JOHN BENTON HARRIS: *The Tantrum*, 1966

LUTZ DILLE: *Laughing Man,* 1962

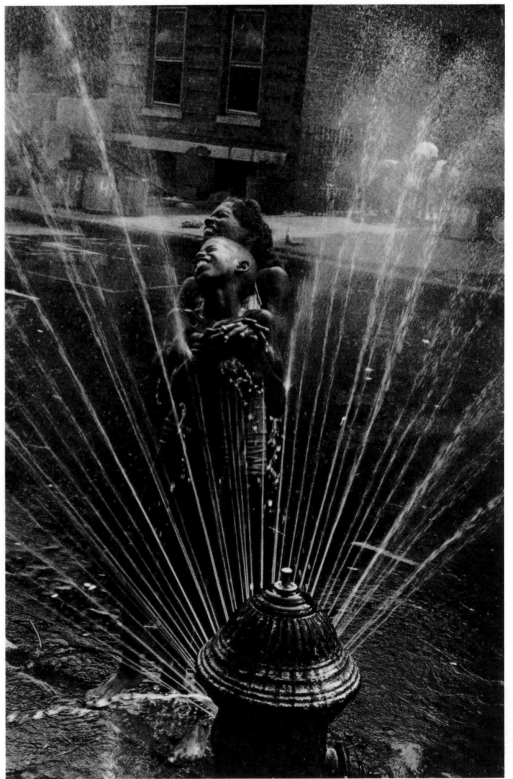

LEONARD FREED: *Fun with a Fire Hydrant*, 1967

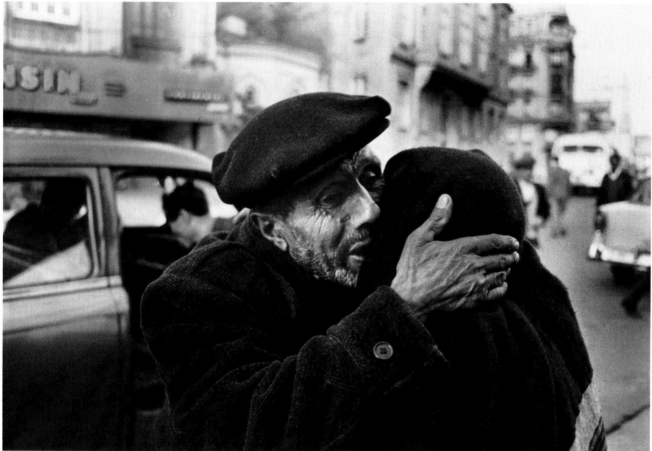

MARY ELLEN MARK: *Sorrow at Parting*, 1965

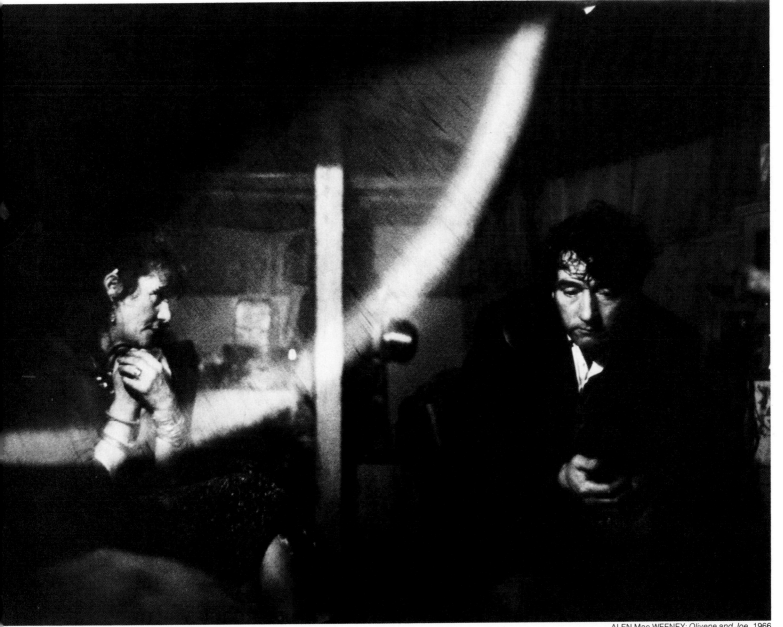

ALEN Mac WEENEY: *Olivene and Joe,* 1966

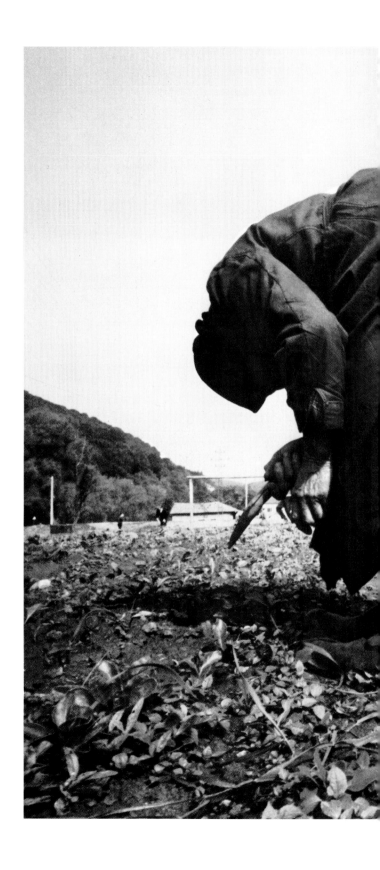

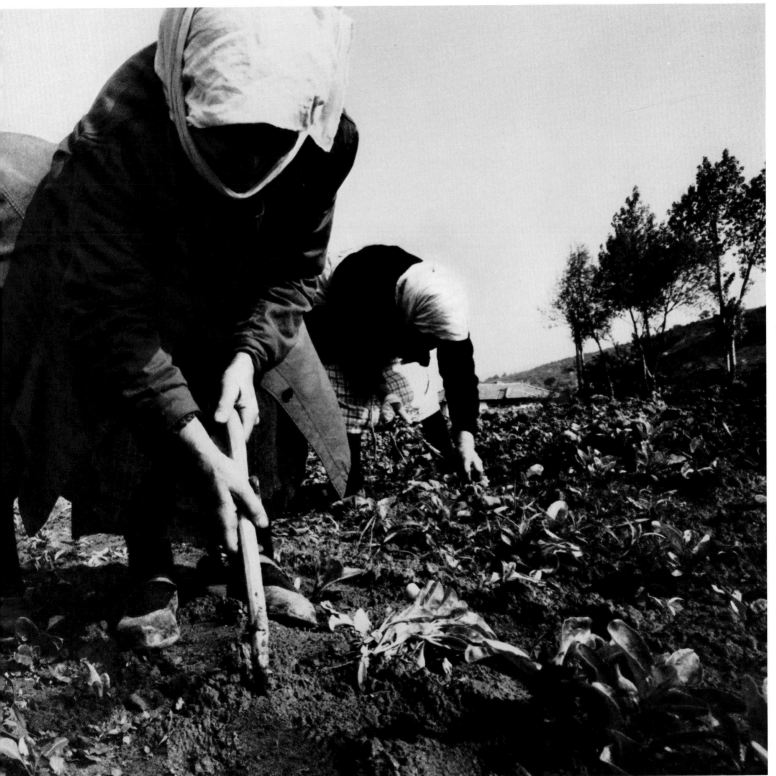

KEN HEYMAN: *Women Hoeing, Bulgaria,* 1966

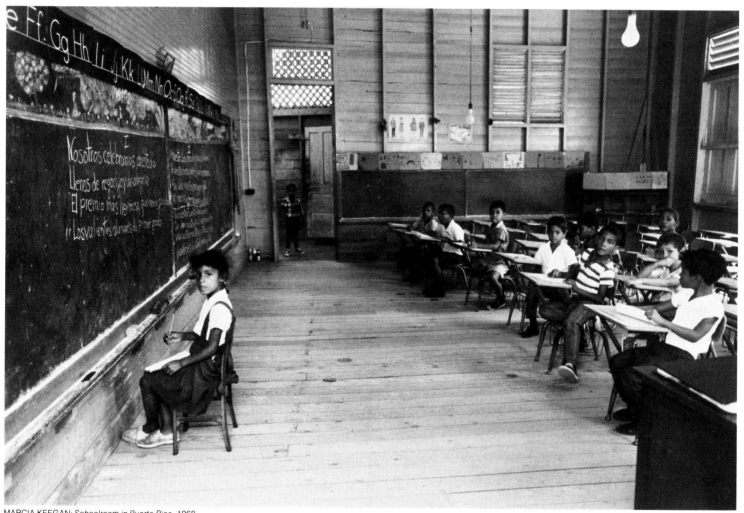

MARCIA KEEGAN: *Schoolroom in Puerto Rico*, 1968

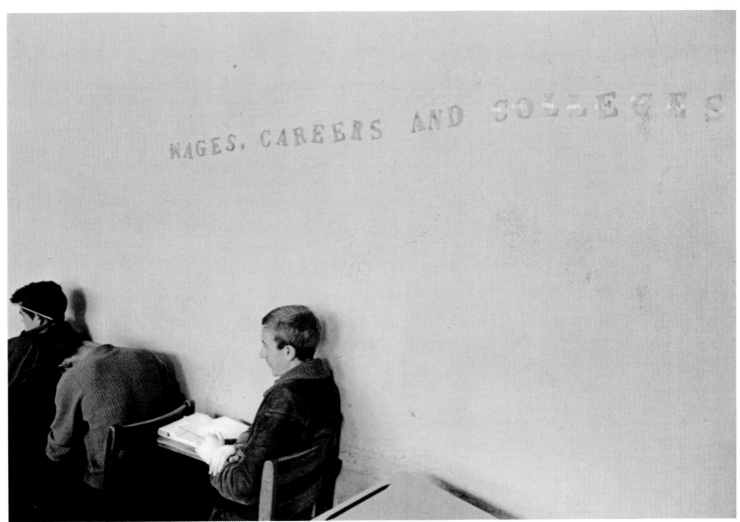

RON JAMES: *The Lesson—Planning a Career,* 1963

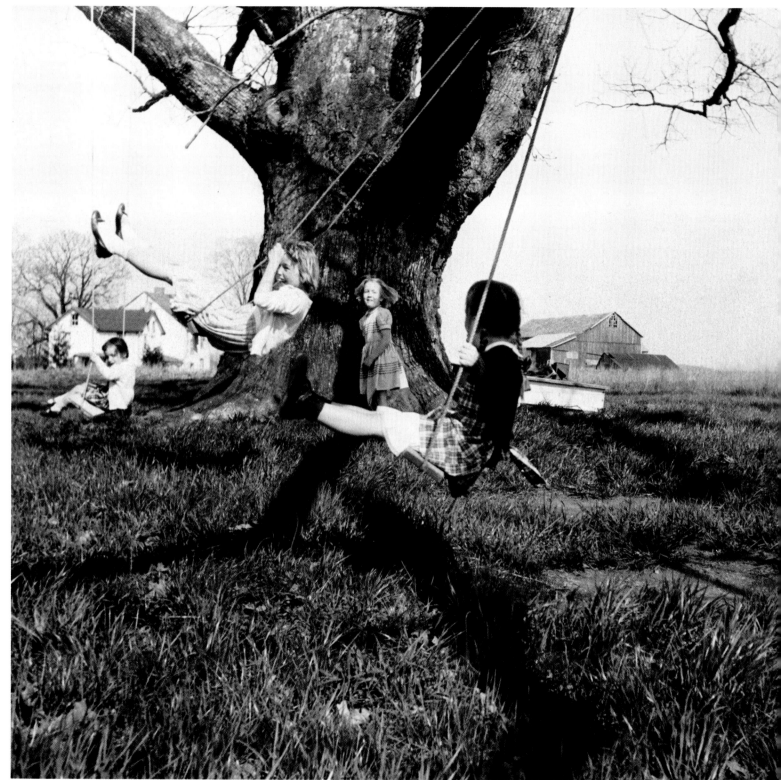

FRANCES McLAUGHLIN-GILL: *April Afternoon*, 1956

ERNST HAAS: *Boys Playing Handball, New York City, 1974*

JOEL MEYEROWITZ: *Ballston Beach, Truro,* 1976

DAVID ALAN HARVEY: *Lummi Indian Praying*, 1976

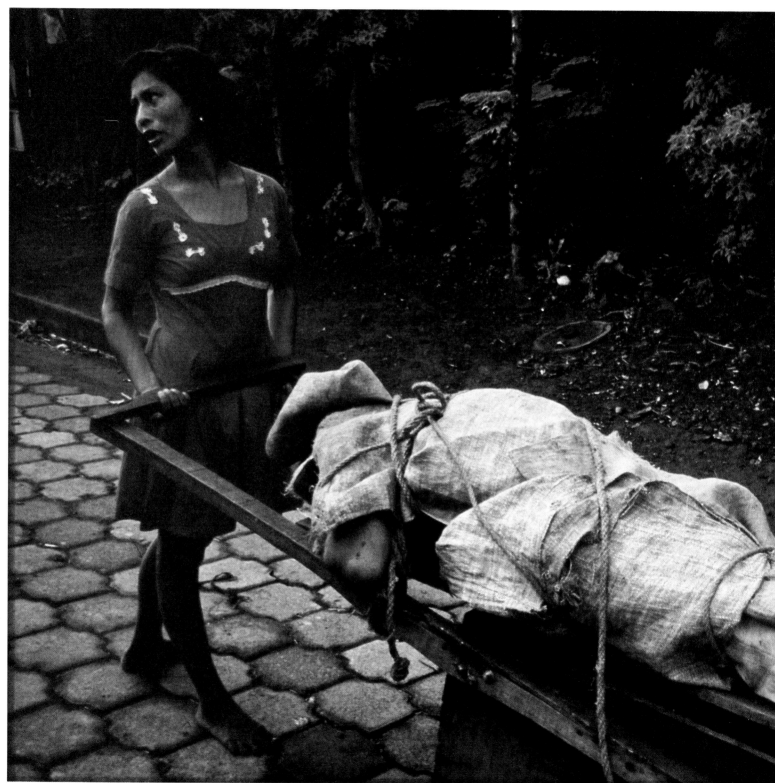

SUSAN MEISELAS: *Monimbo Woman with Husband's Body, Nicaragua,* 1978

40

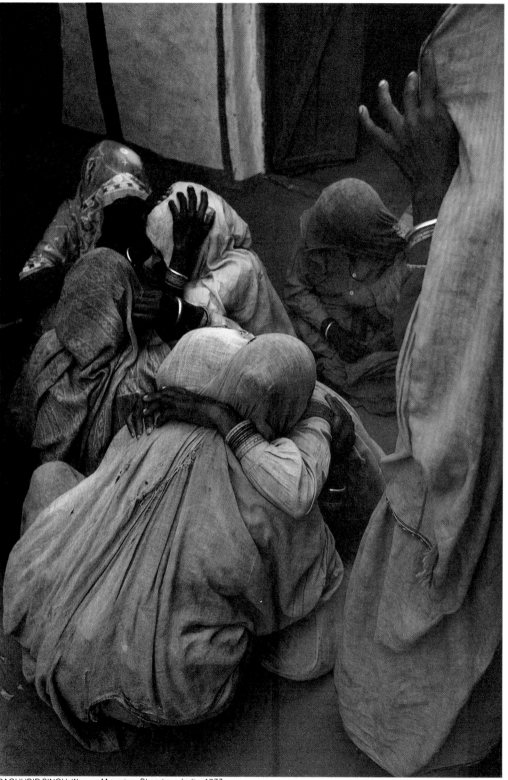

RAGHUBIR SINGH: *Women Mourning, Bharatpur, India,* 1977

Still Life **2**

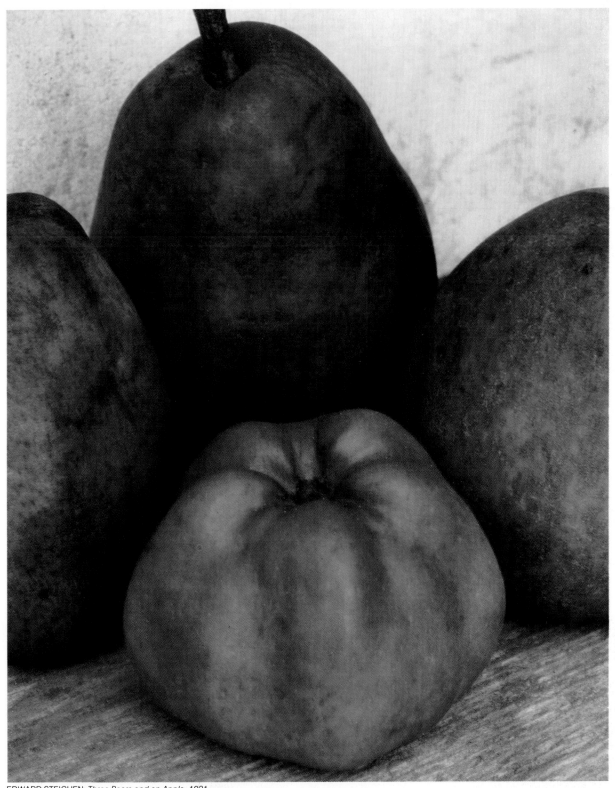

EDWARD STEICHEN: *Three Pears and an Apple,* 1921

The Challenges of Picturing Things

The still life is one of the most venerable genres of art. For many hundreds of years, painters have delighted their patrons with richly detailed, almost palpable visions of bowls of fruit, table settings, hunting gear and other amenities of civilization. Even when painting made its bold turn toward abstraction at the beginning of the 20th Century, still lifes—such as the fruit arrangements of Paul Cézanne and the cubist guitars of Georges Braque —remained a favorite mode of artistic expression. Understandably enough, photography's earliest ventures into the realm of still lifes mimicked the inclinations of painting, depicting much the same subjects and usually evoking the same sense of leisure and comfort. Today, however, still-life photographers are fully their own masters, dealing with a great variety of moods and subject matter. Their versatile craft, in fact, has become an indispensable linkage in the engine of commerce.

Every time we open a magazine, a catalogue, an illustrated cookbook or a manual on electronics, we encounter the handiwork of still-life photographers. That lusciously glowing tube of lipstick, that opulent car interior, that fruit-laden bowl of cereal . . . are all proof of the thriving state of the art. Thousands of commercial photographers earn a livelihood by showing off products to their best advantage and stirring the appetites of the consumer public. To a significant degree, the economy is driven by such small touches as the moisture that a photographer artfully applies to a chilled bottle of soda pop or the sparkle that he elicits from an automobile's chrome. Not all still-life photography is commercial, of course. Photographers, fascinated by the play of light and shadow or the balance of volumes and masses, record them for no other reason than esthetic pleasure. The tradition of celebrating inanimate objects is not only very much alive, but has been extended by modern photographers who create works of art in pictures of things that few people ordinarily consider beautiful—eggbeaters, an ambulance door *(pages 71-86)*.

Regardless of the subject matter of still lifes (or the motivation for taking them) the one thing that all good still lifes have in common is their requirement for painstaking attention to detail. Consider, for instance, the labor that Edward Steichen—one of the greatest still-life photographers—put into his picture of apples and pears, reproduced on the preceding page. Steichen was deeply interested in finding ways to represent volume, scale and a sense of weight in his pictures. And he employed a uniquely tedious technique for this still life. Having decided that diffused light was best for the purpose at hand, he placed the fruit and his camera inside a tent of thick blankets and directed a nickel-sized spot of light through a small hole in the tent so that it bounced off one side of the interior. The camera was equipped with a handmade diaphragm having an opening so small that he estimated its aperture as f/128. He made a series of pictures at various exposure times from six to

36 hours. "The fact that the longer exposures lasted more than two days and one night," he wrote later, "meant that, as the nights were cool, everything, including the camera and the covering, contracted and the next day expanded. . . . The infinitesimal movement produced a succession of slightly different sharp images, which optically fused as one. Here, for the first time in a photograph, I was able to sense volume as well as form."

Such an expenditure of effort is by no means uncommon. On the contrary, Steichen's explanation of his approach deals with only one of the many factors that must be considered in creating successful still lifes. Every subject, whether it be a single apple or a complicated array of utensils, confronts the photographer with all sorts of options of camera angle, distance, lighting, background and so on. The photographer must decide whether to emphasize the shape, mass or texture of the subject. He must be aware of the way the eye will move across the final picture—linearly, in a spiral or zigzag pattern, or simply leaping about. He should know how to compose the elements of the picture to create tension or a sense of tranquility. He ought to consider the various sorts of balance that can be created by manipulating the dark and light tones. And if he is working in color, he must deal with its own influences on movement, tension and contrast.

There are no hard and fast rules for exercising the options open to the still-life photographer. The same subject can be pictured with equal beauty in any of a number of ways—balanced or not, tense or tranquil, massive or textured, in diffused or strong light. But the fact that there are no rules makes it easier to demonstrate, as still-life photographer Richard Steinberg does in the series of pictures on pages 48-68, how lighting, composition and camera angle influence the qualities a viewer will see in the photograph. For none of Steinberg's comparison illustrations turns out "better" than the others—they merely turn out different. It is up to the photographer to decide which among these different approaches would suit his purpose best. And in that decision lies the challenge of the still life—a challenge that has made this great theme a source of artistic inspiration to photographers since the day of Louis Jacques Mandé Daguerre and William Henry Fox Talbot. □

Designing for Different Effects

The making of a good still life involves a whole series of decisions, all basically esthetic yet logical in the choices they present. The first question—and perhaps the most important—that the photographer must ask himself is what kind of picture, in the broadest sense, he wants to make, what purpose he wants his camera to serve. Does he want to convey an idea, a message? A mood? A literal, catalogue-like description of an object? Or is he primarily concerned with the specific qualities of the elements of his composition?

In the photographs on these pages, Richard Steinberg, using the same basic elements and identical lighting, has produced two strikingly different pictures by answering that question two ways. In the first one, at right, he has arranged those elements to convey an idea: someone has eaten a salad and found it, apparently, pretty good. In the picture opposite Steinberg offers us nothing but beauty. There is no narrative: the objects are there as shapes and textures in a pleasing composition. In one a message, in the other a feeling. Simply a difference in point of view, but a world of difference all the same.

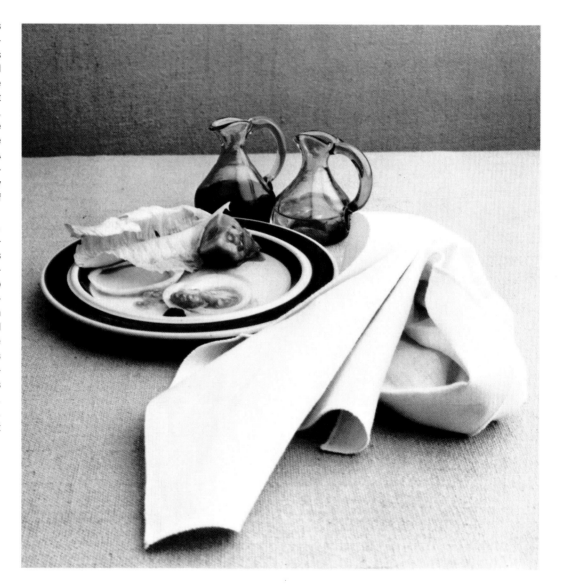

Two quite different still lifes —one telling a little story of a meal enjoyed, the other celebrating the beauty of foodstuffs —result from comparatively minor alterations to the subject matter. To stress the importance of the photographer's intent in effecting this change, Steinberg adhered strictly to the same elements of composition, the same equipment and even the same lighting setup (diagram) for both pictures, although it would obviously be easier to make different styles of pictures by altering those variables. The camera, a Hasselblad with a wide-angle, 60mm lens, was aimed downward at about a 25° angle. The single light at the right side was elevated and tipped down toward the subject at about a 45° angle; a reflector on the opposite side was tipped downward at the same angle as the light, forming a triangle with light and table. Base and background are burlap.

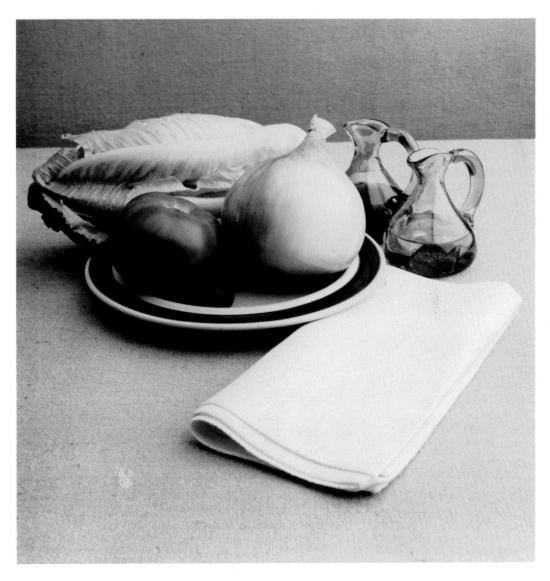

The Qualities Light Reveals

When an artist looks at an object, he sees a great deal more than the casual onlooker does, for he separates and analyzes a number of essential qualities that the brain ordinarily sums up instantly into a whole: shape, the object's two-dimensional outline; form, the three-dimensional aspect (sometimes called volume); and texture, the character of its surfaces. To make a successful still life, the photographer has to decide which of these qualities is of primary importance to the purpose of the picture.

The principal tool for emphasizing one or another of these characteristics in the picture is light, as Richard Steinberg demonstrates in the still lifes at right. Using a wad of crumpled tissue paper for his subject, he illustrates each of the three essential qualities, changing only the lighting and keeping all other conditions constant. (If the subject had been different, these same qualities might be revealed by other sorts of lighting setups.)

In the first picture at right, the accent is on shape; there are no lights and darks to suggest volume or texture. In the center picture, the subject is presented in the round, its form defined. In the picture at far right, Steinberg has emphasized texture, accenting the wrinkles in its crumpled form.

Shifts in the camera angle or the arrangement of the subject would have influenced these qualities, too. The photographer can separate and understand the subject's essential qualities only if he studies it at length, pondering the metamorphoses of its shape, and the coarsening or refining of its textures as he tries the many possibilities that are available to him.

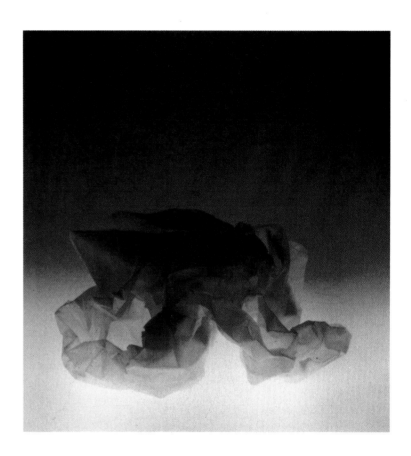

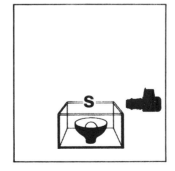

A single light was placed under the crumpled wad of tissue paper resting on a paper-covered glass tabletop. Since the light could not pass entirely through the crumpled mass of paper, a silhouette effect was created that accentuated the basic shape of the wad. Of the three essential qualities of this or any other irregular object, this two-dimensional aspect would alter the most if the viewing angle were changed.

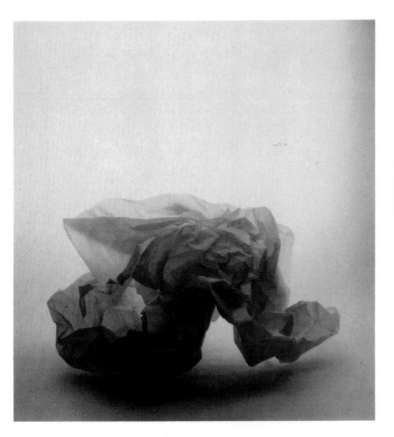

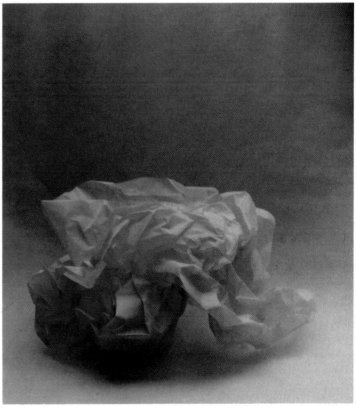

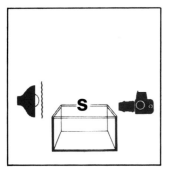

To capture the form of the crumpled paper, the subject was illuminated from behind with a single light. Because the object was partially translucent, strong light coming through and around the object created shadows and highlights that define the volume of the crumpled paper. The large image of the wad was obtained by using a long-focal-length lens (150mm) and separating it more than the normal distance from the film with an adapter ring.

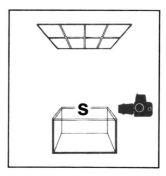

A skylight about 40 feet directly overhead gave light with enough directional quality to bring out the texture of the crumpled paper. This provided soft highlights and shadows, letting all of its irregularities show. As in the other two pictures, the camera, a Hasselblad, was not elevated.

A Form Reshaped by Camera Angle

The photographer selects his point of view—his angle—as willfully as a poet, novelist, or editorial writer, because angle controls shape. The form of any object except a sphere will be altered, for good or ill, by a change in camera angle. To take one example, the elegant grace of a milk-filled bottle can be reduced, enhanced, or informed with a hint of menace according to the elevation of the camera from the horizontal, as Richard Steinberg demonstrates in the pictures on these pages.

Steinberg brought about these aspect changes by alterations in angle alone; lens and lighting are the same in all three pictures. The view at right, made with the camera at the horizontal, shows the true shapes of the bottle and its stopper, for this straight-on aim provides the only way to render their curves undistorted. The center picture, made with the camera elevated slightly, deepens the curves and foreshortens the bottle without subverting its gracefulness. The much higher view at far right significantly alters the bottle's apparent shape and subliminally poses the possibility of eruption. (What if that fluid were champagne?) It is understandable that this is a favorite angle for picturing a missile on its pad.

While shifts in viewpoint are the easiest way to reshape an object (and its impact on the viewer), they also complicate the photographer's task. When a still life contains several elements, the photographer must take care that the angle that enhances one element does not destroy another.

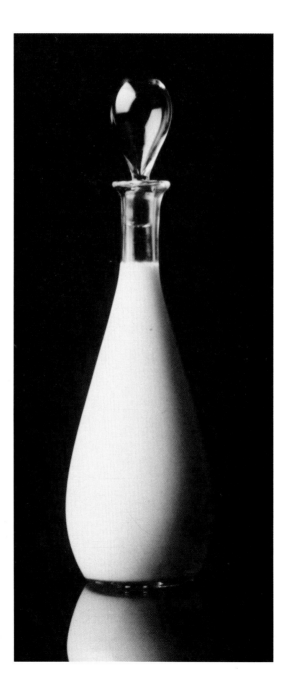

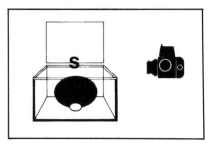

For a realistic view of the shape of the stoppered bottle, the Hasselblad camera was fitted with a normal 80mm lens and set level with the bottle. A single light, at the same level, was placed at left and a white reflector opposite it.

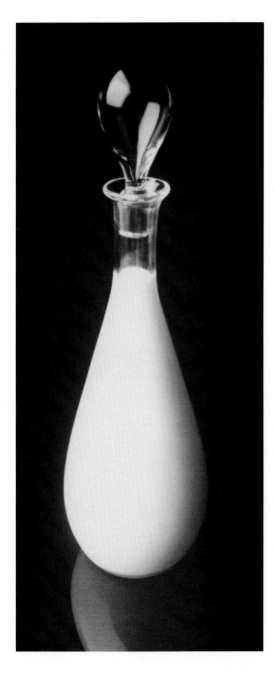

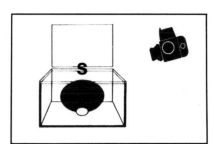

To foreshorten the bottle and increase its apparent curvature, the camera, still full front, was raised so that it pointed down at an angle of about 25°. The light and the reflector remained where they were for the level shot.

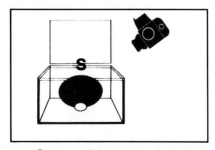

For the most dramatic photograph, the camera was raised until it was angled at 45°. Light and reflector were not moved. From this viewpoint the stopper is much nearer to the lens than the bottle, and looms disproportionately large, while the bottle itself becomes fat and squat.

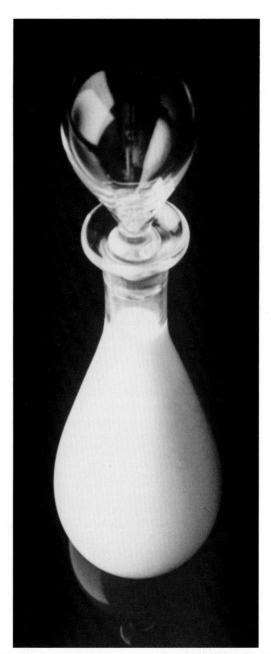

Balancing with Composition

Balance. Tension. Movement. The elements of composition that are considered on these and the following pages may seem farfetched critics' words. They are, however, almost literally meant pictorial characteristics that result from the way people see things. Some arrangements of objects in pictures suggest serenity, others motion, still others tense activity. The reason for this lies partly in human experience with real—as against pictured—objects, partly with the brain's automatic tendency to try to group elements into larger units.

Both these factors make the viewer seek balance in a picture, almost as if he saw its elements on a seesaw. In the picture on this page, the balance is obvious. Foursquare and almost bisymmetrical, its center of gravity nearly in the center, this is an example of what artists call static balance. It can be used effectively in a still life that seeks to create a tranquil mood. The picture opposite is in balance too, but in a kind of balance, called dynamic, that lends a sense of activity and excitement. One carnation is balancing three, yet the isolated carnation holds its own because it has been allotted more space than the three; the space around each object, as well as the object itself, has weight and becomes an active element in the stability of the picture.

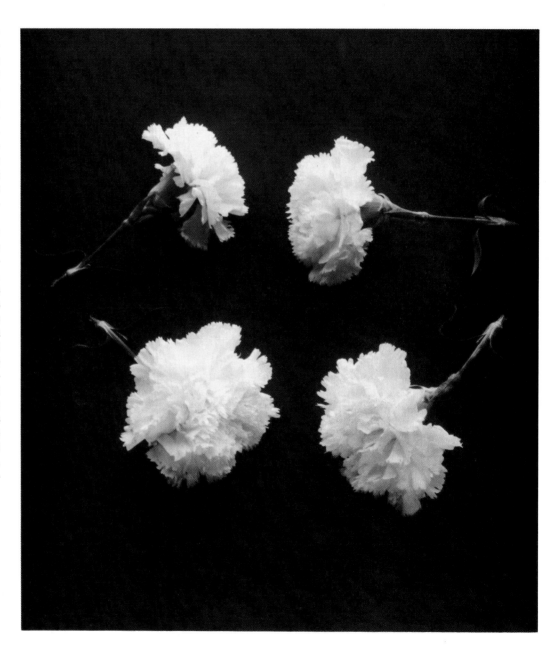

Only the arrangement was changed to produce these two totally different pictures. Both show the same four carnations, photographed with the same camera and light setup (diagram above). To the viewer, however, the symmetrical placement of the flowers at left seems calm and immovable, while in the view at right the counterweighting of three flowers by one suggests a stability—perhaps only temporary —that has been wrought by some active force.

Balancing with Tones

However artfully a photographer has arranged the elements of the still life and chosen the camera angle, it is the tones of the photographic image—the blacks, whites and grays—that must in the end fulfill the promise of balance and tension in the composition. In the three studies of seashells on these pages, Richard Steinberg has altered nothing but the placement of his lights to create three completely different kinds of tonal balance. In the picture at near right, made with top-front light, the difference between dark and light tones is not great, but within that limited range almost all possible tones are discernible, conveying texture and roundness. The light is uniformly distributed, and since there is no gradation of tones in foreground or background, the shells are totally self-contained, appearing to float in space.

In the upper picture on the opposite page, made with side light, the left half of the large shell seizes the eye, but its much brighter mass is balanced by the faint right half of the shell, which gains importance by contrast with the black background. The smaller shells are almost evenly divided into very light and very dark areas, giving added stability to the picture.

In the third picture *(opposite, bottom),* Steinberg used top lighting to obscure the shape and form of the shells and to build up maximum tension between tones. The very dark overall tone of the picture makes the highlights along the tops of the shells leap out, even though they are, in fact, not very bright and occupy little area. The shells here have a mysterious, almost disturbing air, but the viewer's emotional need for tonal balance is fully satisfied.

A single light, placed just above the camera, produced a minimum of shadows and very even illumination throughout the picture above. Steinberg used 55 P/N Polaroid Land film in his Deardorff view camera, which was tilted downward at an angle of about 10°.

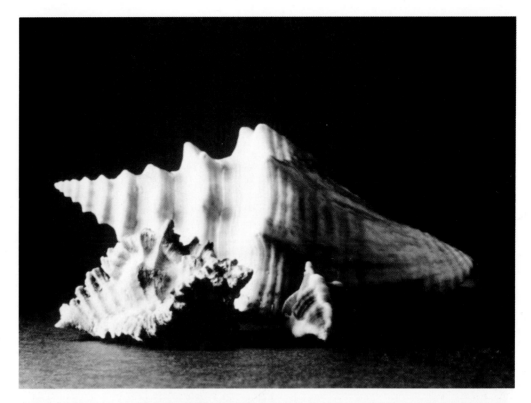

In this side-lighted study, the right half of the big shell, so important as a balance to the dazzling left side, was given a measure of illumination by a reflector placed opposite the light source. The conical shape of the main shell, widest near the center of the picture, helps to lead the eye from the brighter to the dimmer region.

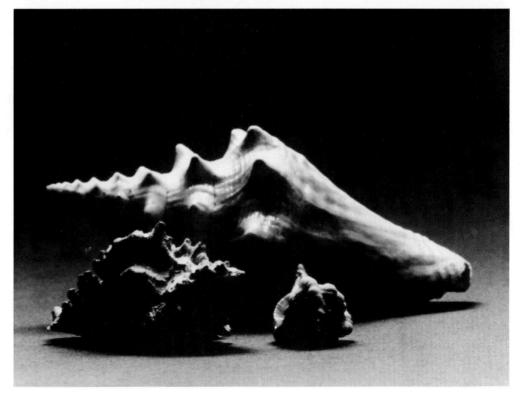

The light is directly overhead in this rather eerie photograph. To be certain that the highlights would stand out sufficiently to do their balancing job, Steinberg blended the gray foreground into a pitch-black background behind them.

Two Ways to Lead the Viewer's Eye

Movement in a still life? It does not occur literally in a picture, of course—but it can be generated by the process of perception. Any visual pattern will cause the eye to move about, investigating. The photographer's task is to compose his picture so that the eye is led where he wants it to go. There are several ways in which this eye movement can be created, and each has a distinctive impact on the viewer.

In the photograph at right, the rolls are arranged so that the eye is caught at any of several high-contrast (and therefore attention-getting) points located near the edges of the picture, then is led in S-sweeps or a tightening spiral to the center. There is a continuous path along which the viewer is carried until he is brought to a principal point of interest—the spiral roll. Compare this relatively serene view with the bread picture on the opposite page. Here the eye is forced to move much more actively, almost helter-skelter. It is drawn back and forth from torn loaf to whole, from spongy interior to seeded crust. In this arrangement the eye can find no final goal; it must keep moving—and the result is a feeling of tension that suggests powerful force.

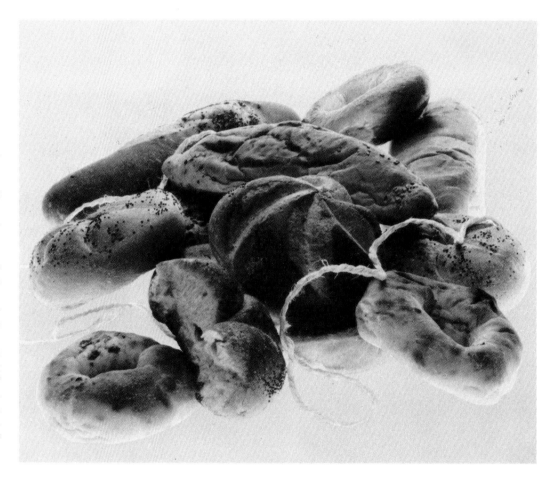

Both these pictures suggest movement because they do indeed force the eye to move. But the one above leads the eye gently to a preselected point, the one opposite shifts the eye back and forth in a tense, random fashion. In both, the motion is carried by progressions of contrasting areas that act almost like arrows; the difference lies in the way those areas are arranged.
The lighting setup (diagram at left) was the same for the two pictures; the camera, a 2¼ x 3¼ Cambo view type, was kept at the same angle in both instances but was brought much closer for the shot on the opposite page.

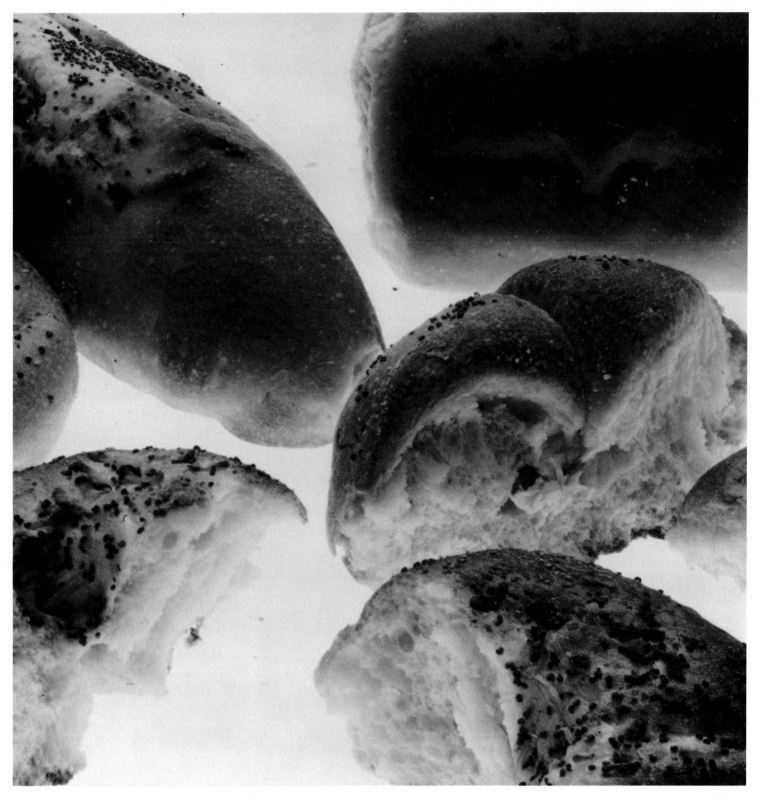

The Advantages —and Problems —of Color

Color is more than an aid to realism in still-life photography—more than the factor that makes a glass of wine look tempting, a bowl of fruit edible or a flower arrangement alive. When skillfully handled, color can become an active force in a picture, generating mood, leading the eye along a certain path, imparting tension, and creating a subliminal sense of unity.

But color requires the still-life photographer to think even more clearly about the purpose of the picture before he goes to work. If the purpose dictates a detached mood, his palette should probably be limited to a few cool hues such as blue or yellowish green, kept to fairly low intensities. For a picture that seems to involve the viewer more, reds and deep yellows, presented in a wider range of intensities, are preferred. The addition of a bright blue or blue-green to the reds may produce a jangling, psychedelic effect, but even a lively picture should not deviate too far from the predominant hues. Yet quite dissimilar colors sometimes balance one another. In the traditional bowl of fruit, a small but bright strawberry may offset the paler green of a large melon, creating a subtle balance.

Colors can generate movement in all sorts of ways. A splash of color contrasting with its surroundings will usually seize the eye first. A series of related colors may then guide the eye along a certain course. To arrest this movement and send the eye leaping off in some new direction, the photographer can insert a bright color in a chain of duller ones (or a dull color among brighter ones). Three-dimensional position is also suggested by color: a red will appear closer to the viewer, whereas a blue will seem farther away. The photographer must watch the background closely, for a diversity of colors there can distract from movement among the main elements of the picture. The color of the background also can increase or reduce contrast.

Choosing and arranging colors demands the closest sort of attention, and lighting them to advantage requires equal care. Oddly, some of the most challenging subjects are those with a bare minimum of color variety. In the picture of a glass of Scotch opposite —a superb example of the difficult art of photographing glassware—Richard Steinberg allowed nothing but the brilliantly lit contours of the ice cubes and glass to compete with the one strong tone of the amber liquid.

For the vibrant vision of a drink, opposite, Richard Steinberg used a single backlight whose rays were softened by a pane of translucent glass (diagram above). A glass table supported the subject and provided gleaming reflections. His 8 x 10 Deardorff view camera was aimed at the light source directly behind the drink. Although he only had to worry about one color, Steinberg spent three days getting the reflections and light just right —and he had to use nonmelting ice cubes made of plastic.

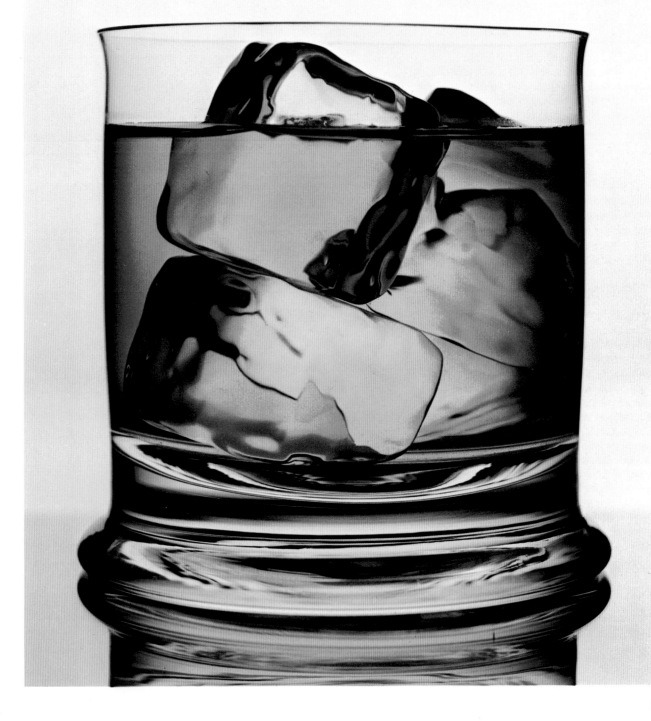

Backgrounds That Alter Colors

In still-life photography, the color of the background can almost totally alter the appearance of the subject of the picture. One background color may make the subject stand out clearly, another may work against the subject's color and form. The colors that exhibit greatest contrast are complementary pairs. That is, one is the spectral opposite of the other. Complementary colors—red and green, yellow and violet, orange and blue, for instance—not only contrast well but they actually intensify each other. Thus, a leaf on a strawberry will look greener and the strawberry will look redder than if either were photographed alone on a white background. On the other hand, a white background may often be preferable to a background of a noncomplementary color: A picture of a green subject on a blue-green background will exhibit little contrast.

The mutual intensification of complementary colors should be exploited cautiously. If a complementary background and subject are both vivid, the intensification of the colors becomes positively jolting, as in psychedelic art. One of the best ways to focus the eye on a still-life subject is to photograph it on a complementary but paler background. This produces good contrast but does not force the subject to compete with the background for attention.

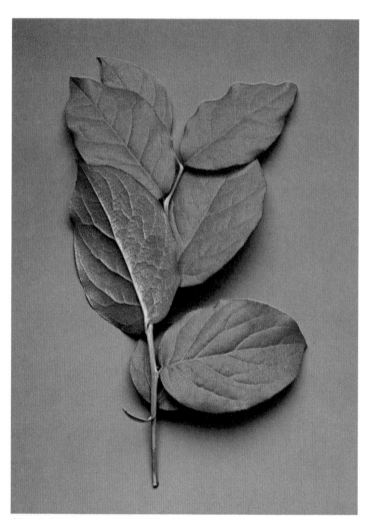

Although all the pictures on these pages were lighted identically (diagram at left), contrast is lowest in the picture above, because the green color of the lemon leaves is not complementary to the blue background. This forces the eye to work harder to see some of the borders.

Contrast is greater when the same green leaves
are photographed on a pink background
because the two colors have a complementary
relationship. Since pink is a pale version of the
complementary hue—red—the background does
not vie with the leaves for attention.

A cardboard background also produces good
contrast and makes the leaves seem bright
green because there is some red—degraded by
mixture with black—in its brown color. The
strong vertical lines in the corrugated cardboard
reinforce the pattern of the veins of the leaf.

Colors That Are Warm and Cool

Colors, oddly enough, seem to add temperature to a picture. Because they trigger mental associations, golden yellows and reds appear distinctly warm, while blues and yellowish greens seem cool. But the impressions generated by these two families of colors go beyond mere illusions of temperature. Warm colors, especially if they are dark, make an object seem quite heavy and dense. Pale, cool colors, on the other hand, give an object a light, less substantial appearance. Furthermore, warm colors appear farther forward, cool colors farther back. Both sides of this "distance effect" can be put to work within a single picture to increase the illusion of depth—by the simple trick of placing warm-colored objects against a cool-colored background.

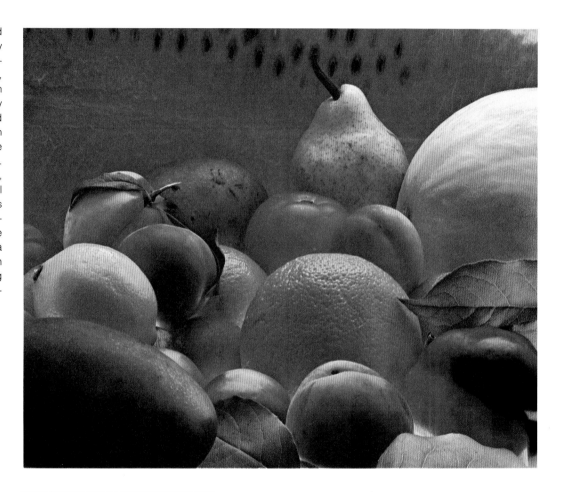

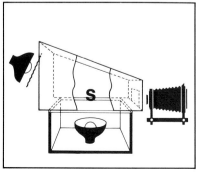

Because of their warm colors, the fruit above have a succulent-looking weightiness and seem to press toward the viewer. To enhance the naturally warm colors of the subject, Richard Steinberg used an ingenious lighting technique (left). He enclosed the fruit in a specially constructed tunnel lined with gold foil, which strongly reflects yellow and red wavelengths, to suffuse the entire scene with very warm golden light. Light entering at the far end of the tunnel was bounced down on the fruit from the slanting roof. A second light, positioned directly under the glass table that was supporting the fruit, illuminated the arrangement from below.

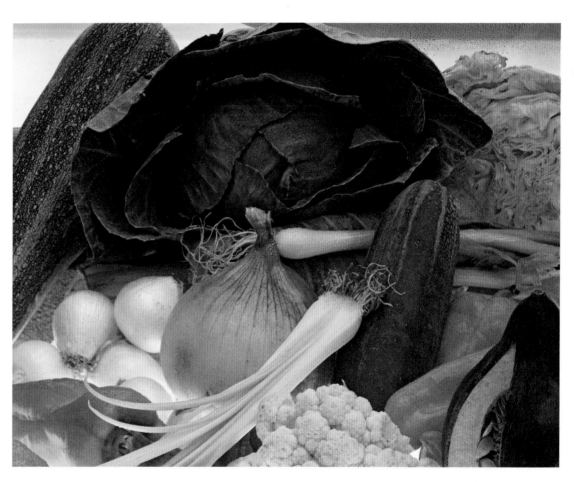

Although the vegetables in the picture above are of the same scale as the fruit opposite, they seem more remote and less substantial because of their cool colors. Here, too, Richard Steinberg heightened the effect through lighting. The vegetables were backlighted by a lamp positioned behind a sheet of blue gelatin-filter material; a reflector board bounced some of this blue-tinted light onto the front of the vegetables (the camera was aimed through a hole cut in the reflector). Two other lights, one above the subject and the other below its glass support, provided a preponderance of untinted illumination. To add a hint of warmth, Steinberg included a pale brown onion, flecked with droplets of water that suggest garden freshness.

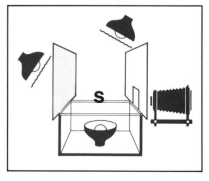

Abstractions in Color

Color offers a special way to release a mundane object from the bonds of realism and create abstract beauty. The lettuce leaf at right, for example, is no longer something to be grown or eaten. Richard Steinberg has turned it into a study of pure form and color.

To tighten the many-chevroned pattern that he discerned in the light-green tracery of the veins on the darker green of the lettuce leaf, Steinberg decided to shoot across the "valley" of the leaf, dropping its main vein out of sight. By lighting his subject from underneath, he took advantage of the difference in opacity between the leaf and the relatively unpigmented veins to make the pattern still bolder. Between the leaf and the light, he placed a piece of translucent acetate-plastic inscribed with parallel lines. The lines provide an artificial but intriguing echo of the vein structure, further elevating this still life into the realm of the abstract.

A single light illuminated the lettuce leaf (right) from directly below, silhouetting the parallel lines on the acetate-plastic and making the leaf veins stand out clearly. The light was positioned close to the glass tabletop that supported the leaf and plastic. To get this larger-than-life close-up, Steinberg extended his 180mm lens more than the normal distance from the film by fitting an adapter ring to his Hasselblad.

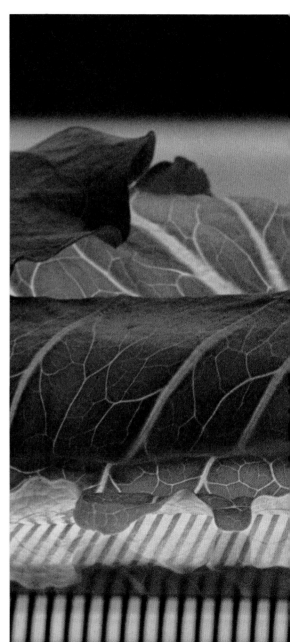

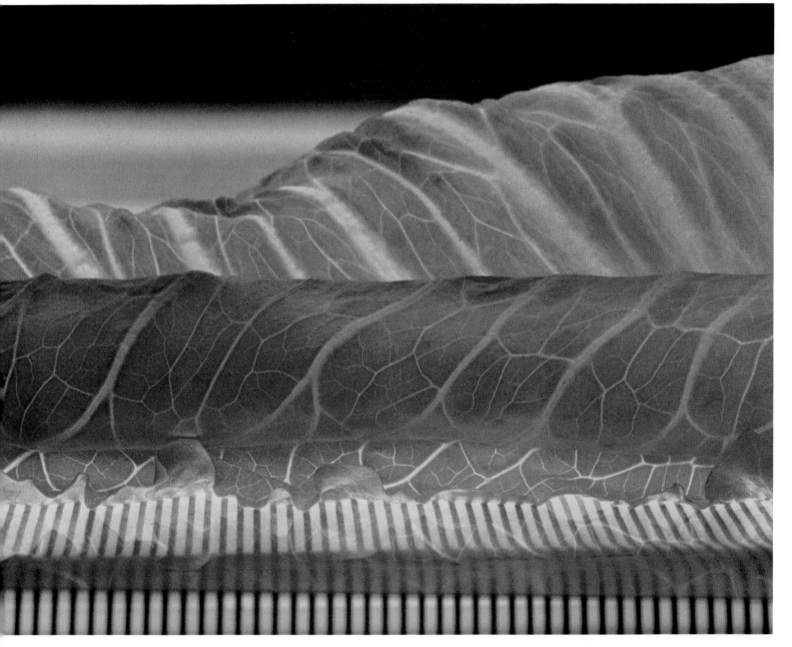

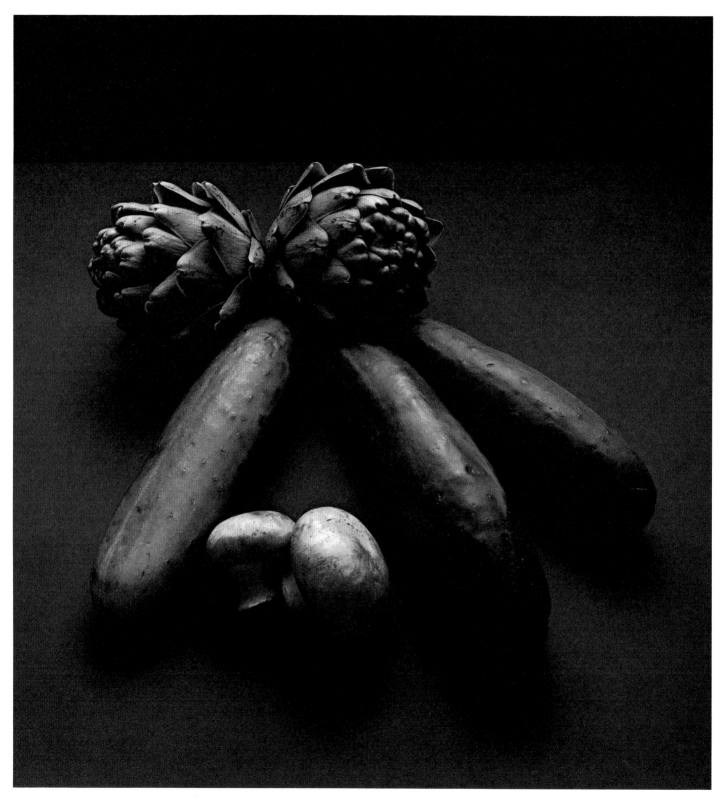

The lighting and camera placement for the picture opposite were selected to create a strong sense of movement toward the viewer. A single light, above and behind the vegetables, built up bright highlights and forward-thrusting shadows. Richard Steinberg's camera was aimed downward and toward the light to catch the highlights, which helped offset the green. A sheet of blue paper served as the background.

One color sometimes displays a remarkable ability to balance another out, giving still lifes a controlled tension that can be extremely appealing. A single spot of red, for example, is able to offset a much larger expanse of white because its vividness makes up for its lack of area. In the still life of vegetables on the opposite page, the reverse effect is seen: the cream-white of the relatively small mushrooms serves to balance out all the green of the larger cucumbers and artichokes.

Composition and lighting helped to make this color balance possible. The cucumbers, radiating outward from the artichokes, lead the eye directly toward the mushrooms. If the mushrooms had been placed in the background or off to the side, they would have lost much of their visual impact, but Steinberg locat-ed them between two cucumbers—just far enough from the picture's center of gravity so that they do not appear to be escaping, and close enough to the viewer so that they seem particularly impressive. Running along the tops of the cucumbers are near-white highlights that help to prepare the eye for an encounter with the cream color of the mushrooms.

The cool, blue background also contributes to the balance. Cool colors not only seem to recede but they also tend to hold the elements of a composition apart and allow them to be examined separately. A background of red or reddish brown would have caused the vegetables of this still life to seem more tightly clustered and would have worked against the mushrooms' feat of offsetting so much green. □

The Discriminating Art of the Still Life

Towels, tools, babies' clothing—all commonplace objects—seem at first thought to be unlikely subjects for serious photographs. However, discerning photographers have taken a careful second look at these and similar homely objects, and have found in them the ingredients for outstanding still-life photographs, distant though they are from the driftwood, flower arrangements and bowls of fruit of the classic still life. As the pictures on the following pages make clear, there is virtually no limit to the variety of still-life subjects, or to the ways in which they can be lighted and arranged for effective and artistic compositions.

What makes a successful still life is not the subject, or any tradition-bound way of showing it, but the photographer's sense of observation—his ability to look at the subject and to see, first in his mind's eye and then in the camera's viewfinder, an image of a finished picture. This process of looking—and of seeing—led Martus Granirer, for example, to take the photograph on the opposite page.

Granirer originally studied the towel as it hung over a shower stall, where it was caught in a flood of early-morning sunlight; it appeared to hover there. He was intrigued by the mystery it presented. How could one know it was not hanging against the wall? Feeling that this air of mystery was often an essential part of a good still life, he decided to re-create a simpler version. To capture the hovering

effect, he extended the towel out from the wall of his studio on a long rod. Careful lighting, arrangement of the folds and stripes of the towel, and the selection of a nonspecific background—a piece of mottled, creased, seamless paper—all helped re-create the puzzle that had first caught his attention.

Granirer, in working with a single object, used a basic type of still life. It is not necessarily the easiest kind to make, for the object alone must carry the picture, with nothing to relate to except the background. Often, success is more readily achieved by relating the principal object to other objects, or at least by repeating it. This can be done either by adding more objects of the same kind or by lighting the object in such a way that it is echoed by a shadow or reflection.

More complex still lifes are also possible. Many contemporary photographers take close-ups of just parts of objects—small household objects such as scissors and large objects such as automobiles and buildings. In these close-ups, the detail stands for the whole, and although the object is generally recognizable, the emphasis is on the abstract elements of form, color and texture. Finally, many photographers still work with the classic still life, carefully grouping and lighting a number of different objects—flowers, fruit, kitchen utensils, or musical instruments—to produce a harmonious and meaningful whole.

In this, as in many of his still lifes, Martus Granirer deliberately set out to persuade the viewer to focus intently on a paradox of pictorial representation. He suspended a bath towel on a three-foot rod, making it seem to float alone through space—without any obvious clue as to why. The sense of indeterminate distance that permeates the picture was achieved by moving the camera 15 feet away from the towel and photographing it with a long-focal-length lens. The long lens alters size relationships by flattening out the folds in the towel, thus depriving the viewer of perspective and heightening the illusion that the towel is afloat, alone in space.

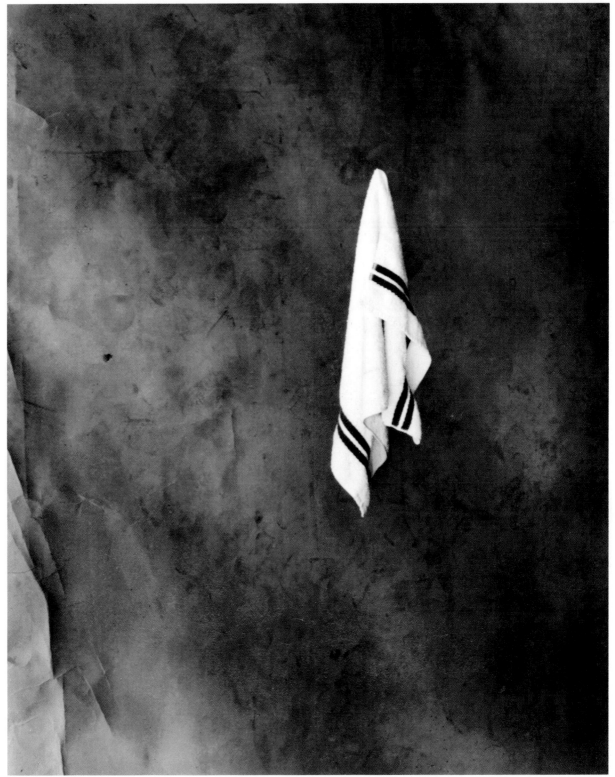

MARTUS GRANIRER: *Towel*, 1965

Focusing on the Single Object

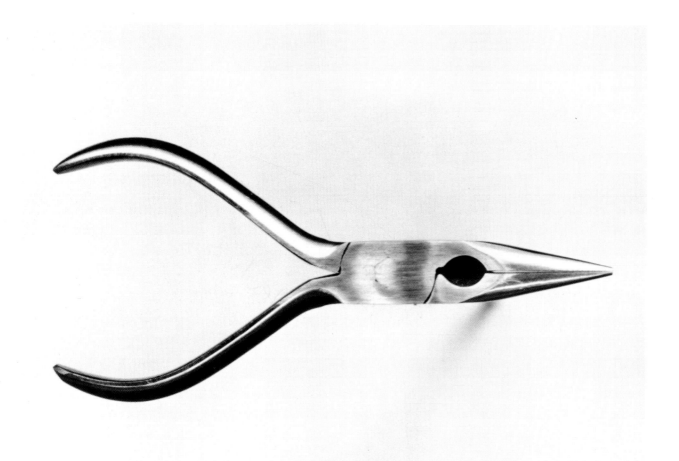

WALKER EVANS: *Pliers,* 1955

When a single object is the center of attention in a still life, it must carry its own weight. The photographer can help it along, however, in several ways. He can provide a plain background that contrasts with the object but does not distract from it; or he can place the object in a more complex setting that extends or varies its shapes and colors; and he can light the object to advantage. The most satisfactory lighting arrangement is generally one that emphasizes the object's intrinsic character: the grain of wood, the texture of fabrics or metal, the curves of a distinctive shape. With such encouragement, even the most ordinary objects, such as pliers, pitchers or collars, bespeak their own merits.

An uncompromising portrait of a pair of needle-nose pliers was Walker Evans' illustration for a 1955 Fortune article on tools. His picture eloquently honors the grace of the implement's shape and the steely toughness of its material.

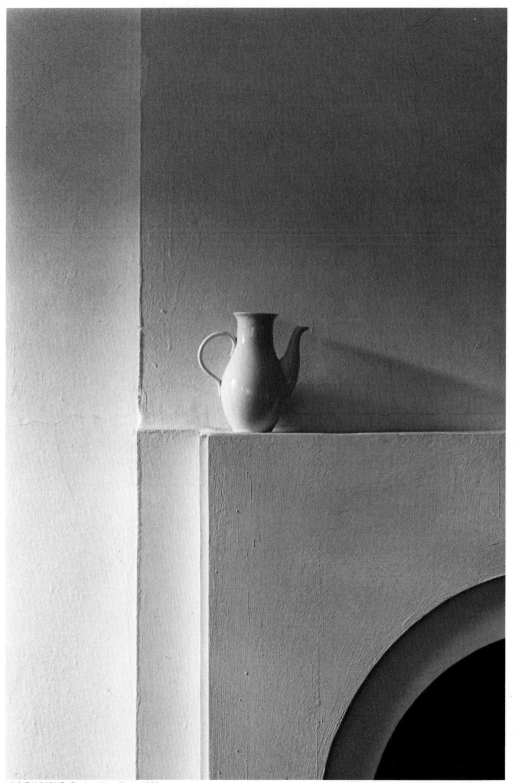

In Lilo Raymond's photograph of a white pitcher on a mantel, the vessel's curves are set off by the mantel's straight lines and echoed by the arcs of the fireplace. Diffuse afternoon sunlight, coming through an unseen window, casts delicate gray shadows on the otherwise unbroken whiteness of the wall.

LILO RAYMOND: *Pitcher, New York,* 1980

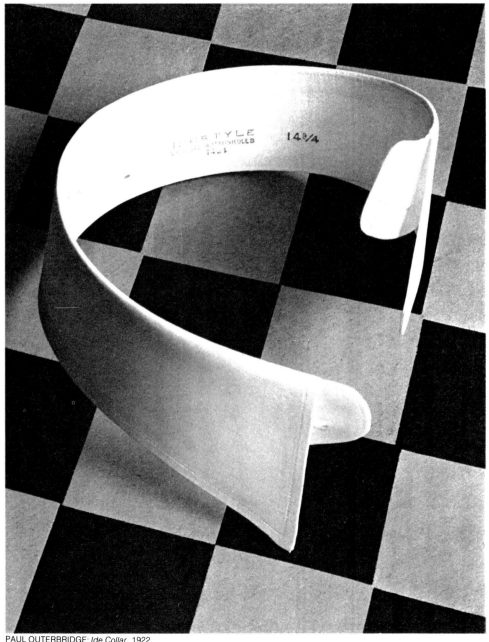

A starched collar placed on a chessboard-like background made a sensationally up-to-date advertisement when it appeared in Vanity Fair in 1922. Instead of using a real chessboard, however, Paul Outerbridge—with the attention to detail for which he was noted—painstakingly cut out squares of linoleum to match the scale of the collar.

PAUL OUTERBRIDGE: *Ide Collar,* 1922

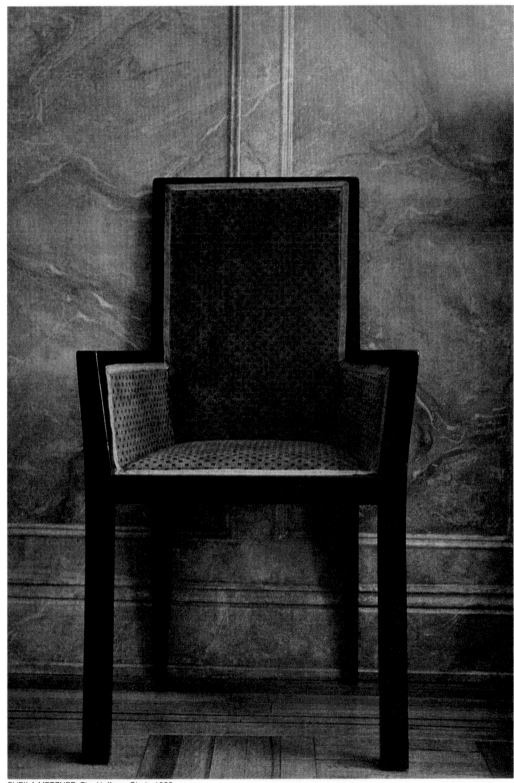

SHEILA METZNER: *The Hoffman Chair*, 1980

An Art Deco chair, photographed in the glow of late afternoon against a pale marble-like wall, recalls the elegant simplicity of a vanished era. To capture the chair's rich blacks and muted grays, Sheila Metzner had the print made in France by the Fresson process of four-color carbon printing.

Patterns Made by Repetition

Still-life subjects can frequently be made to reveal more about themselves—their form or purpose or intrinsic properties—if they are deliberately repeated in the same picture. There are two basic ways to achieve this repetition. One is simply to use two or more of the same kind of object, as in the pictures on pages 78 and 79. The other is to use only one object, but to arrange and light it so that it repeats itself by casting a revealing shadow, as shown on these pages.

Both techniques require a thoughtful approach to be successful. In Edward Weston's deceptively simple study of an egg slicer *(right),* for example, the shadows cast by the homely utensil not only add an element of contrast but also introduce a view that reveals more of the structure of the slicer, emphasizing—as an unshadowed photograph could not—the fine steel wires that cut the egg. Similarly, André Kertész used shadows to repeat the long lines of the fork on the opposite page. In the composition of his still life on page 79, however, Kertész achieved repetition more literally, creating a spare and slightly mysterious image with two pairs of eyeglasses.

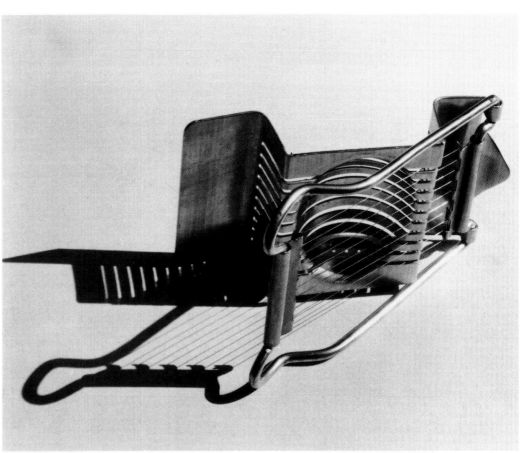

EDWARD WESTON: *Egg Slicer,* 1930

The strong, handsome lines of the shadow in Edward Weston's picture are in effect a second view of the egg slicer, showing what it looks like at an angle to the camera's view.

What could have been an ordinary catalogue ▶ *shot of a fork is turned into a striking still life by making the fork repeat itself in shadow. The rounded form of the plate, repeated in its shadow, serves to contrast with—and underline—the elongated shape and shadow of the fork.*

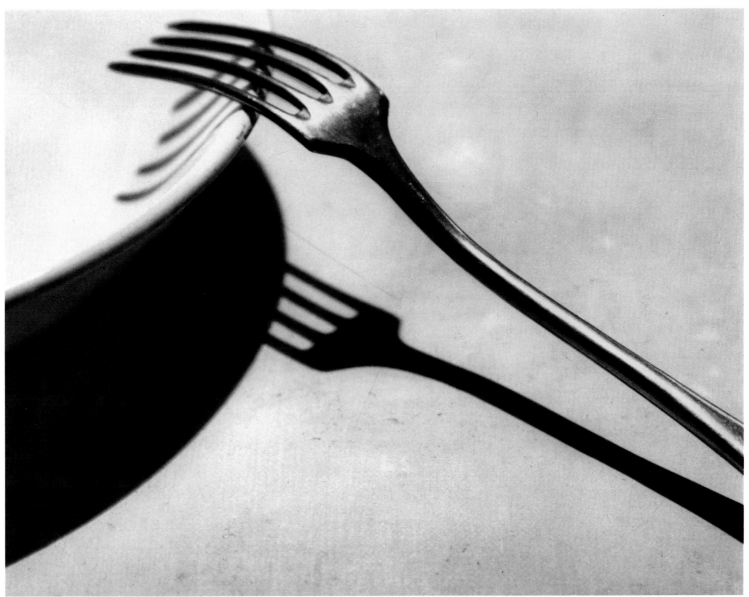

ANDRÉ KERTÉSZ: *Fork*, 1926

A baby's shoes and socks seem to have been snapped just where they were dropped, but closer analysis shows that the composition was hardly accidental. The toes of each pair point downward, each curve reinforcing the others and evoking the tiny feet of the toddler to whom the items belong. Edward Steichen made the photograph for a children's book written by his daughter.

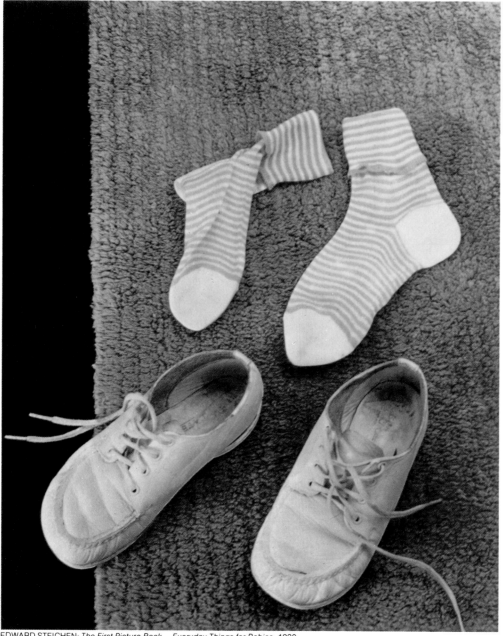

EDWARD STEICHEN: *The First Picture Book—Everyday Things for Babies,* 1930

Two pairs of glasses resting on a table along with a ▶ filled pipe in a bowl suggest the reflective life of an intellectual. Photographed in the Paris studio of artist Piet Mondrian, the still life is dominated by spare, geometric shapes and stark contrasts — qualities of Mondrian's own abstract compositions.

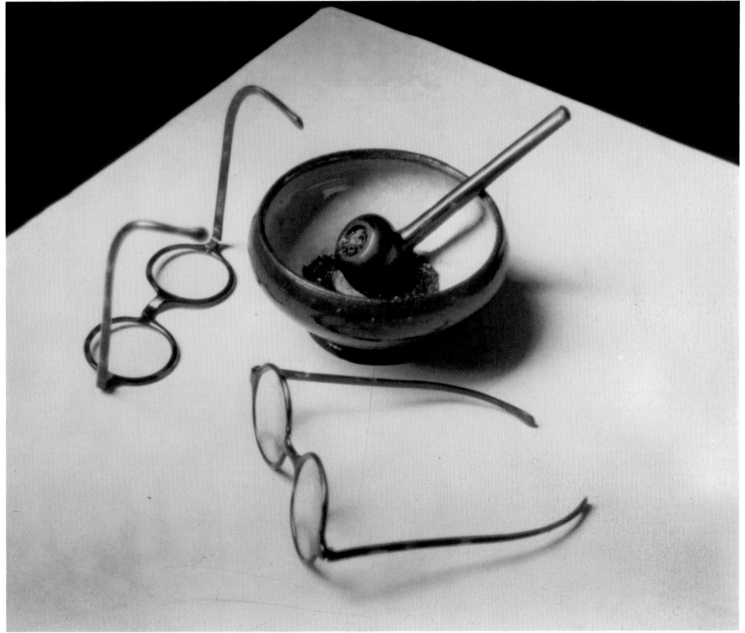

ANDRÉ KERTÉSZ: *Still Life in Mondrian's Studio,* 1926

Parts of Objects

There is really no such thing as an abstract photograph, because some real object is always in front of the camera when the exposure is made. But photographers whose primary interest is in form and color can achieve abstract effects by moving in close to emphasize a pleasing arrangement of line, shape and color rather than by concentrating on the entire object. Since the object itself is usually recognizable, the viewer has the added pleasure of assessing how well the part suggests the whole.

In this kind of still-life photography the range of subjects is vast. Monumental buildings or large machines are as suitable as flowers, fruit and other small objects frequently treated in still lifes—provided the details chosen from them are good subjects in themselves.

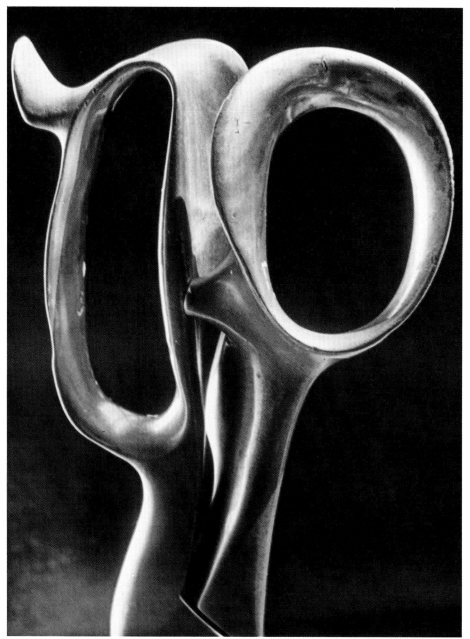

A monumental sculpture in shining metal is seen to be, on closer inspection, merely the handles of a pair of scissors. By bringing the camera close, photographer Pål-Nils Nilsson has endowed a mundane object with mysterious beauty. The object is depicted out of scale, disoriented from reality. Yet its image is undistorted, and eventual recognition evokes pleased surprise.

PAL-NILS NILSSON: *Scissors*, 1959

In close-up, the massive, unshadowed base of a
marble column is transformed into a delicate
silverpoint design. Hiromitsu Morimoto printed
the photograph on rag paper coated with liquid silver
emulsion to create a surface that would absorb
the image and capture the subtle high tones.

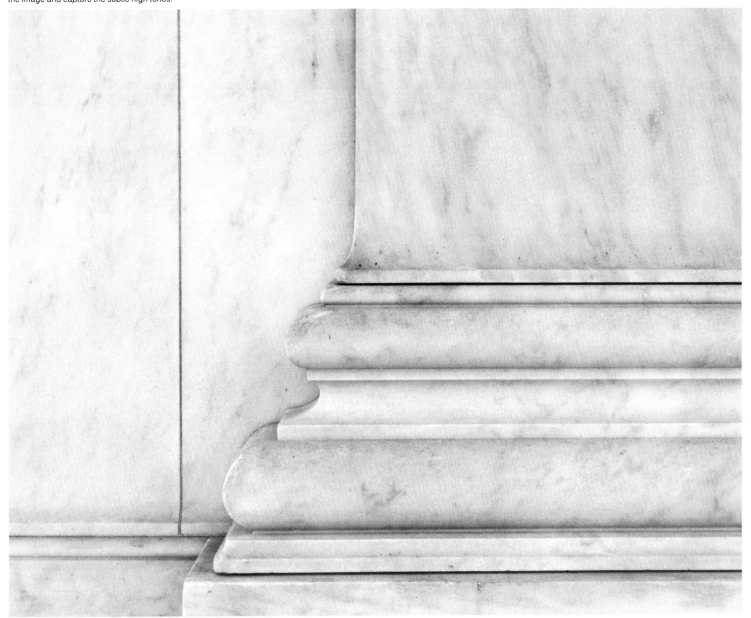

HIROMITSU MORIMOTO: *Marble Column, Washington, D.C.,* 1979

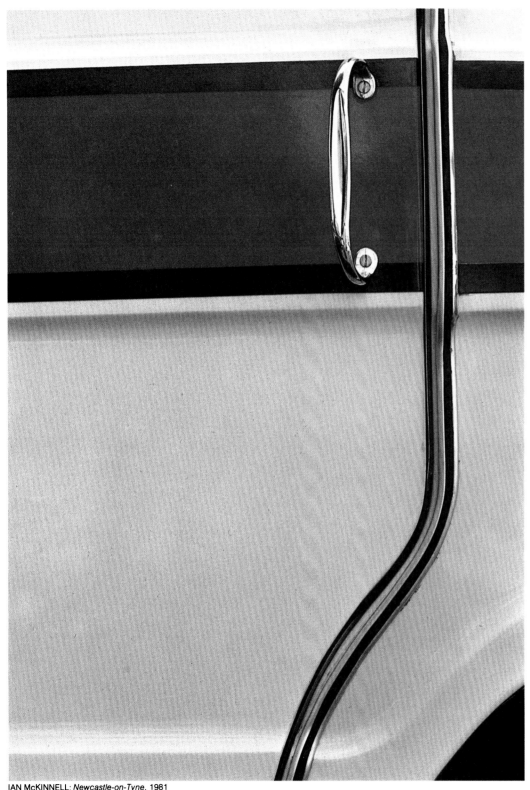

When the bright red band and curved chrome
rail of an ambulance door are framed so that the
identity of the subject is virtually lost, the result is
a handsome arrangement of shapes and colors. This
is one of a series of images based on airplanes,
buses and other vehicles by a British photographer
who started his career as a graphic designer.

IAN McKINNELL: *Newcastle-on-Tyne,* 1981

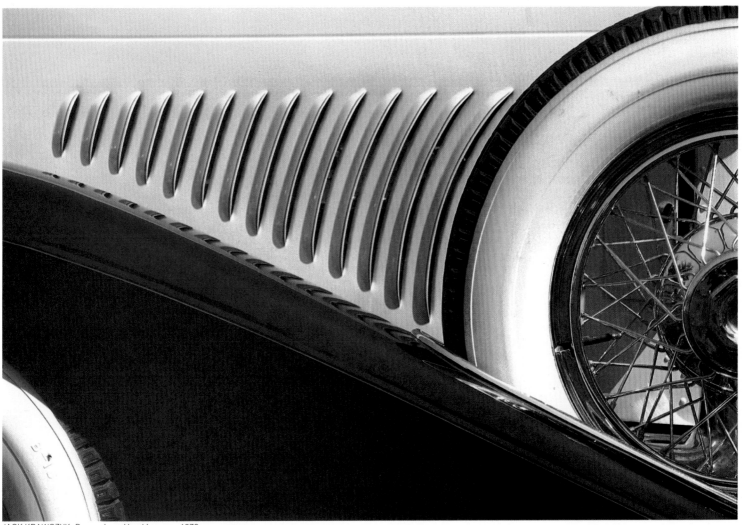

JACK KRAWCZYK: *Duesenberg Hood Louvers,* 1978

This close-up of the hood louvers, fender and spare tire of a 1931 Duesenberg celebrates the details of a classic car's impeccable workmanship. Taken by a car enthusiast, the picture also works as an elegant abstract design.

Groups of Objects

In photography as in painting, the classic still life is built up by combining many small objects usually associated with the kitchen, the dining room and the parlor —flowers, fruit, kitchen utensils, bottles, playing cards, musical instruments and so on. The aim is always to achieve a pleasing juxtaposition of shapes, colors and textures, but the still life is also often used to say something about life and the world. In its simplest form, a dish of succulent fruits may suggest the bounty of nature, as in Olivia Parker's three pomegranates at right. In more complex forms, a diversity of objects may be heaped up to suggest the richness of a lifetime's experience, as in Marie Cosindas' jampacked image on page 86.

Because it is usually set up indoors, the still life allows the photographer more control over the result than most other types of photography. But to arrange and light a large group of objects in such a way that the picture will be not only well composed but meaningful requires perseverance. To set up the understated study on the opposite page, for example, John Gruen started with 25 egg beaters, which he arranged and rearranged until he had eliminated all but seven.

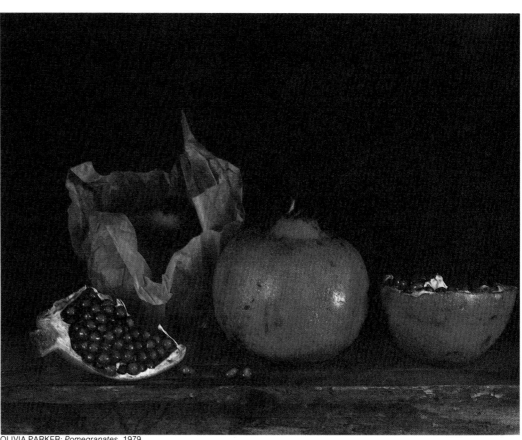

OLIVIA PARKER: *Pomegranates,* 1979

Three pomegranates fresh from the market are the subjects of this classic still life by Olivia Parker. One is still wrapped in blue paper, another has been broken open to show the seeds inside. The front light makes them stand out against the dark background and focuses attention on their vibrant color and generous outlines.

Seven old-fashioned egg beaters, as upright as ▶ toy soldiers on parade, are photographed in a side light that emphasizes their volumes and enhances the timeless quality of the composition. "The objects look fragile," says photographer John Gruen, "but they have endured for decades. I use the camera to freeze them forever."

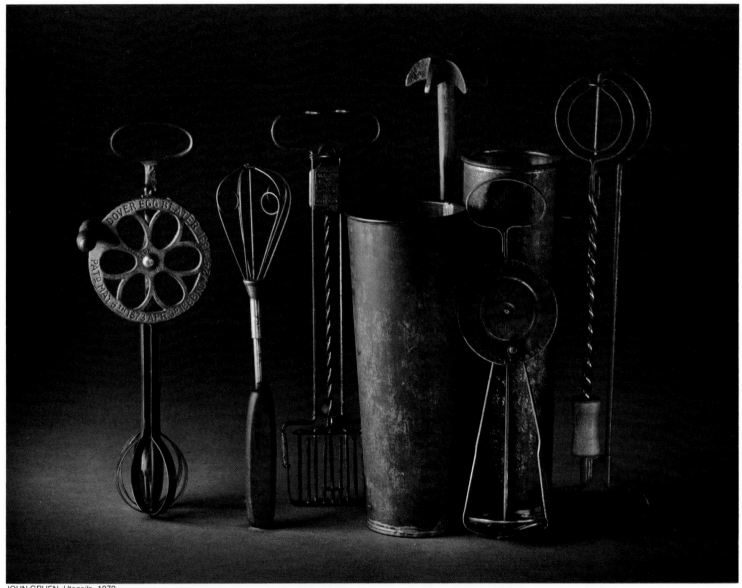

JOHN GRUEN: *Utensils*, 1979

With luxuriant abandon, Marie Cosindas piles up
dolls, masks, beads, artificial fruit, statuettes,
pictures and other trinkets against a patchwork
backdrop to suggest the accumulated memories of a
lifetime. The soft, natural light, the numerous
broken forms and the tiny spots of glowing color
divided from one another by thin, dark shadow
lines help create a shrinelike stained-glass effect.

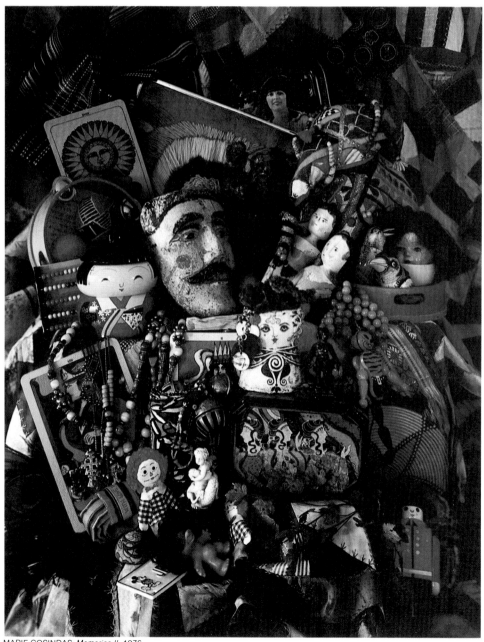

MARIE COSINDAS: *Memories II,* 1976

Portraits **3**

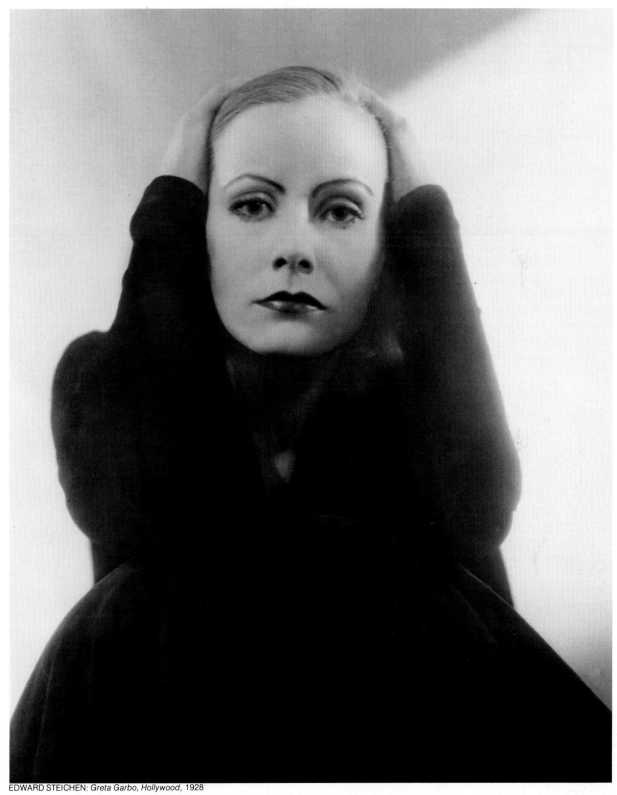

EDWARD STEICHEN: *Greta Garbo, Hollywood,* 1928

Making a Picture a Portrait

The fallacy in the old saying that a photograph never lies can seldom be seen more clearly than in a portrait. For a quick demonstration take a look at the gallery in almost any high-school yearbook. Those pictures lie. They may show faces recognizable to friends and family, but few if any reveal their subjects as they are remembered — living, distinctive personalities. Now take a look at the portfolio of portraits on pages 103-119. Some of these pictures show well-known people, their features familiar to the public, yet they are far more than good likenesses. They are outstanding portraits because they do not lie — they reveal the character behind the face.

Because character revelation is the essence of good portraiture, the exact recording of physical details sometimes becomes secondary. In André Kertész's self-portrait *(page 125),* a strong impression of character is created with nothing more than a shadow. Yet the physical features of a subject cannot be ignored, for some — or all — may reveal the person's character while others conceal it. Choosing which of these details to emphasize and which to subdue is one of the major tasks in producing a good portrait. It is generally a mistake to smooth out all the wrinkles in a middle-aged woman's face, since the wrinkles help establish her for what she is. Without the wrinkles, the picture lies. And it is also generally a mistake to fail to conceal a jug-eared man's big ears. Rarely do they tell anything about his character, and they are likely to distract the viewer from features that do.

To reveal the character of a subject, the photographer can call on a number of techniques. None requires unusual equipment. Good portraits are taken with every kind of camera. However, a lens of moderately long focal length (80mm to 135mm for 35mm cameras, 150mm or 180mm for 2¼ x 2¼s, 210mm for 4 x 5s) makes it easier to get a big image and avoid the size distortion that may exaggerate the nose in a full-face view.

The diffused light of outdoors that comes through a window is preferred by many portraitists; because it is natural it makes a natural-looking picture. A similar effect can be achieved with bounce light provided by a strobe or flood aimed at a ceiling or other reflecting surfaces. Such diffused illumination also softens details so that imperfections in features or skin do not stand out (an advantage or a disadvantage, depending on the photographer's intent); but it gives equal emphasis to all the subject's features (generally a disadvantage, since it reduces the photographer's control over what is shown).

More skill is required to take advantage of the dramatic effects provided by undiffused, directional illumination from sunlight and directly aimed floods and strobes. This kind of lighting creates sharp highlights and shadows that enable the photographer to emphasize bone structure and skin texture — and to control which features show and which do not.

The use of color film greatly expands the portrait photographer's range by

revealing the coloring that is often a distinctive part of the sitter's appearance and personality, as in the portraits by Joel Meyerowitz *(pages 118-119)*. The photographer can also use color to suggest the temperament or circumstances of the sitter, as in the portraits by Marie Cosindas *(pages 106-107)*.

The impact of personal features in communicating character is sometimes strengthened by showing the subject's surroundings, as the portraits by Helen Levitt *(pages 108-109)*, Mary Ellen Mark *(pages 110-111)*, Diane Arbus *(pages 114-115)* and Duane Michals *(pages 116-117)* demonstrate. But background details can also be distracting, and many portraitists eliminate them. One way to provide a neutral background is to hang behind the subject the background paper often called no-seam. Sold by photographic supply stores in rolls containing 12 yards, it is 9 feet wide and comes in black, white and many colors.

Such devices as backgrounds and lights help a photographer to focus attention on physical aspects of the subject. These mechanical aids help to suggest the sitter's character, but rarely as powerfully as does expression, and expression depends to a great extent on posing. A natural expression — i.e., a characteristic one — requires a natural pose. If the subject is forced into an uncomfortable position, the portrait will look artificial. However, an air of alertness adds life to a picture, and to achieve it the photographer may have to induce the subject to lift or turn his head or body beyond the position he would normally assume when totally relaxed. This flash of interest is what the oldtime studio photographer was after when he commanded, "Watch the birdie!" Similar attention-getting ploys continue to be useful today.

Beyond the basic principle of posing for natural alertness, photographers have discovered some guidelines that are generally helpful but cannot be considered hard rules because so many of the best portraits disregard them:

1 A three-quarter view for a portrait presents people in a more informal, natural manner.

2 A full-face view may convey an air of formality (and makes obvious any unsymmetrical features).

3 A profile almost always looks dramatic — and of course pitilessly emphasizes nose and chin lines.

4 A seated subject who leans forward slightly will seem relaxed; if he leans back, he will seem aloof.

5 A full-length portrait taken from eye or chest level makes the subject look shorter than he is; one taken from knee level or below makes him seem taller.

Prescriptions such as these cannot be followed blindly, for each portrait is a unique challenge. A good one demands an understanding of basic photographic techniques, but it also demands more — an understanding of the subject. Only if photographers get to know the human being in front of the camera can they capture character in a picture and make it a portrait. □

Capturing Character on Film

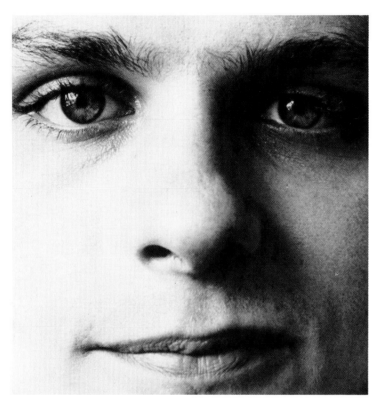

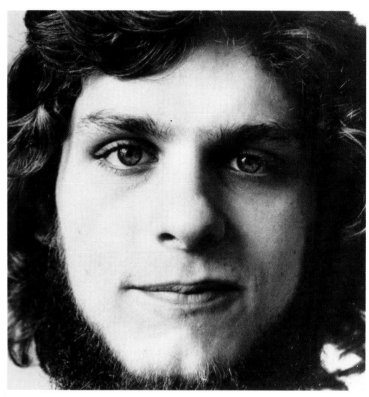

There seem to be three different young men on these pages. Each picture suggests a distinctive personality. And yet all three portray the same man. The difference is in how much of the man the picture includes, that is, in how the subject was "framed."

This selection of the scope of view is considered by Richard Noble, the New York photographer who made the series of demonstration pictures that is shown here and on the following nine pages, as a first step in depicting character in a portrait. By including in the image only the eyes, nose and mouth of his subject *(above),* Noble showed a bright, pleasant youth—almost any bright, pleasant youth. But when Noble took a slightly broader view, showing long hair and a bit of a beard, the picture includes enough elements to hint at individualism and a strong will. Only the three-quarter view on the opposite page, however, provides the details of stance and clothing that reveal the experimental, even rebellious side of this young man's character.

From extreme close-up to three-quarter view, each of these three portraits of the same subject tells something different about his personality simply because it emphasizes different aspects of his appearance. For the two close-ups the camera was about a foot from the subject (the picture at left above was cropped slightly); for the three-quarter view at right the distance was about eight feet. All three pictures were made with a Hasselblad and a 150mm lens; the neutral background used here, like that in the pictures on the following pages, was created with a long strip of 9-foot-wide no-seam paper.

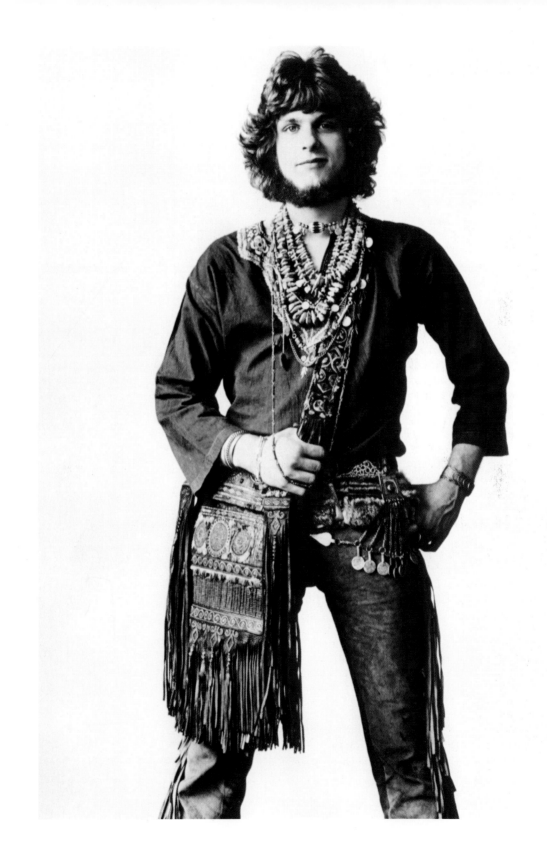

The Couple: A Problem of Light and Pose

Richard Noble artfully applied a number of simple techniques to bring off a dual portrait that makes this couple look the way grandparents ought to look. The picture owes much of its strength to the lighting and the posing, which come together to create a simple, clear arrangement of images.

Noble has placed the man and woman together in the frame of his picture so that their figures relate closely to each other and convey the idea of long years of mutual affection, perhaps being marked by the celebration of an anniversary. The man, behind the woman, looks calmly at the camera with a hint of good humor in the eyes and mouth. The right side of his face is in shadow, thus creating a neutral background for the woman. Her face, framed by her fur collar, is turned slightly to one side so that it forces the viewer's

eye to travel diagonally toward both her and the man. Even a potentially distracting element—the orchid pinned to her coat—helps unify the picture, for it is placed to serve as a visual balance for the other points of interest.

These effects seem to result only from the posing, but the posing depends on the lighting. It was strong daylight from a window to the left. Its direction made clear the texture of the man's skin, establishing his mature character, and also crossed the angle of his spectacles so that they did not cast reflections toward the camera. The woman's face seems to be in softer illumination because it was turned aside. In that direction, her glasses would have mirrored the brightly lit part of the studio, but Noble hung a piece of black velvet to the right of the camera; its reflection in the spectacles is invisible.

Positioning his subjects by a window with northern exposure (diagram above), Richard Noble took advantage of the shadows cast by the daylight coming from the left to create his composition and to emphasize the facial folds and creases of age. Black velvet hung to the right killed reflections that otherwise would show up in the spectacles of the woman.

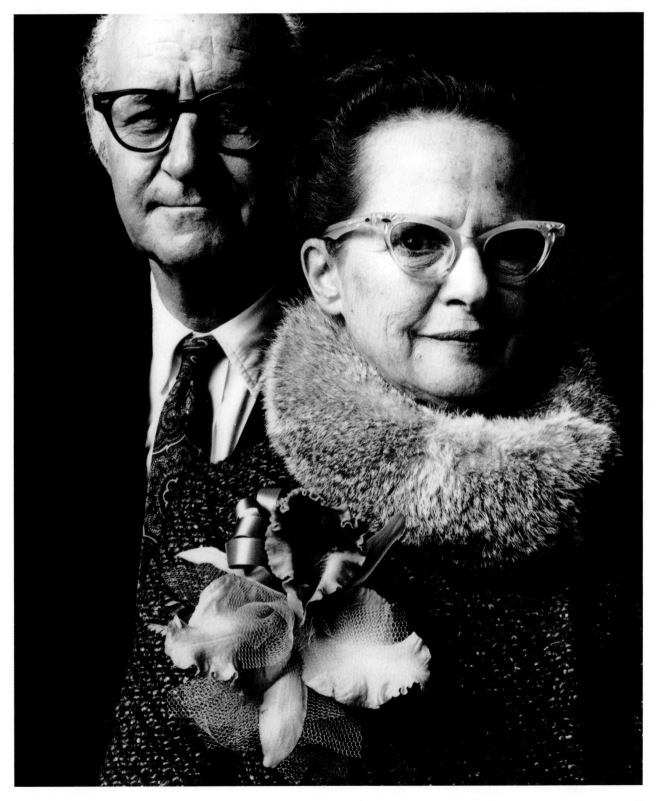

Two Views of a Woman's Personality

Country woman with wind-tossed hair, ready for a sail or a swim? City sophisticate prepared for opening night at the theater? This subject is both, and Noble created these two totally different portraits of her, each presenting an equally valid aspect of her character.

To suggest the youthfully informal side of his subject, Noble deliberately set her in a romantic atmosphere. He posed her full face, but smiling, in very diffuse illumination—the only light was that reflected around the room from a strobe shining on the white no-seam paper behind her. A fan provided a breeze to ruffle her hair.

A different set of techniques was used for the shot designed to emphasize the woman's more sophisticated side. Above a low-cut, stylish evening wrap, her fine shoulders are bared. Her hairstyle is now changed, pulled back to reveal her bone structure, and she presents her profile, her head proudly uptilted to show her beauty. The light aimed at her face was diffused because it was bounced off an umbrella reflector, but it was still strong enough to reveal every mature wrinkle and the classic elegance of her features.

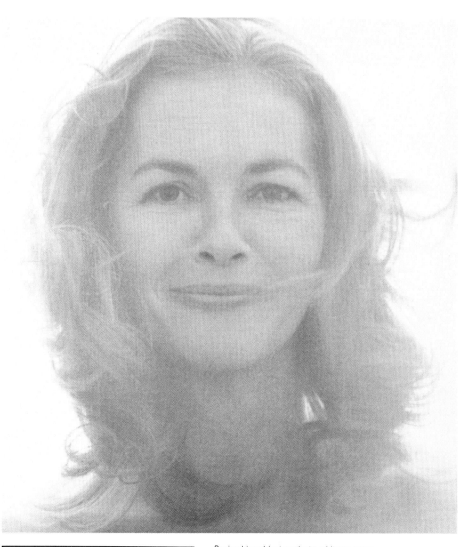

Posing his subject against a white no-seam background and bouncing the illumination from his light source off the reflecting surface (diagram, left), Noble gave this portrait a fresh, outdoors look. Helping the atmosphere is the halo around the head; it is caused by flare—a spreading of exposure to ordinarily unaffected silver grains in the negative when a bright area (the background) is overexposed, as it was here with a setting of 1/60 second and f/11.

Using dark no-seam background to make his subject stand dramatically out of the portrait, and reflecting his light source from a white umbrella at the left, Noble made his model into a classic figure. The nighttime atmosphere was enhanced by the use of a red filter, which heightened the contrast of the portrait.

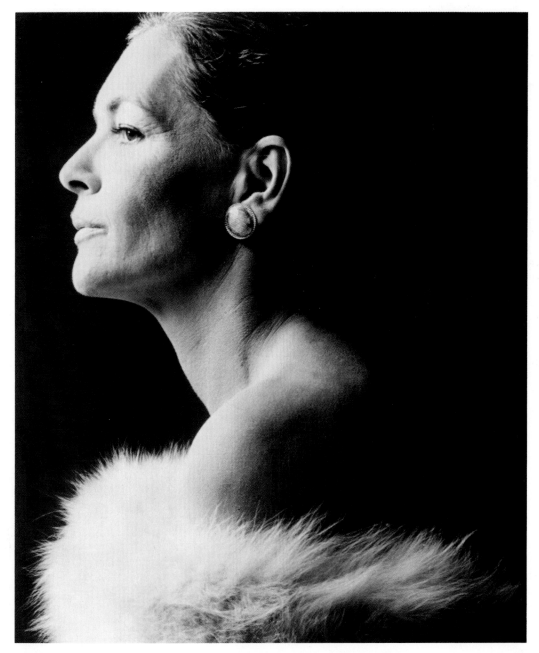

A Child's Spirit — in Tears or Smiles

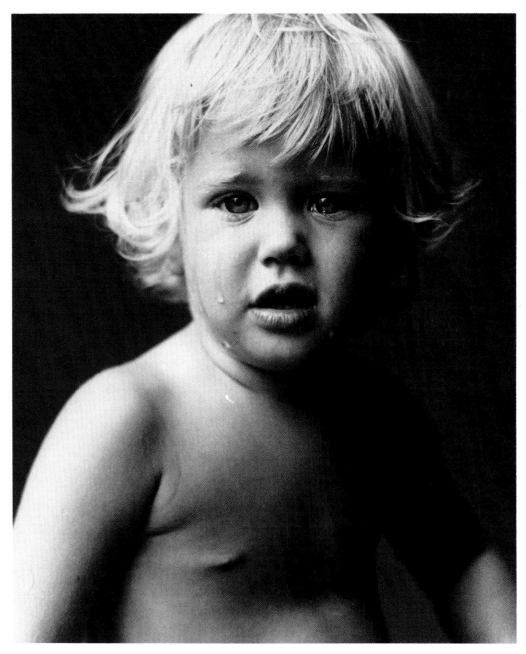

Children are mercurial, their moods shifting from moment to moment, their features instantly reflecting changes of emotion. The portraitist can easily turn this to his advantage, by arming himself with a plentiful supply of film and shooting rapidly as his subjects' tears give way to impish grins.

To obtain the two pictures of a two-year-old boy on these pages, Noble took more than 75 pictures in a two-hour session. The child was upset at being asked to sit still with a camera aimed at him and burst into tears *(left)*. But once the boy was released and allowed to roam about the studio, he began to make funny faces and the camera recorded the delightful picture opposite. The lack of clothes may have contributed to the feeling of freedom in this instance, but whatever makes a youngster relax will do the trick.

Framed in front of a dark background and illuminated by natural light pouring in from a window at the left, an unhappy young face was alertly caught in midteardrop by Richard Noble, shooting at 1/15 second and f/8.

The young man was portrayed in a happier ▶ mood romping in what seems to be unconfined space — an effect created by unrolling the no-seam paper to cover the floor as well as the wall behind the child, thus hiding the line that separates floor from wall. Light was bounced against the paper from a strobe at the right, and an exposure of 1/60 second at f/11 was used.

Creating a Composition from a Group

Group portraits are often counted successful if they get everybody in focus. How much more they can achieve is shown here in Richard Noble's demonstration of two different techniques for creating interesting arrangements with several people in one picture. In the first method, the subjects are permitted to group themselves. Each looks at the camera, and each is aware that his picture is being taken. The composition is unorganized. But the result—especially if the group is as uninhibited as this pick-up team of Little Leaguers—can be a portrait of charm and spontaneity.

The second approach requires the photographer to arrange his group by an old-fashioned formula: two groups of figures are distributed to the sides of two or three central figures. Add a couple of artificial props like the potted fern and the wrinkled-sheet backdrop, and the same nine boys are imbued with warmth and nostalgia. □

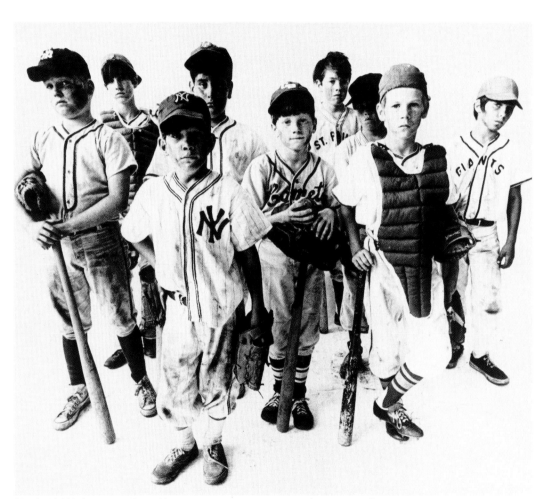

Shooting his Little Leaguers against a white no-seam background to bring each out distinctively, Noble used a 20mm lens on his Nikon F. The short focal length of the lens made the boys standing closest to the camera seem big and those in the background seem small.

Re-creating the look of the group portraits of ▶ ball teams of long ago, Noble composed the players against a wrinkled but unobtrusive muslin sheet and arrayed them on a brick floor. The bats at center, pointing directly at the camera, draw the eye to the central figures.

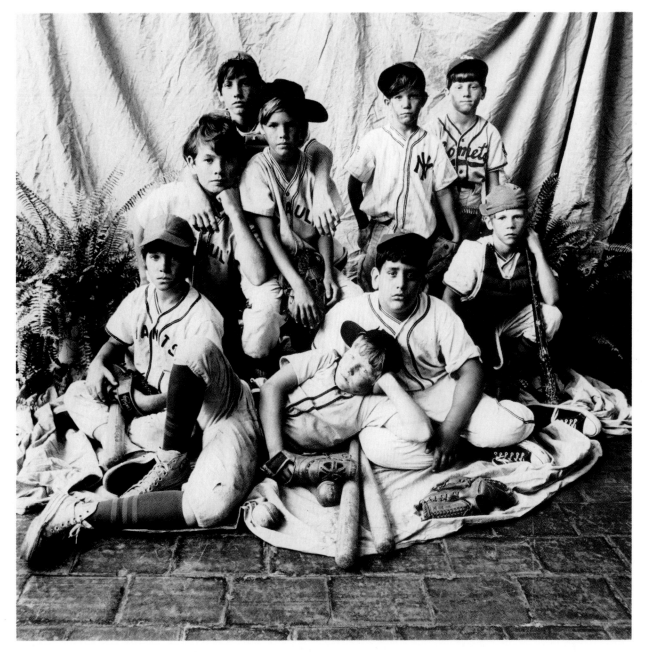

Studies in Style

In 1959, a leading American fashion photographer, Richard Avedon, published a remarkable collection of portraits entitled *Observations,* which appeared to bring a startling gloss of perfection to the art of portrait photography. The pictures were mostly of famous people and well-known public personalities. But they revealed their subjects' unsuspected depths and nuances. It was as though Pablo Picasso, Judy Garland, the Duke of Windsor— faces that had long been pictorial clichés—were being introduced for the first time. Clearly Avedon had added something extra to portraiture, and the photographer explained what it was. "They are all pictures of me," he said, "of the way I feel about the people I photograph."

Like Avedon, all the great portraitists bring part of themselves to their pictures, whether the subjects are public personalities or private people known only to their friends and relatives. The late Diane Arbus, for one, made a point of avoiding celebrities for her subjects, so there was no way the public could compare her version with someone else's. Nevertheless, Arbus portraits have a distinctive look, one that reflects the photographer's preoccupation with the bizarre aspects of everyday life. Her subjects may have been obscure, but Arbus always made a strong personal statement about them.

Photographers make their statements in hundreds of different ways. The results depend on the cameras they use, the lighting effects they prefer, the settings or backgrounds they select, the poses they look for and the rapport they develop with their subjects—all ingredients in a portraitist's personal style.

Avedon's style is at once elegant and off-beat. As a young photographer in the mid-1940s, he made a splash in the fashion world when he broke into the pages of *Harper's Bazaar* with a series of candid and highly unconventional pictures of models running barefoot along a beach. He had made his first portrait with a box camera at about the age of 10—a study of composer Sergei Rachmaninoff, whom he had stalked on the back stairs of the composer's New York City apartment. ("I used to hide among the garbage cans . . . listening to him practice," Avedon confessed years later.)

Avedon often uses simple lighting—a single 1,500-watt floodlamp above and near the camera—to produce portraits of classic elegance, and retouches some prints to emphasize such features as a curving shadow line. He frequently eliminates backgrounds to underline what he believes to be his sitter's most striking quality—the swanlike grace of Signora Gianni Agnelli *(opposite),* for example— until a characteristic is emphasized almost to the point of refined caricature.

In Richard Avedon's book "Observations," Italian beauty Marella Agnelli, wife of the head of Fiat, seems as cool and streamlined as a modern sculpture. Avedon selected pose and lighting that would emphasize her graceful neck; he also retouched the finished print to help outline the smooth curve of shadow.

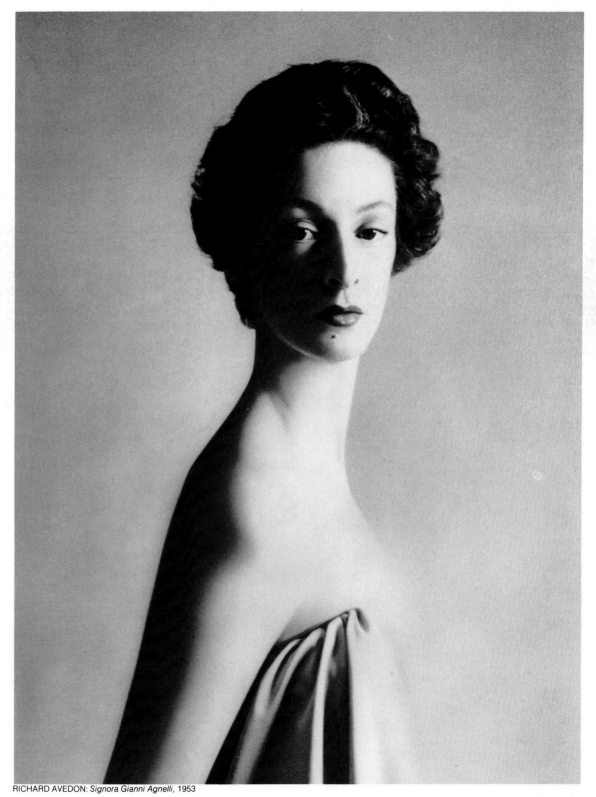

RICHARD AVEDON: *Signora Gianni Agnelli*, 1953

Yousuf Karsh

Yousuf Karsh is obsessed with the quality of greatness. He has probably portrayed more of the world's famous and accomplished people than has any other photographer. A list of the luminaries who have posed for his camera includes nine American Presidents, seven members of the Presidium of the U.S.S.R., four popes, and most of the greatest musicians, writers and painters of the century. Being "Karshed," as one sitter wittily put it, is a mark of success in any field.

Karsh began his own climb to prominence in 1933 when, a refugee from Armenian Turkey, he opened a portrait studio in Ottawa, Canada. He soon built up a reputation in Canada, and by 1941 had gained international renown.

Karsh's portraits, with their rich textures and somber tones, seem infused with a kind of monumental dignity and grandeur. He generally uses a big 8 x 10 view camera that reveals every wrinkle and pore and emphasizes his subject's usually concealed personal details. They contribute to the aura of what he calls "an inward power," which he feels everyone possesses. "When one sees that residuum of greatness before one's camera, one must recognize it in a flash. There is a brief moment when all that there is in a man's mind and soul and spirit may be reflected through his eyes, his hands, his attitude. This is the moment to record. This is the elusive 'moment of truth.' "

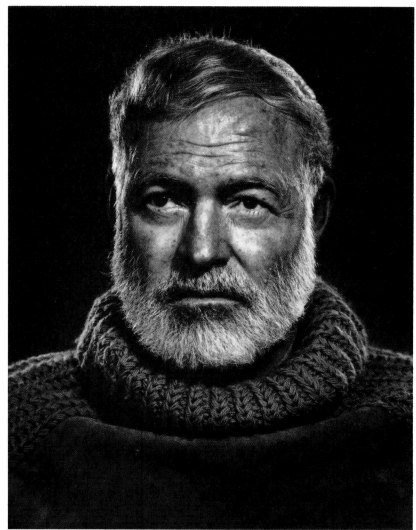

YOUSUF KARSH: *Ernest Hemingway,* 1957

For all the hard, masculine quality of his novels, Ernest Hemingway impressed Karsh as being gentle underneath his toughness—a paradoxical combination of characteristics that the photographer managed to convey in what Hemingway regarded as his favorite portrait.

"Austere intensity" is the phrase Karsh used to ▶ describe painter Georgia O'Keeffe (widow of photographer Alfred Stieglitz). This portrait, taken in her New Mexico home, underneath an animal skull like those in many of her paintings, conveys the spareness and force of her art.

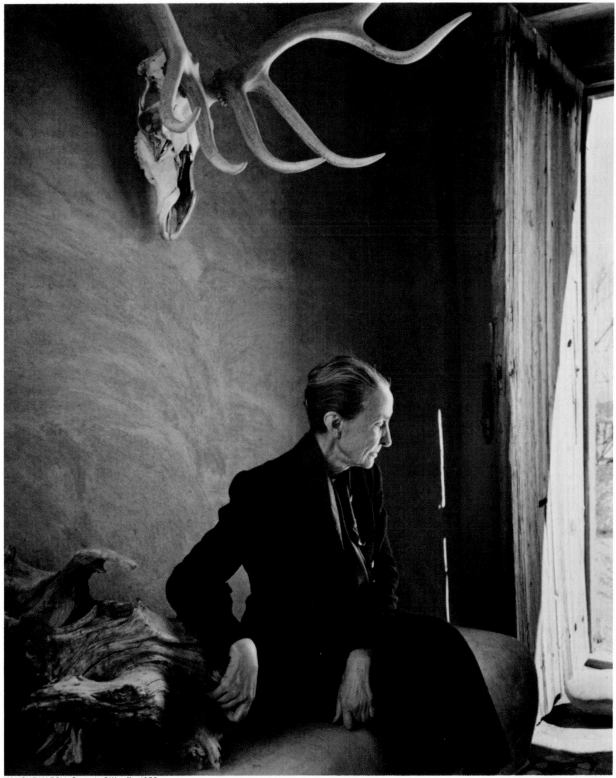

YOUSUF KARSH: *Georgia O'Keeffe*, 1956

Marie Cosindas

Whether taken in her own studio or in the home or workplace of the sitter, Marie Cosindas' color portraits are as carefully composed as Old Master paintings and are bathed in the same natural light. They are, however, no mere copies of nature. Cosindas uses color not just to show what things look like but to express how she feels about them.

The look of a Cosindas portrait reflects her own lifelong interest in color and design. As a child of immigrant parents in Boston, she loved the colorful architecture and ceremonies of the Greek Orthodox Church. Later, Cosindas studied design and painting at the Boston Museum School and the Modern School of Fashion Design. Her first successful photographs were still lifes in black and white, but in 1961 Ansel Adams, with whom she had been studying for several months, pointed out that she was thinking in color even when shooting in black and white. Cosindas re-shot some scenes: "Seeing the first color photographs emerge was a revelation," she said. Since then she has worked entirely in color.

Cosindas plans her portraits carefully, choosing and arranging the setting, clothing and props to express her view of the sitter's personality and temperament. Once she starts shooting she uses filters to modify and harmonize the actual colors. She was one of the first photographers to work in Polacolor, a type of self-developing film that allows the photographer to see the picture within a minute or two of taking it. With Polacolor Cosindas can maintain control of all stages of the picture: In the early part of a portrait session she can show the first takes to her sitter and point out ways to improve the pose. Then she can continue to shoot until she gets it right.

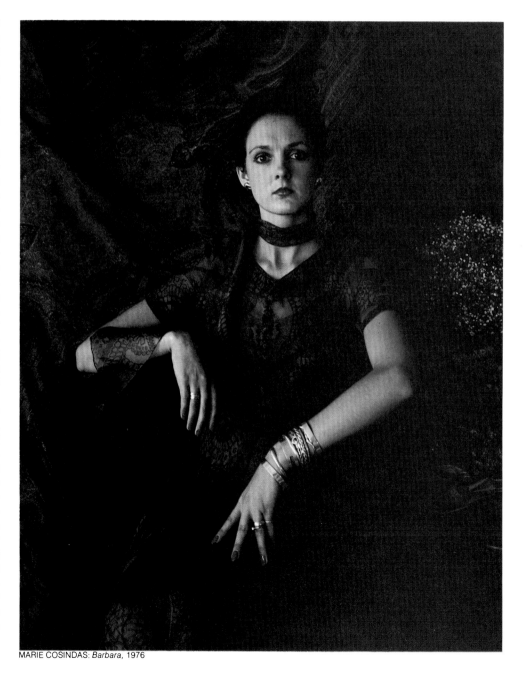

MARIE COSINDAS: *Barbara,* 1976

In this portrait of a New York dress designer, taken in the photographer's Boston studio, Cosindas plays color against pose to express the contradictions of an artist's temperament. The almost regal posture suggests a person of icy restraint and self-control. But the brilliant reds that dominate the picture suggest a fieriness below the surface.

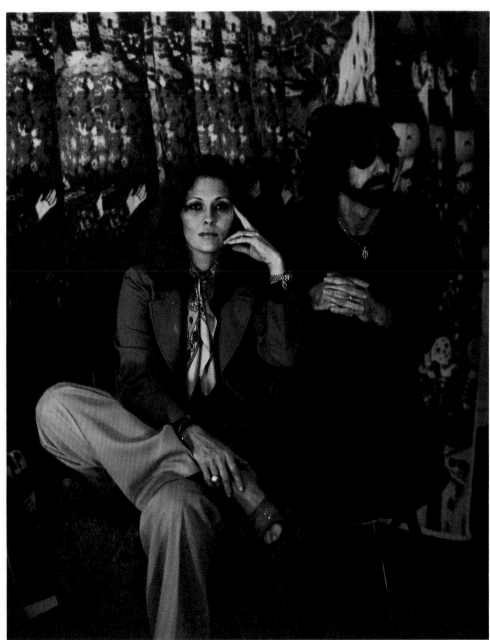

This portrait of actress Faye Dunaway and her former husband conveys the quiet inner life of a public figure normally seen from afar. The muted greens and blacks work together with the relaxed, informal pose to establish a grave, contemplative mood. Sparse and scattered reds framing the woman's face draw attention to her most revealing feature, her thoughtful eyes.

MARIE COSINDAS: *Faye and Peter,* 1976

Helen Levitt

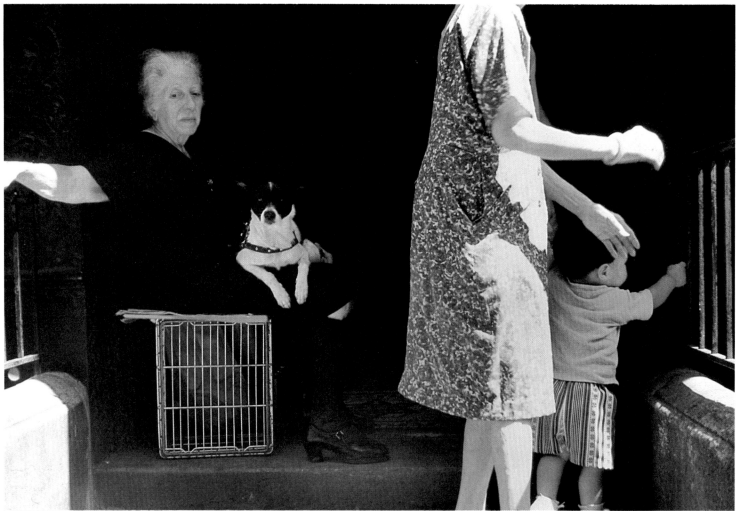

HELEN LEVITT: *New York,* 1972

The informal portraits of Helen Levitt differ fundamentally from studio portraits. Unposed and unplanned, they are taken on the wing, and the photographer herself knows little or nothing more about her subjects than the photograph shows. Nevertheless, the portraits seem to go deep into the lives and characters of the people they depict.

Levitt first made a name for herself as a street photographer in the 1940s when she made black-and-white photographs of New York children. In 1959 a Guggenheim grant encouraged her to begin working in color. Like all street photographers, Levitt works with a small hand-held camera, and must capture her subject so quickly that her actions are almost reflexive. When, by happy accident, color, character and composition all coalesce, she snaps.

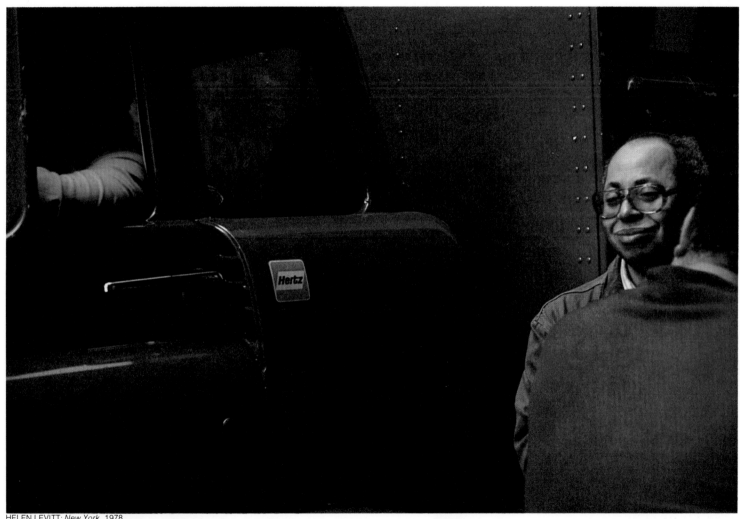

HELEN LEVITT: *New York, 1978*

◄ On New York City's lower East Side, an old woman with a pet dog in her lap thinks her own thoughts as the rest of the world goes by. In this bittersweet evocation of old age, Levitt concentrates attention on the woman's face simply by eliminating all other faces. The dark, dull background gives the people the monumental presence of allegorical figures—Childhood, Maturity, Old Age—and underlines the mood epitomized in the old woman's melancholy face.

On a crowded sidewalk in New York, the seraphic smile of a balding, middle-aged man suggests a secret life far from the city's bustle. Other human beings are indicated by the back of another pedestrian and the arm of the driver whose truck fills the background, but only the smiling man is shown full face. The simple color scheme unifies the composition while focusing attention on the smiling man although he is far from the center of the picture.

Mary Ellen Mark

Mary Ellen Mark is a photojournalist. She travels about with her Leica, hunting for a photogenic scene, an intriguing face, an expressive glance or gesture. Her portraits always show people "immersed in their environments," in settings that reflect their personalities. However, rather than being concerned with preserving the "decisive moment," as Henri Cartier-Bresson would have it, Mark is looking for something more immediate. She strives for a kind of slice-of-life, documentary realism. "I try to make statements not only about a person, but about his environment—how he lives in it, and how he reacts to it." Like the historic pictures of New York immigrants and slum dwellers made by Jacob Riis at the turn of the century, her portraits are social comments.

Mark first won notice with a portfolio of documentary portraits that she made in 1965 while she was traveling and studying in Turkey not long after leaving the classes in photography at The Annenberg School of Communications in Philadelphia. She photographed the Turkish faces with compassion and a probing objectivity. "I look for a sense of irony," Mark says, "of humor and sadness at the same time"—the kind of wistful irony that illuminates the portraits of young Turkish girls shown here.

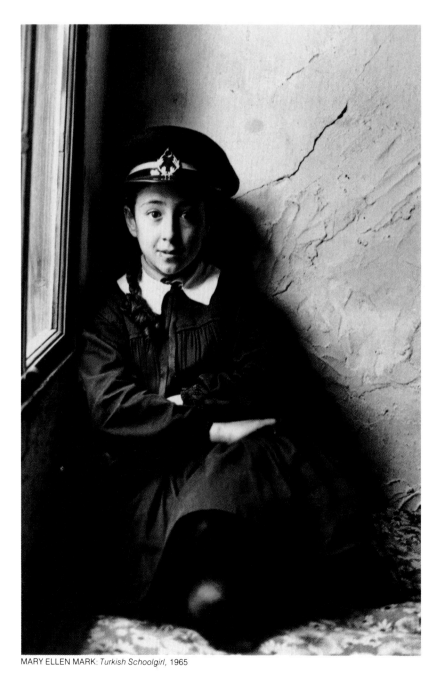

Many of Mark's portraits are of children, who have "a built-in charm." This youngster, clad in a Turkish school uniform, peers at the camera from under an incongruously large and military-looking cap.

MARY ELLEN MARK: *Turkish Schoolgirl,* 1965

This coquettish portrait epitomizes the quality of irony that Mark tries to capture. "You'd expect a nice, cute shot of a young girl," she explains, "but this girl seems precociously seductive, almost a vamp."

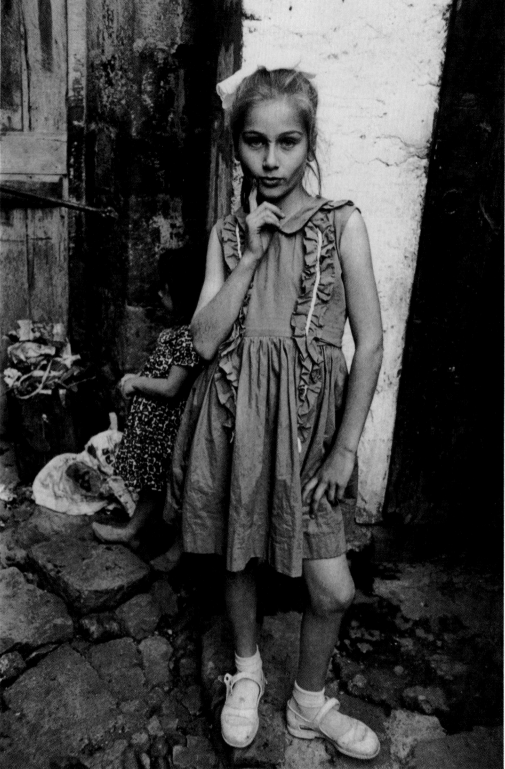

MARY ELLEN MARK: *Girl in a Turkish Village,* 1965

The strong, lucid compositions of Arnold Newman are closely controlled. His subjects pose as immovably as statues, against backgrounds that are often simplified to the point of abstraction. Their faces have none of the spontaneity or emotion that most photographers try to capture. For Newman is after something else. "Candid portraits are indications of the moment," he says. "They usually are not typical over a long period of time." And Newman wants to make portraits that last.

Newman, one of whose interests is photographing artists in settings that suggest their work, started out as a painter himself. When he turned to photography, he brought with him a painter's instinct for powerful and well-balanced composition. As a portraitist, he arranges his picture like a still life, taking great pains to achieve just the right placement of forms. He urges his subjects into position, bullying and cajoling them like a movie director, waiting until a relaxed expression indicates to Newman that the subject is approaching the look of permanence he has been striving for. Then Newman stops down the diaphragm of his 4 x 5 view camera to a small aperture in order to achieve maximum sharpness, and with the subject in position, he makes exposures of a half second or more. Finally, in the lab, he produces dozens of test prints, experimenting with contrast and cropping until he achieves a portrait as perfect and as permanent as a well-designed canvas.

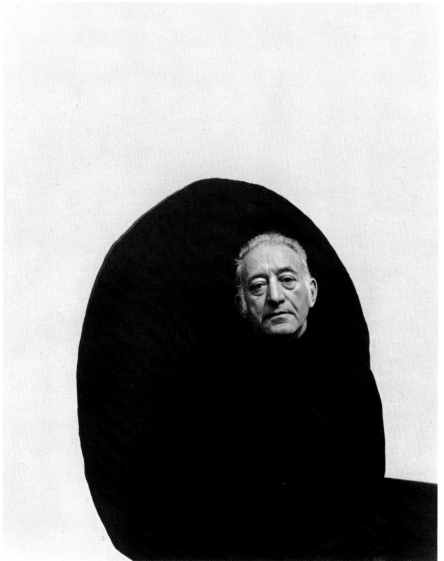

ARNOLD NEWMAN: *Adolph Gottlieb,* 1970

Newman's portrait of abstract artist Adolph Gottlieb is itself almost pure abstraction. Wearing a black sweater so that his torso all but disappears, he stands seemingly disembodied against the background of one of his sculptures.

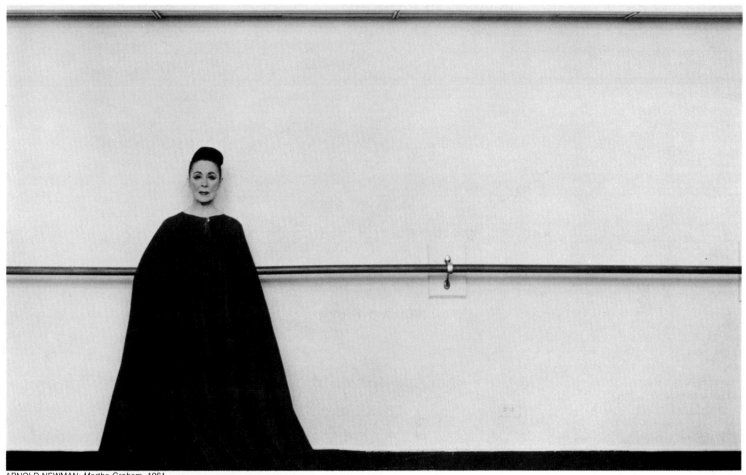

ARNOLD NEWMAN: *Martha Graham*, 1961

Newman posed Martha Graham, the grande dame of modern dance, in a black cloak against the exercise bar of her dance studio. Then he printed the picture to emphasize contrast and create this dramatic design of black shapes against a wide, stark white background.

Diane Arbus

On the surface, a portrait by Diane Arbus is as simple as a family snapshot. There is a minimum of technical display. The sitter is viewed straight on and is obviously aware of being photographed. What makes Arbus portraits so extraordinary is the stark, unrelenting way she looked at her subjects. "If you scrutinize reality closely enough," she once said, "if in some way you really get to it, it becomes fantastic."

Arbus applied this scrutiny to a wide range of sitters. Some faced life with special burdens: dwarfs, giants, transvestites; others were simply unknown, ordinary people. But her overriding aim was to penetrate the human paradox: "Everybody has that thing where they need to look one way but they come out looking another way," she said. "Essentially what you notice about them is the flaw."

Her fascination with people cut across every social class and included the prosperous middle-class New Yorkers she had grown up with in the 1930s. At 18 she married Allan Arbus, and together they established a career in fashion photography: He made the photographs; she served as stylist. Not until she was in her middle thirties — after studying with Lisette Model — did she begin the serious pursuit of her own photography.

Arbus was widely published in magazines, but did not have a significant individual exhibit during her lifetime. After her death in 1971, however, the Museum of Modern Art gave her a major retrospective. Described then as "extremely powerful and very strange," Diane Arbus' portraits continue to reveal the flawed human countenance in a poignant and often painful way.

DIANE ARBUS: *Blonde girl with shiny lipstick, N.Y.C., 1967*

By staring just slightly off camera instead of directly into it, the young woman above lets herself be photographed while keeping a vestigial distance between herself and the viewer. Arbus used a precisely focused Rolleiflex to get every detail of the woman's face, from her shiny lipstick to the wispy remains of her tweezed eyebrows.

To brief photographic encounters with strangers ▶ such as the man opposite, who holds his hat in a salute to the flag, Arbus brought a rare empathy. "For me," she said, "the subject of the picture is always more important than the picture" — an attitude that made even guarded subjects like this one willing to submit to her camera's inspection.

DIANE ARBUS: *Man at a parade on Fifth Avenue, N.Y.C.*, 1969

Duane Michals

Some of the most bizarre, individualistic portraits of all are produced by a maverick freelancer named Duane Michals, who took up photography by chance, hates photographic studios, never reads a photo magazine and sometimes scarcely bothers to show the features of his subject.

Michals began taking pictures during a trip to the Soviet Union in 1958 simply because he wanted to keep a record of his journey. He had no previous experience in photography, and he had to borrow a camera and ask a friend how to use it. But his pictures were so successful that eventually he quit his job as a layout designer, traveled to Paris to study portraiture and then plunged into photography as a professional.

Michals is less concerned with producing recognizable pictures of people than with creating visual images that symbolize their personalities. "I often try to photograph things about a person that are not visible," he says mysteriously. To do this he places his subjects in settings full of odd juxtapositions, symbolic objects, stray window reflections, strange light effects. The results, like these two portraits of famous modern painters who are associated with surrealism, are themselves sometimes outspokenly surrealistic photographs.

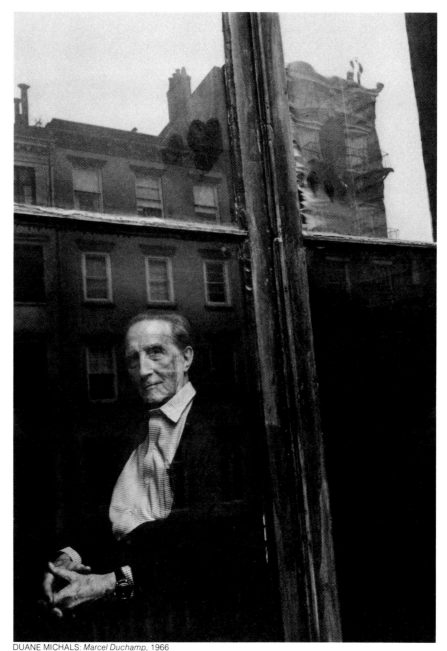

Michals photographed Marcel Duchamp through the closed window of the photographer's New York City brownstone. He balanced precariously on an outside ledge and used a wide-angle lens to capture images in the window panes, just as Duchamp had done in some of his work.

DUANE MICHALS: *Marcel Duchamp,* 1966

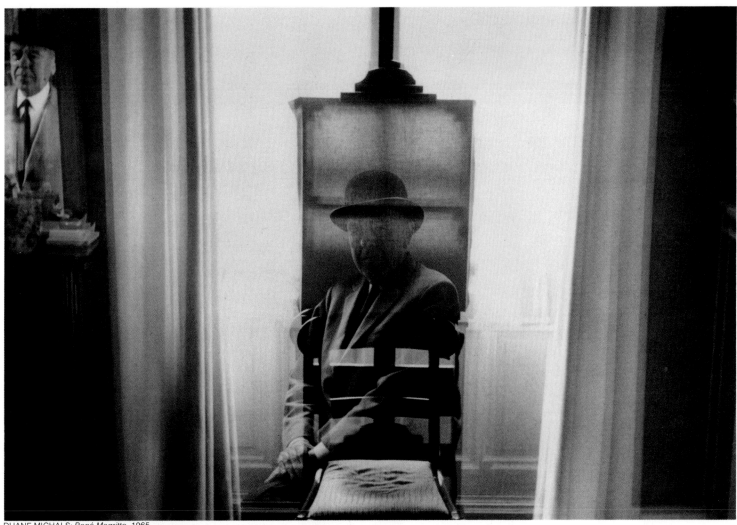

DUANE MICHALS: *René Magritte*, 1965

To suggest the surrealism of Belgian painter
René Magritte, Michals tried a double exposure,
placing a ghostly image of Magritte against
an equally ghostly canvas. A second image of
the painter in the mirror at left enhances
the supernatural feeling of Magritte's style.

Joel Meyerowitz

Like amateur snapshots, Joel Meyerowitz' large color portraits are informally posed and are taken outdoors in natural light. Yet the glowing tones of skin and hair are captured with a richness and subtlety that are far beyond the capacity of the average point-and-shoot camera. Moreover, the sitters gaze calmly into the camera, without the mugging or embarrassment more typical in snapshots.

Best known for his large-format color images of Cape Cod and St. Louis, Meyerowitz employs a view camera to make his striking and innovative color portraits as well, using it in informal situations where most photographers would switch to small hand-held cameras. The large negative captures subtleties of color, light and detail with a fidelity unobtainable from small negatives, and the view camera's two- or three-second exposure also forces sitters to keep very still, contributing to their general air of calm.

Meyerowitz' first subjects were people who stood around watching him as he photographed the buildings and landscapes of Cape Cod. Later he sought out people whose coloring interested him—redheads for the most part. Meyerowitz does not pose his subjects as a rule; instead, he talks to them in a gentle, unhurried way until he sees them make some unique, individual gesture. At that moment, he simply says, "Just stay like that"—and takes the picture. □

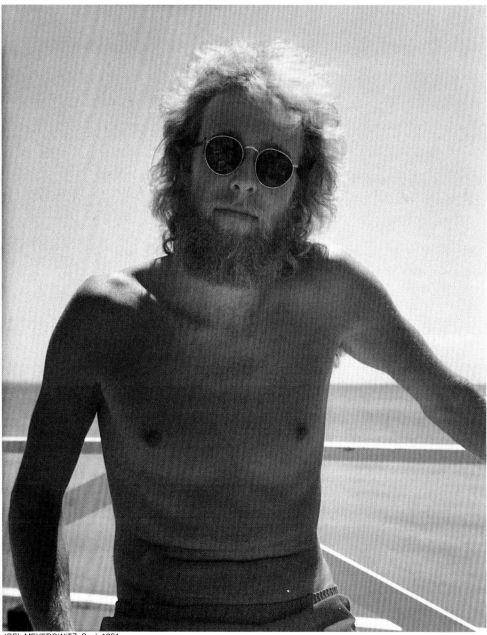

JOEL MEYEROWITZ: *Paul*, 1981

This bearded young man was photographed one fine summer day on a deck at Cape Cod, looking, in the photographer's words, "like a young Poseidon—watchful, relaxed, comfortable." Despite the strong backlighting, the face is bathed in a soft radiance that brings out the healthy glow of suntanned skin and makes every individual hair of the mustache and beard stand out.

To emphasize the red hair and thick freckles of this young vacationer at Cape Cod, Meyerowitz moved in close and shot her in a strong front light that minimizes shadows. The pale blue of sea and sky set off her striking coloring, and the small orange cushion in the lower right corner accents the dominant reddish-orange of the picture.

JOEL MEYEROWITZ: Sarah, 1980

Photographing the Photographer

Inevitably, photographers who make portraits come to the most challenging subject of all: themselves. To this intimate subject they must bring what they bring to other portraits—an evocation in the mind's eye of the character of the subject. Therein lies the test: How do we see ourselves, which aspect of our character do we wish to build up, which play down? The view we take is every bit our own, both in its emphasis on particular traits of personality and physique and in its photographic style.

The double role of photographer and subject makes extra demands on technique. For one thing, the picture must be created whole in the mind. Unless a mirror or stand-in is used, the camera viewfinder shows only the background, leaving pose and expression to be imagined as the picture is taken. Precise focusing may also be tricky simply because there is no visible subject to focus on.

Actually operating the shutter release while standing in front of the camera is not so difficult. A friend can do it, or the photographer-subject can use a long cable release. Many cameras also have self-timers to trip the shutter 10 seconds or so after the button is pressed, giving the photographer time to get into position. (This device is not an unalloyed blessing; a photographer using one may find that the expression the camera records is only the triumph the subject feels in having beaten the timer to the click.)

While the self-portrait made with a mirror *(opposite)* is in many ways the simplest, it can lay a trap for unwary beginners. They may get a sharp image of the mirror frame and a blurred image in the mirror. Actually a reflection appears as far behind the mirror glass as the subject is in front of it—the light rays involved must travel from subject to mirror glass and back to camera lens.

For a sharp image, the photographer must focus on the reflection, not on the mirror frame. If, for example, the photographer is standing six feet from the mirror and the camera is on a tripod one foot in front of him, the correct focusing distance is 11 feet, not six feet.

Such techniques are quickly picked up. It is more difficult to come up with an image that will convey the photographer's feeling about himself. It is here that ideas and imagination become more important than technical know-how. The image may be simple and straightforward, as in Alfred Stieglitz's portrait of himself as a carefree young idler in Venice *(page 122)*. Or it may be complex and ambiguous, as in Judith Golden's hand-colored self-portrait *(page 127)*. In each case, however, the image does a great deal more than merely show how the photographer looks.

Awake with time on his hands early one morning in a Philadelphia hotel room, Lee Friedlander photographed his reflection in the bathroom mirror. The idea of picturing the photographer's presence in his surroundings captured Friedlander's imagination—most of his photographs emphasize the relationship of setting to human subject—and in 1970 he published a portfolio of self-portraits showing himself in such poses as a shadow by a highway, a reflection in the window of a bar and an image in an antique mirror at a glazier's.

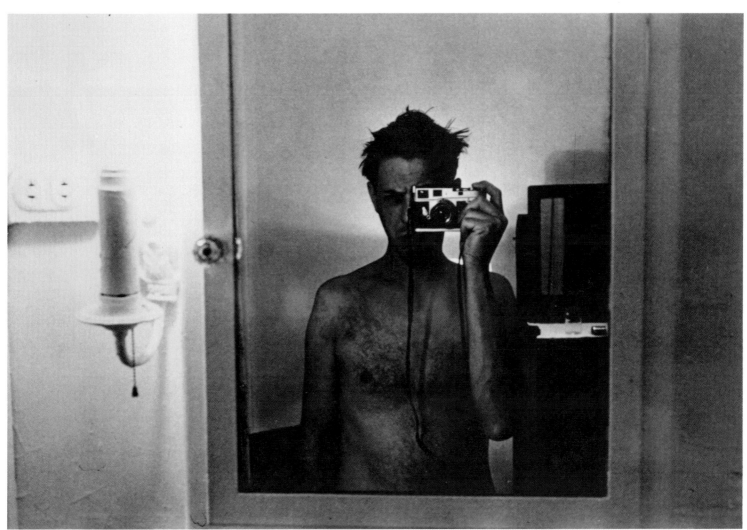

LEE FRIEDLANDER: *Mirror of Myself*, 1965

ALFRED STIEGLITZ: *Myself on Holiday,* 1890

On vacation in Cortina, Italy, in 1890, the pioneering photographer Alfred Stieglitz sprawls across the steps of a building to produce this self-photographed spoof (left) on a then-popular portrait style — a pose obviously contrived but putting on a casual and romantic air.

Another photographic innovator, Edward Steichen artfully juxtaposed dark and light areas — placing a black-framed picture tastefully near his head — to make this self-portrait in his Milwaukee home in 1898 (right). "I was the only model around at the time," says Steichen, pointing out one of the integral advantages of the self-portrait: A model is always available, always on time and never complains.

EDWARD STEICHEN: *Self-Portrait, Composition Study,* 1898

BILL BRANDT: *Reflection of Myself and My Coast*, 1966

Positioning himself in front of the rugged cliffs of the lonely East Sussex coast of England, a background he has used in his spare, contrasty work, the English photographer Bill Brandt made this study of himself (left) in 1966. For it, Brandt placed his Hasselblad on a low tripod in front of him and shot into a mirror that was tilted up to keep the camera from showing. The frameless mirror itself does not show either. Only its reflected images appear in the picture: the photographer portrayed against a doubled view of the scenery that he has made his own.

Seated in his Paris apartment in 1926, André ▶ Kertész was struck by the strong shadows cast on his wall by the late-afternoon sun. Silhouetting himself against its rays, he composed this shadow-portrait of himself and his portable Voigtländer Alpin view camera.

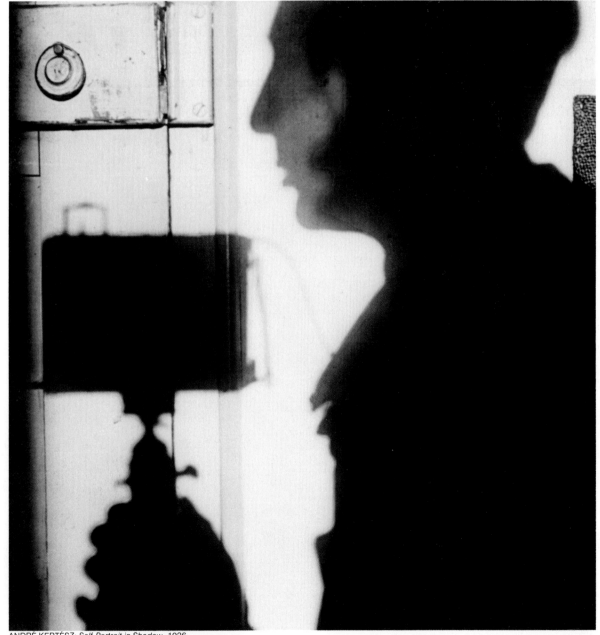

ANDRÉ KERTÉSZ: *Self-Portrait in Shadow,* 1926

JOYCE TENNESON: *Self-Portrait with a Child's Chair*, 1980

In this self-portrait, Virginian Joyce Tenneson
reclines on a blanket outdoors, apparently offering
herself for the viewer's inspection. Her own fragile
delicacy is echoed by the ornate little chair and
the pale tones of the hand-coated silver print.
But the masklike face and introspective eyes
suggest that more is being held back than revealed.

Peering through a hole cut out of a fashion magazine ▶
cover, Californian Judith Golden combines her
frankly middle-aged face with that of a young
professional beauty. Golden's aim is to demonstrate
how the lives of most women "are masked in role
models presented by the media — an illustration of
perfection that does not exist." She underscores the
point by hand-coloring her black-and-white print
with traditional photographic tinting oils.

JUDITH GOLDEN: *Magazine Series*, 1975

DUANE MICHALS: *Portrait as if Dead,* 1968

*Taken when he was 36, this self-portrait by
Duane Michals was an effort to "see myself as if
I were dead, a salute to being alive and
to what I don't know about not being alive."
Using the self-timer on his Nikon 35mm, Michals
photographed himself first against the
wall, then laid out on a table. The negatives
were sandwiched to make the print.*

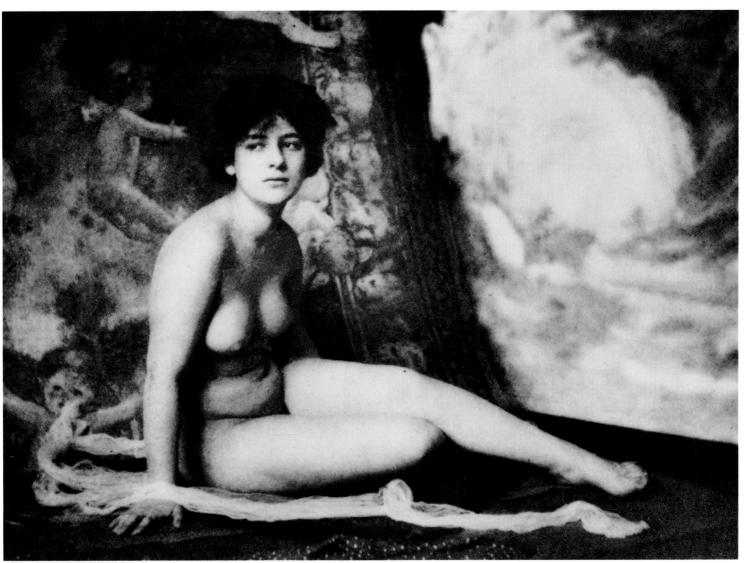

FRANK EUGENE: *Nude — A Study*, 1910

The Nude
Changing Views of the Human Form

The nude occupies a unique niche in art. To the artist it is the object in nature most intimately known; it is also one to which response — deriving as it does directly from sexuality — is complicated by the array of attitudes and taboos that have grown up around sex in every society in the world. There is no nude study that does not have its sensual or erotic element, however detached the artist — or the viewer — may believe himself to be. For this reason, people view the nude as they view no other object.

Dealing artistically with this "special object" is a problem with which painters and sculptors have been struggling for more than 2,000 years. They have had to contend with changes in moral attitudes, politics and religion, and with constantly shifting ideas about beauty.

On the matter of beauty alone, compare the three small pictures at right. Each represents an ideal of its time, but how different they are. The first is a sumptuous vision of womanhood, even though proportioned somewhat differently from the current taste. She is a goddess but still a woman, since she was the product of a mind that regarded gods and goddesses simply as superpeople endowed with superform. Her creator, the Fourth Century Greek sculptor Praxiteles, set a standard of cool yet natural female beauty that is still recognized today. The second picture springs from the medieval Christian idea that sex is sinful. The Venus painted in the 16th Century by the German painter Lucas Cranach is more human, in that she is conscious of her nudity (as Praxiteles' Venus is not) and, therefore, consciously provocative. To that end, her proportions have been smoothed and slenderized until they relate not to any real woman but to a medieval erotic idea. The third example is blatantly seductive. In the 18th Century, François Boucher returned to the classic for his inspiration. But he also had to satisfy the French court of Louis XV and its preoccupation with intrigue; so Boucher managed to portray his Venus as a bewitching woman who remains a goddess only by an eyelash, and only because no earthly woman could be quite as ravishing as she.

Now the problem belongs to photography: Professionals and amateurs alike must deal artistically with that special object, and at the same time must speak for themselves and their own societies. The problem is compounded because photography has had scarcely a century to develop professional approaches to this subject, and because the camera is more revealing, more clinical than any paintbrush. The amateur making nude studies outside a formal classroom will find that his first attempts to follow the guidance of the master photographers are almost certain to be missteps. Brought face to face with the fine distinction between nudity and mere nakedness, a novice quickly learns that creating a really fine nude study is about the most difficult task in photography. It is this constant tension between art and morals, between intent and ability — ultimately between good pictures and cheesecake — that has made of the

PRAXITELES: *Venus of Cnidos,* 330 B.C. LUCAS CRANACH: *Venus,* 1532

FRANÇOIS BOUCHER: *Triumph of Venus*, 1740

nude such a tantalizing, ever new, ever changing and all too often disastrous photographic challenge.

When photography was born, at the beginning of the Victorian period, the nude instantly proclaimed itself a subject worthy of exploration by the camera—but only within the confines of that strange mix of prissiness, sentimentality and prurience that was dictated by the taste of the times. The frontispiece for this chapter *(page 131)* is a typical example of a Victorian photographer's nude. The viewer's sensibilities are relieved at the outset by the setting: a rich tapestry background filled with cherubs, wisps of gauze, a fuzzy something that could be a billowing cloud straight from a canvas by the 18th Century Venetian painter Tiepolo—obviously a work of art, not a picture of a real woman. This effect is carried forward by the treatment of the figure itself. It is a beautiful one, posed with great care to bring out all its natural grace. It is also voluptuous. Any prurience, however, is purposely muted by the soft focus and soft lighting, which seem to put a screen of unreality between subject and viewer. Although there is a face, it has a distant, dreaming expression, and the eyes are modestly averted from the viewer so as not to break the spell of unreality the photographer has so carefully woven.

Later photographers, escaping these constraints, learned to approach the human form directly, as an object in its own right. This led to the further refinement of looking at the human body as a design. Today the nude is entirely liberated: It is photographed indoors and out, as a key piece in a composition or as a mere detail, as a real, live person or as an element in a fantasy. All these approaches are actively employed by major photographers, who mix them or not as they see fit. Truly, the "special object" is a creature of infinite variety, an inexhaustible source of inspiration for the photographer.

Maitland A. Edey

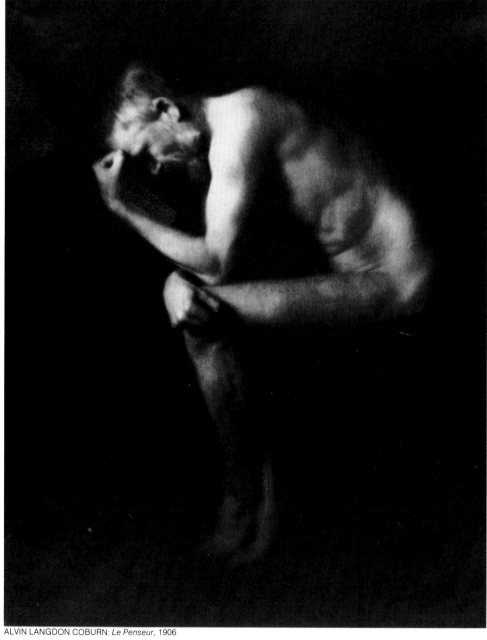

Alvin Langdon Coburn openly imitated Auguste Rodin's famous sculpture, "The Thinker," and used, of all people, George Bernard Shaw as his model in a studied classic pose. The focus is soft and the lighting diffuse. It even fades away to nothing at the feet and leaves the viewer feeling that he might be standing in some dimly lighted museum, looking at a piece of sculpture. Coburn's is the only early-20th Century photograph of a male figure in this section, reflecting an emphasis on the female body that persisted in painting and photography into the last half of the century.

Even more statue-like than the picture at left, its ▶ pose highly unnatural, is this sorrowing study by Edward Steichen. Here is no real woman but a piece of contorted marble. Her head is hidden, her attitude is strained, her nakedness concealed. What remains is powerful and beautiful sculpture, a dream out of Michelangelo and not a flesh-and-blood person at all.

ALVIN LANGDON COBURN: *Le Penseur*, 1906

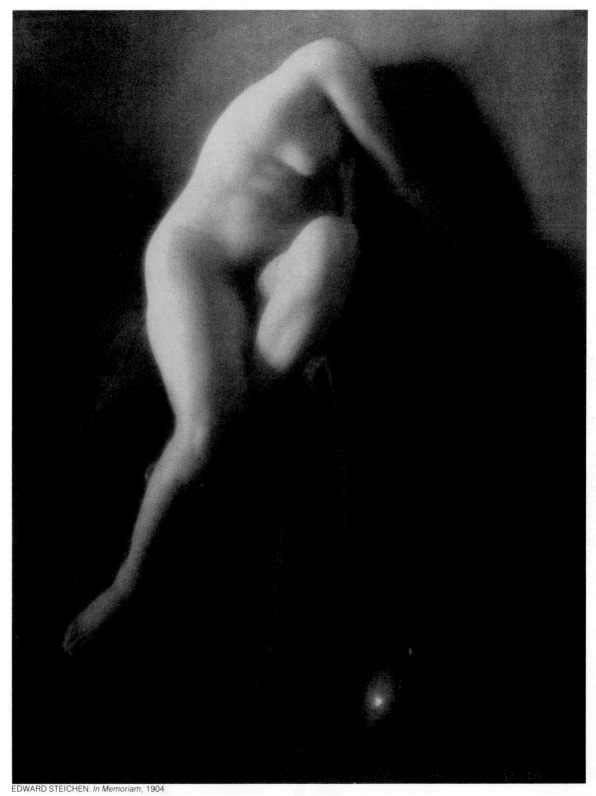

EDWARD STEICHEN: *In Memoriam,* 1904

The Nude as an Object

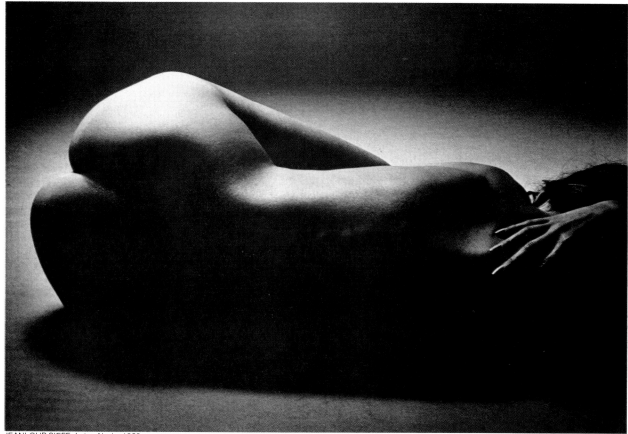

JEANLOUP SIEFF: *Lying Nude*, 1969

When photographers shook themselves free of Victorian prudery and focused sharply on the human body, the change was dramatic. The nude became real, an object in its own right.

Unfortunately that object often fell short of the classic ideal. How to deal with the imperfections of reality and still achieve beauty was the challenge. The greater freedom of the modern times helped im-mensely. Now the new sharp-focus pho-tographers could record the body from any angle and in any way. In addition, a growing familiarity with the imperfect eventually led to a greater latitude in de-fining what is beauty. Most of today's so-called salon nudes reflect this trend, in both their sharp focus and their careful poses, some complex *(opposite),* others simple but subtle *(above).*

French fashion photographer Jeanloup Sieff underscored his feelings about the female form —"it proves the existence of God"—in this photograph which uses light and shadow to emphasize the rounded beauty of the body.

An entirely new canon of beauty emerges when ▶ Edward Weston, the acknowledged master of the body-as-object school, turns his lens on the female nude. This is certainly a real woman, even to the hairs on her legs. But her own beauty is not the point. It is lost in an engulfing new beauty that comes from Weston's arrangement of the form.

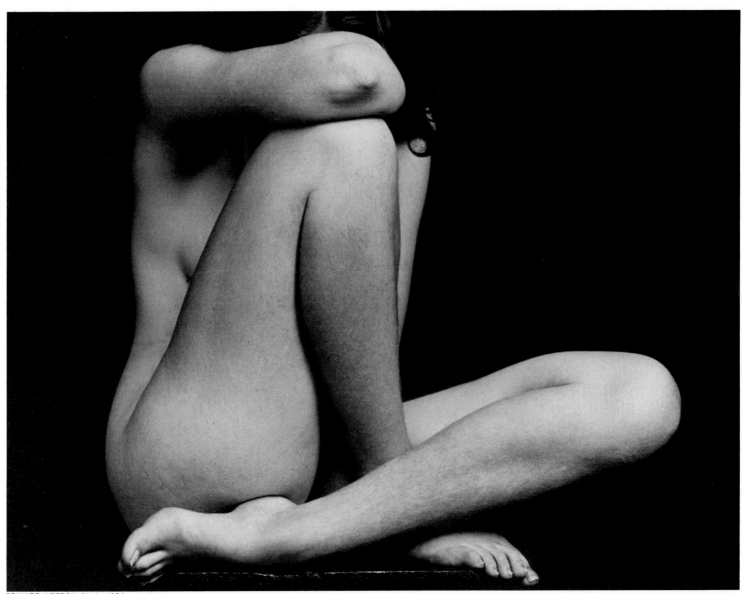

EDWARD WESTON: *Nude,* 1934

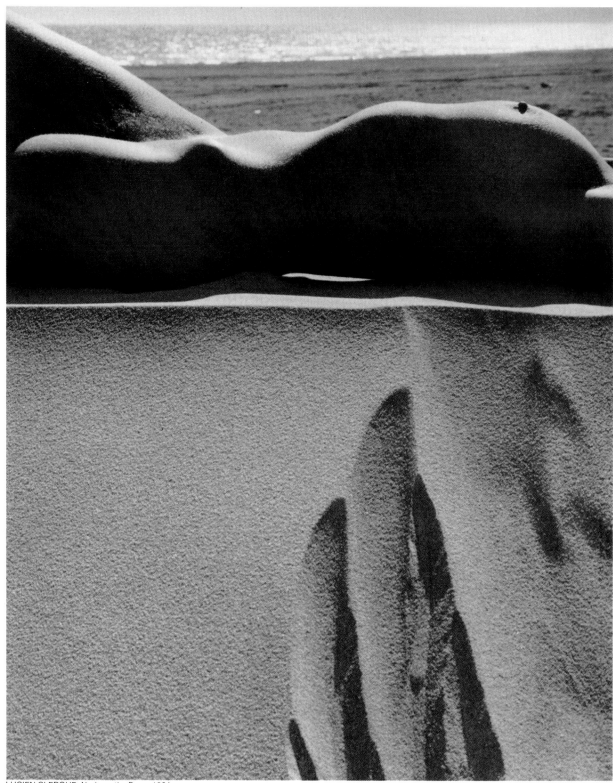

LUCIEN CLERGUE: *Nude on the Dune,* 1964

◀ *In the hands of Lucien Clergue, a French photographer, the nude is again treated as a real subject (left), this time so real that the viewer actually shares her sensations. She is lying on a Mediterranean beach and the breeze is cold—goose flesh is plain on her skin. This brings her dangerously close. Clergue, realizing this, backs off; he does not show her face. "I prefer that the model not be known." Thus, like Weston, he had disengaged from too disturbing a personal relationship with his model by carefully preserving her anonymity.*

Once again an object, and once again a real one. Superficially it might be compared with Coburn's "The Thinker" on page 134. Both are portraits of nude men, both show them in somewhat similar contrived poses reflecting great concentration, but the resemblance stops there. Coburn took care to maintain a safe distance from his subject by turning it into a piece of classical sculpture. Robert Mapplethorpe has no interest in distance at all. He, too, sees the body as sculptural, but he looks directly at it. The sculpture is in the body's forms, not derived from marble, and is emphasized by strong lighting that says: Here is a real man with real muscles. The model chose to hide his face, but that was fine with Mapplethorpe: "The photograph becomes more universal without the face," he says. "People can identify with the anonymous quality of the subject."

ROBERT MAPPLETHORPE: *Ajitto,* 1981

The Nude as a Design

It is inevitable that the camera's eye, studying the human body as an object, will become more and more preoccupied with the pure design elements in it. This can lead in the direction of abstraction, with the pictorial elements so simplified *(left)* or so completely isolated from identifiable surroundings *(right)* that they are not immediately recognizable for what they are. In another direction entirely, a concern for design can incorporate the nude figure in a setting whose elements repeat or enhance those of the figure, and thereby help to make it more explicit. That is the device used by Frantisek Drtikol in the study shown on pages 144-145. Others avoid the explicit by deliberate distortion *(pages 148-149)*.

What makes Harry Callahan's almost blatantly simple picture interesting? Two things. First is the delicate balance between evenness and unevenness of the four lines, the way they come together just off center, the way they trail off separately. Second is the realization that this is not a picture of four pieces of dough or china but a part of the human body: that "special object" again, but viewed as a design by a fresh eye to produce a picture of elegant restraint.

HARRY CALLAHAN: *Eleanor,* 1947

Here is design carried a step beyond that of the picture opposite—so isolated from its context that most viewers will ask, "What on earth is it?" It is a side view of a man's armpit, with a woman's body pressed against his. Its cryptic quality is of no concern to Gene Antisdel, who was less interested in showing the form than "the designs that in themselves are beautiful."

GENE ANTISDEL: *November 10, 1969*

Contrast this design with the calm, enigmatic pair
on the two preceding pages. Here is a picture
absolutely bursting with energy. It takes a
slender model and puts her in a difficult acrobatic
posture, on one knee, clutching her instep. It
then repeats this arresting pattern with a shadow that
is just enough different from the original to give a
truly electric shiver to the entire composition.

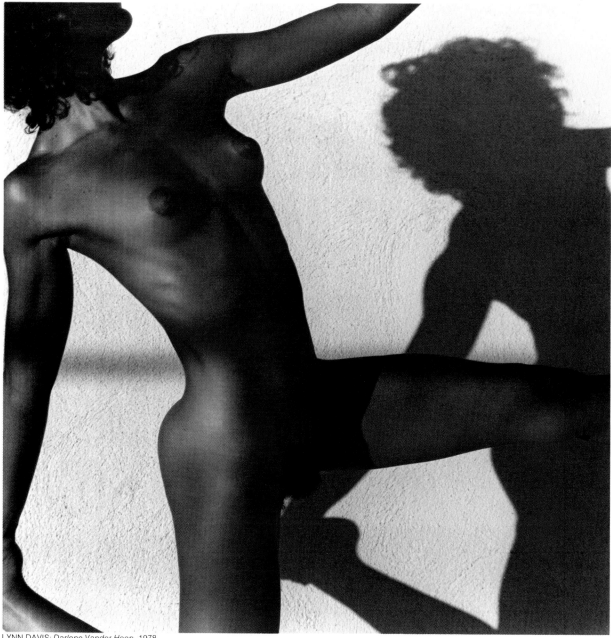

LYNN DAVIS: *Darlene Vander Hoop*, 1978

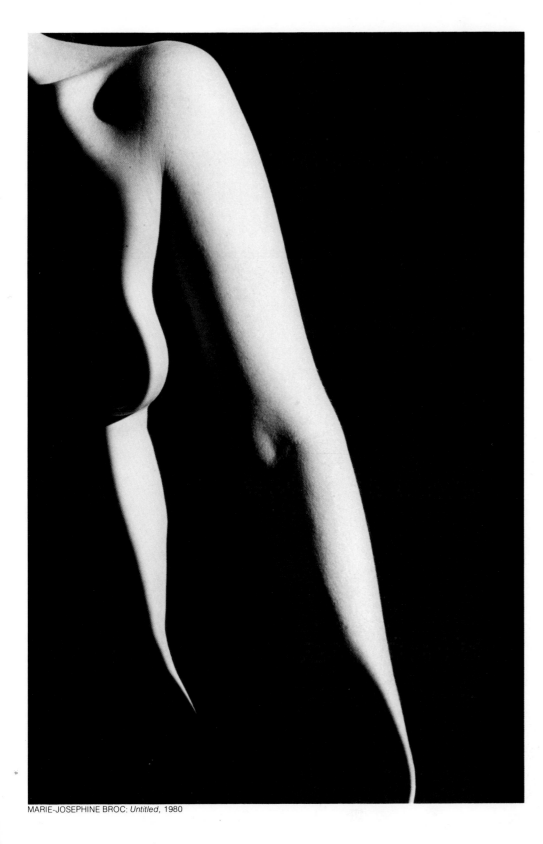

In this study by French photographer Marie-Josephine Broc, the curves and shadows are so strong that they turn the image almost into an abstraction. Broc says of her style, "I produce a minimal light surface that resists the shadow, that shows a gesture, an intention, a feeling." Here the anecdotal parts are cropped away to produce a beautiful, flowing form that only gradually reveals itself as the arm and breast of a woman.

Overleaf: Once again, design is the overriding ▶ aim in Frantisek Drtikol's study of a reclining nude whose own undulations are emphasized by the contrasting undulations of light and dark woven around it. She floats in a dark sea, lapped by three long black waves that not only make her body seem smoother and slimmer than it really is, but at the same time manage to suggest the unseen curves of her back that lie just under the surface. Below, then, all is serenely smooth, but above is just the opposite —not support but contrast. Where the body's curves rise, there are troughs in the strong, black wave pattern running across the top of the picture; where the body dips, the dark wave peaks above. This is an extraordinary photo. It uses the nude as part of a design, but ends up with far more —a figure of unearthly beauty.

MARIE-JOSEPHINE BROC: *Untitled*, 1980

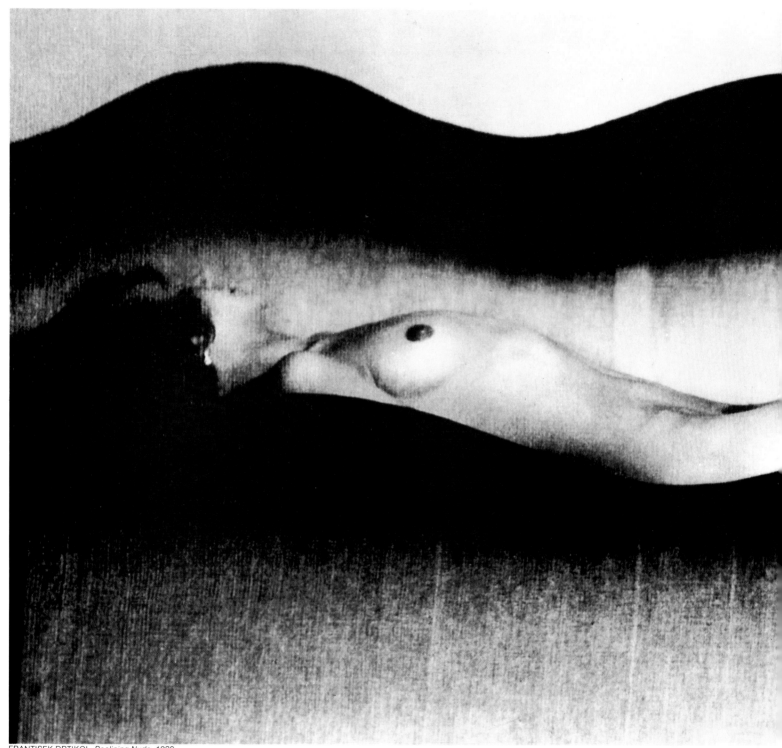

FRANTISEK DRTIKOL: *Reclining Nude*, 1920

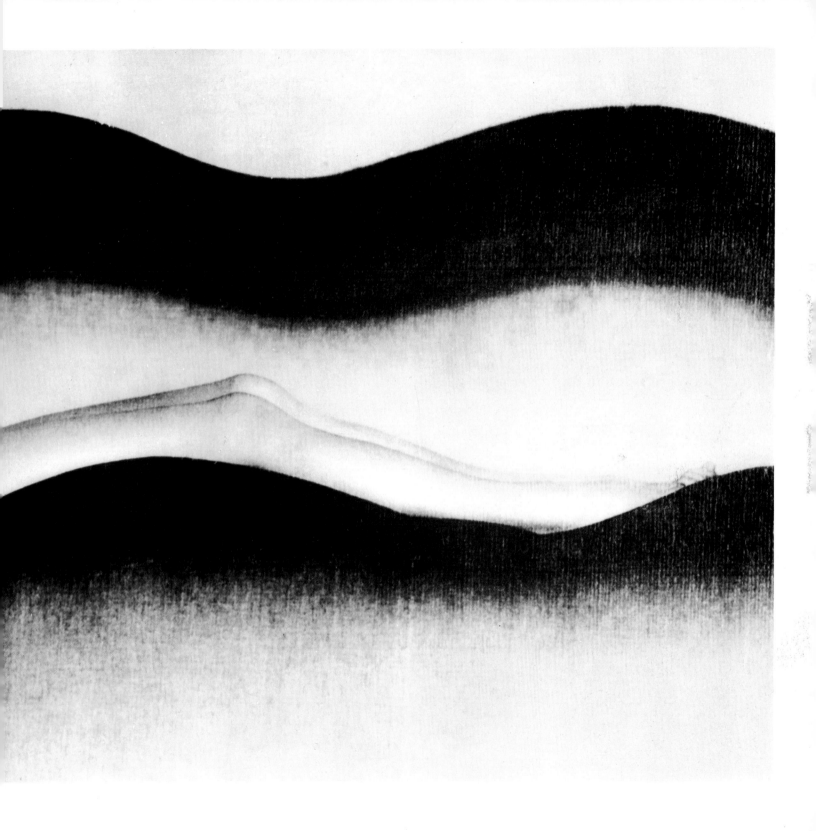

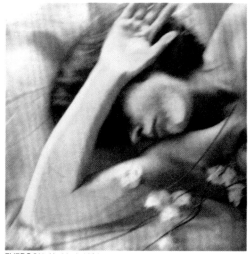

EVERGON: *Untitled*, 1981

Having worked with office copying machines, Evergon became interested in how things look when pressed against glass, so he built a 4 x 8-foot plexiglass structure that his subject could lie on while he photographed her from underneath. Shooting her in four separate Polaroid frames, Evergon produced a series of four different designs in which large sections are devoid of modeling.

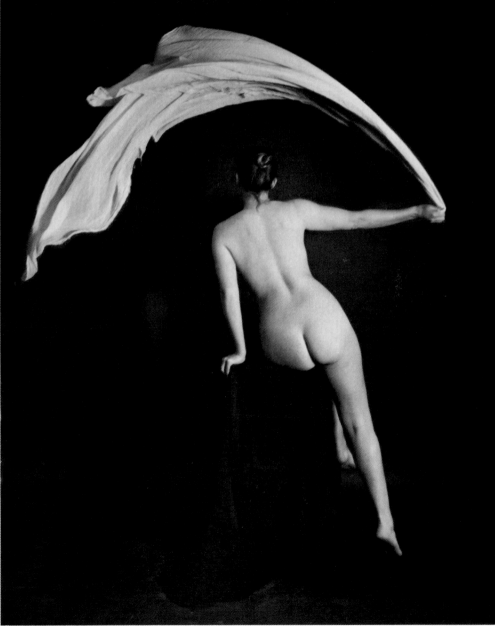

A long veil is caught in a wonderful swirl that arcs over a graceful model in this photograph by George Krause. Working from a small drawing, which he had sketched out before the shooting session, Krause tried the photograph three times before he managed to achieve the image he desired.

GEORGE KRAUSE: *Swish*, 1979

A news photographer known for his dramatic street and crime pictures of New York City, Weegee also experimented with his own specially devised distorting lenses and mirrors in order to get "the kind of woman I would like to meet. I really go for that small slender waist." He achieved the waist in the photograph below, in what looks like a bit of Cro-Magnon sculpture.

Kertész's distortion manages to retain its ▶ resemblance to a real woman despite the wildly contrasting leg shapes, one swollen and convex, the other with its concave shin and endless thigh. What keeps this picture within bounds, with the eye flickering in and out of reality, is the repetition of familiar shapes: head, hands and feet, and the suggestion of a real room in the background.

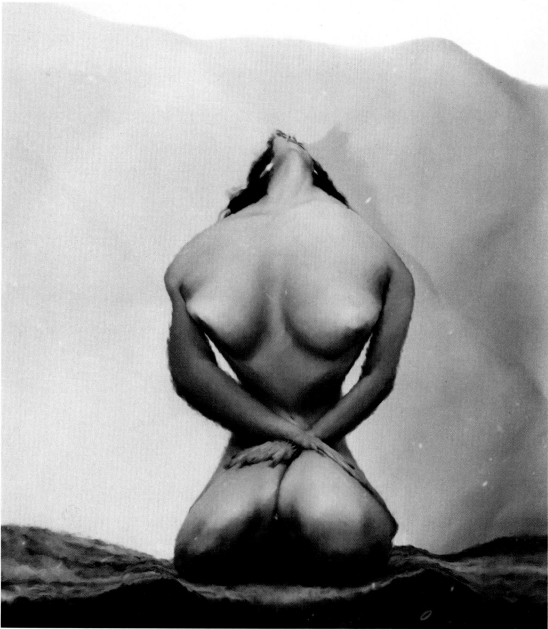

WEEGEE: *Untitled*, c. 1950s

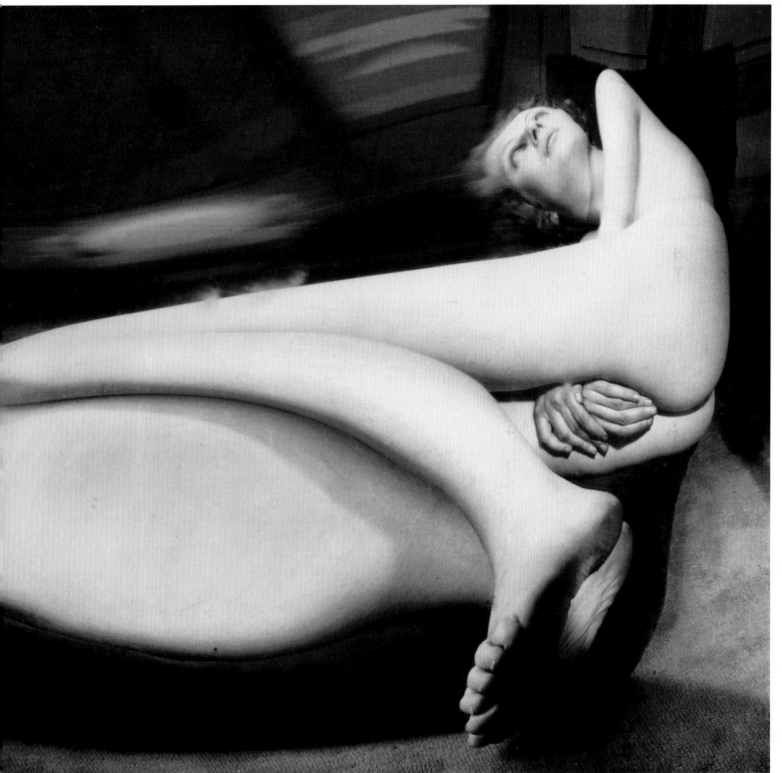

ANDRÉ KERTÉSZ: *Nude Distortion Number 40*, 1930

The Nude as a Person

The nude comes full circle when it no longer embarrasses; when it can exist as a natural figure in a familiar setting; when the photographer no longer feels he must hide behind distortion, soft focus, or classic poses of faceless subjects; when the subjects can stare back at the viewer and challenge him to regard them with equanimity—as living people.

This freeing-up could only come as American attitudes toward sexuality have changed. Today the nude is released from being a mere object and becomes a real person, often the spouse, lover, friend or child of the photographer. Each accepts his or her sexuality as a part of life and expects the viewer to do so too.

Sexual freedom has had a second important impact on contemporary photography. The nude is no longer by definition a nude woman. Photographers now recognize the male body, even the frontal view of it, as a fit subject—though some of the public has not yet come to terms with this new standard.

Harry Callahan was ahead of his time. He began photographing nudes as real people in the 1940s and kept at it for 20 years. But the nude had to be a "person for whom I had feeling." That person was his wife, Eleanor, who compliantly posed for thousands of pictures. This photograph of Eleanor and their daughter, two real individuals at a window sill in a real room, is remarkable in its intimacy: the mother in a golden bloom of womanhood, leading a tousle-headed child toward the sunlight.

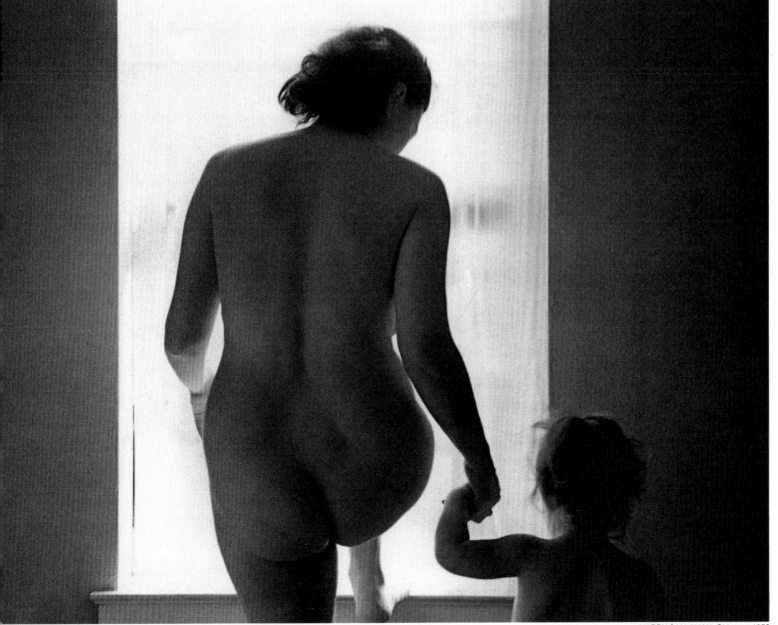

HARRY CALLAHAN: *Chicago,* 1953

151

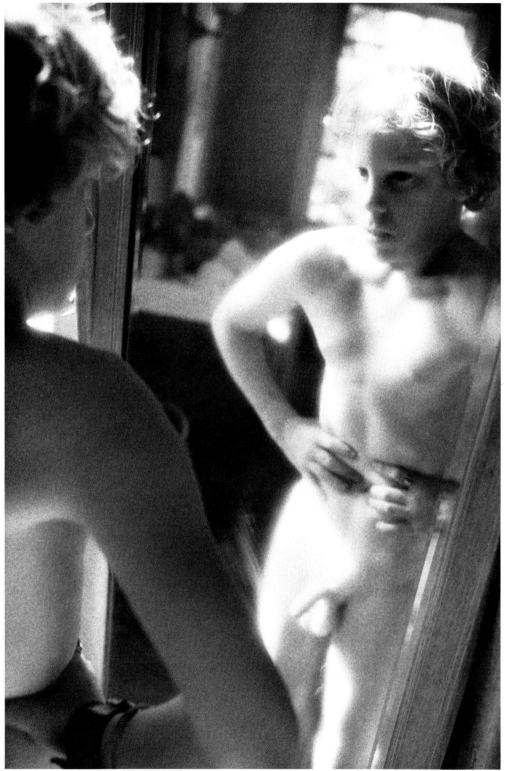

"When I think about people I don't think about clothes," says Starr Ockenga, who has always wanted to record the most intimate of portraits. Here she deals rather delicately with frontal male nudity by choosing a 12-year-old subject whose body is slender and innocent. Moreover, the body is reflected in a mirror. Looking over the boy's shoulder, we find ourselves examining him as he examines himself — with perfect candor.

As in the picture at left, the subject's adolescence ▶ eases the confrontation with the nude girl opposite. But the resemblance stops there. In Ockenga's picture the boy is oblivious of the photographer. Sophi, by contrast, is self-conscious. She lies stiffly on the sofa, her eyes closed. Joan Myers wanted a picture of vulnerability and got it: "a balanced pose with a little tension," she says, "the best kind."

STARR OCKENGA: Boy with mirror, 1978

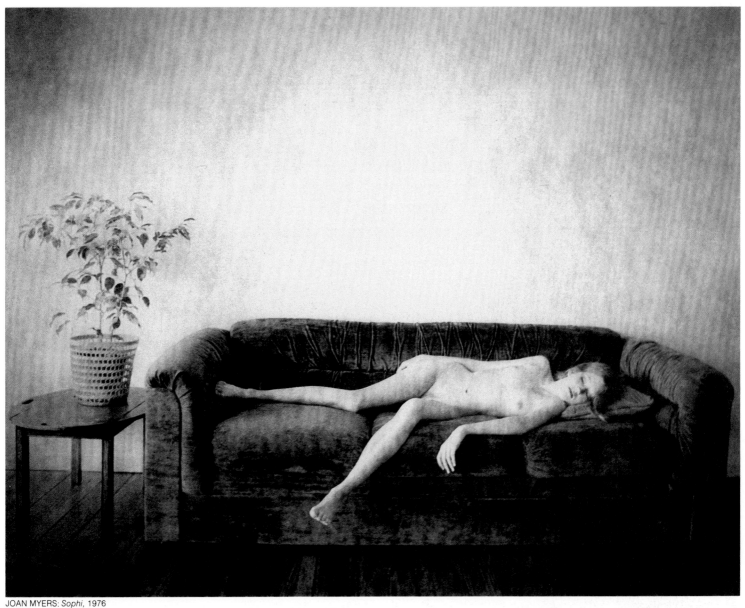

JOAN MYERS: *Sophi,* 1976

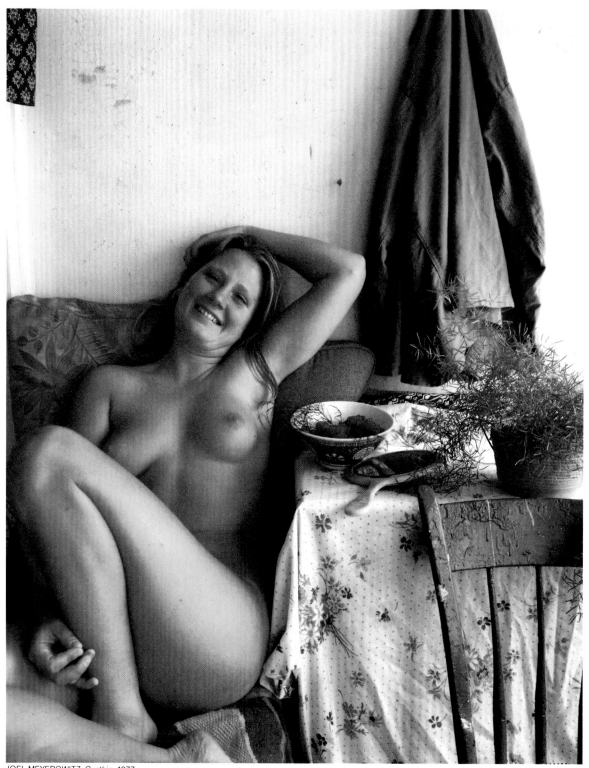

JOEL MEYEROWITZ: *Cynthia,* 1977

Here is a young woman so completely at home in her own skin that we feel her glow of pleasure radiating right off the page. Visiting an artist friend one summer day, Joel Meyerowitz found her daughter on the day bed in the studio, recovering from hepatitis. "She smiled in the giddy way kids do," he says, "and I took her picture. She was a person. The fact of her being nude was secondary."

John Benson makes nude studies because he likes having people see themselves as they are. He uses friends as models and shoots with Polaroid because "being able to see the photograph immediately takes away the mystery and fear." This approach worked for three friends who posed, one clothed, two not, for preliminary shots, studied the results, then relaxed for this fine portrait.

JOHN BENSON: *Untitled,* 1969

Michelle Bogre is attracted to the nude because of its simplicity and straightforwardness. "No one hides anything when they are nude," she says. During one session she was working with a man and a woman, but the sexual overtones were too much for the woman, who was very nervous until the man left. Immediately all tension disappeared and Bogre caught her in a moment of exhilaration.

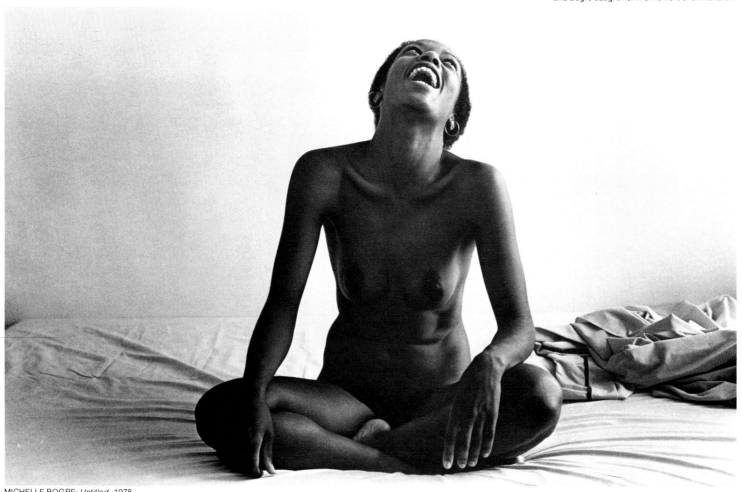

MICHELLE BOGRE: *Untitled*, 1978

When nudity is complicated by emotion between
artist and subject, the photographic challenge is
greater. The subject of this portrait is a close
friend of the photographer, but their relationship was
under some strain. Kelley Kirkpatrick cut through
that problem in masterly fashion, for the impact of the
portrait comes not from nudity but from the
subject's eyes, which are cautious, and from the
protective way he envelops himself.

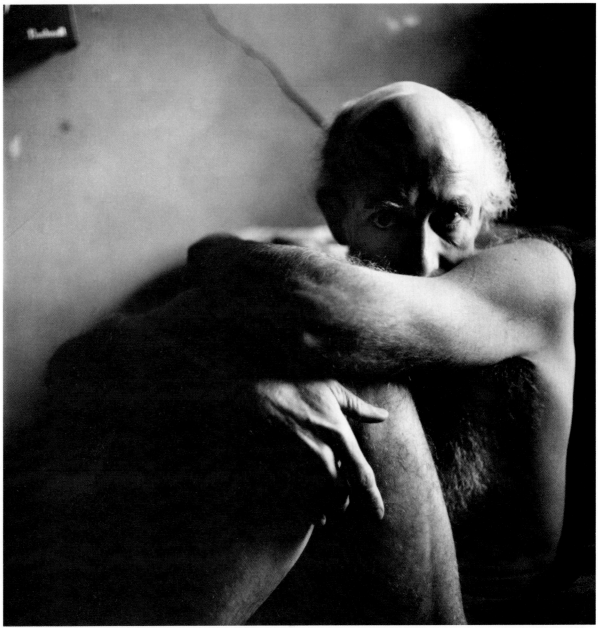

KELLEY KIRKPATRICK: *Untitled*, 1980

The Nude as Fantasy

Having come full circle to deal with the nude as a real person, the next step is to jump out of the circle entirely: The nude as fantasy is a projection of the inner life of the photographer and how he or she perceives the world when alone with a camera and a model.

The nude has always been a potent stimulus for fantasy, setting off scarcely conscious associations: sensual, fertile, vulnerable, erotic. Photographers have responded to this, but have long been forced to do so behind closed doors—in private shows for small circles of friends, in the private circulation of prints, in the private publication of books. This privacy could get dangerously close to pornography, but it is saved by the photographer's taste and intent. To employ the nude body for personal psychological probing is something quite different from making prurient pictures.

The five pictures that follow all speak to some of the most profoundly held feelings of their creators. That each photograph uses the nude as a vehicle for that expression simply reinforces how intricately entangled with other feelings are the sensual and erotic aspects of our natures. Sooner or later sensuality will link up like a strand of DNA with some other bit of psychic cytoplasm: loneliness, fear, anger, a dream of a better life or nostalgia for one's past, yearning for a lost parent, child or lover. Thanks to changing attitudes toward sex, once-hidden fantasies revolving around the nude can now emerge from behind closed doors.

Joel-Peter Witkin was brushed early by damage to the body, and it has haunted him ever since. As a child he saw the aftermath of a car crash and watched a red ball roll toward him: another child's head. More recently, when his wife cut her arms badly in a windowpane accident, he decided to photograph them, but chose to do it in an extraordinary way: All he shows of his wife is her scarred arms in a hammer lock on the body of a hired model. The model is nude "because people without clothes have no social identity," and masked "not to hide her face but to show that the face is the mask of the soul, which we're not yet ready to see." The armless statue was included "to confuse the time frame" for the viewer.

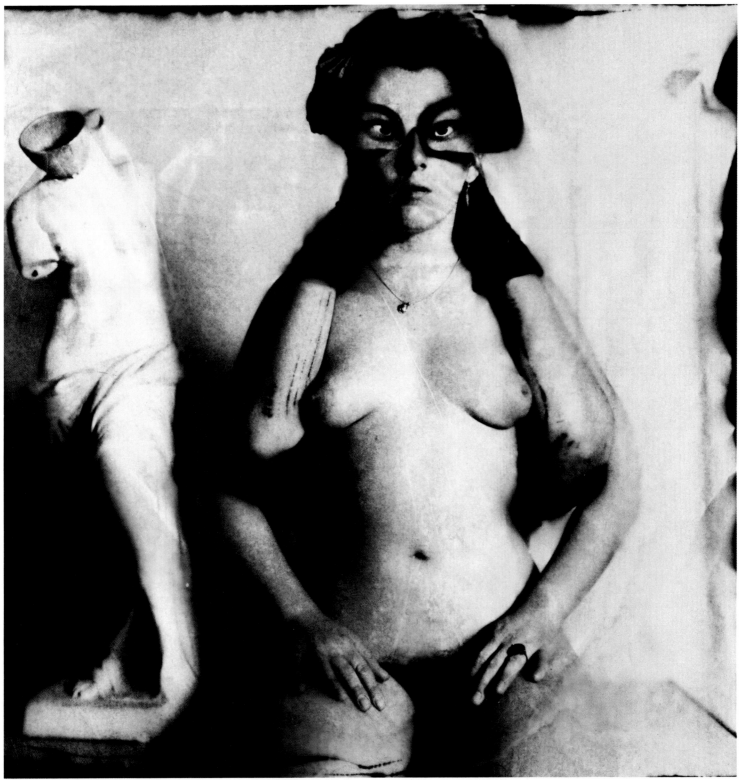

JOEL-PETER WITKIN: *Arms Broken by Windows*, 1980

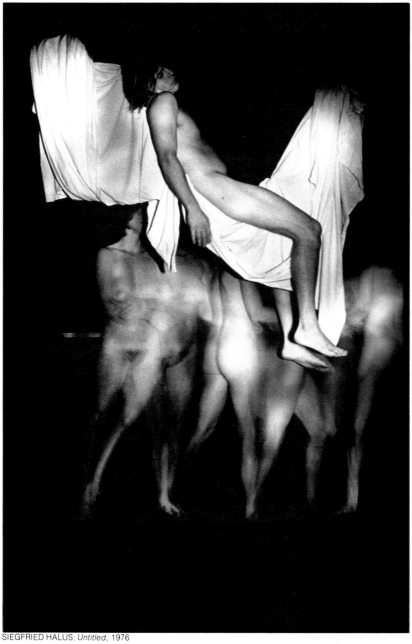

In his evolution as a photographer, Siegfried Halus has reappraised his religious background and moved into a visionary world of his own where nude figures, symbolic of good and evil, wander. This photograph depicts a man rising out of darkness into light, accompanied by female figures. Halus' images are made at night with exposures of 3 to 10 minutes, during which he moves about with a flashlight to illuminate selected figures in particular attitudes. Only where the flashlight falls will the figures be recorded on the film. The platoon of women seen here is actually only one, flashlit several times during a single exposure.

Narcissistic, Sapphic, a voyeur — Irina Ionesco ▶ has been called all these things for the intense inward-looking eroticism that drenches her photographs of women like heavy perfume. Props are important to Ionesco; she dresses up her fantasies with Oriental fabrics, lace veils, rings and necklaces, ostrich plumes. There is also a foreboding of mortality in her work. Here among scattered playing cards from the game of Life lies Death, in the form of a shapely woman in a white gauze veil. According to Ionesco, death is the "ultimate meeting point between living and playing."

SIEGFRIED HALUS: *Untitled*, 1976

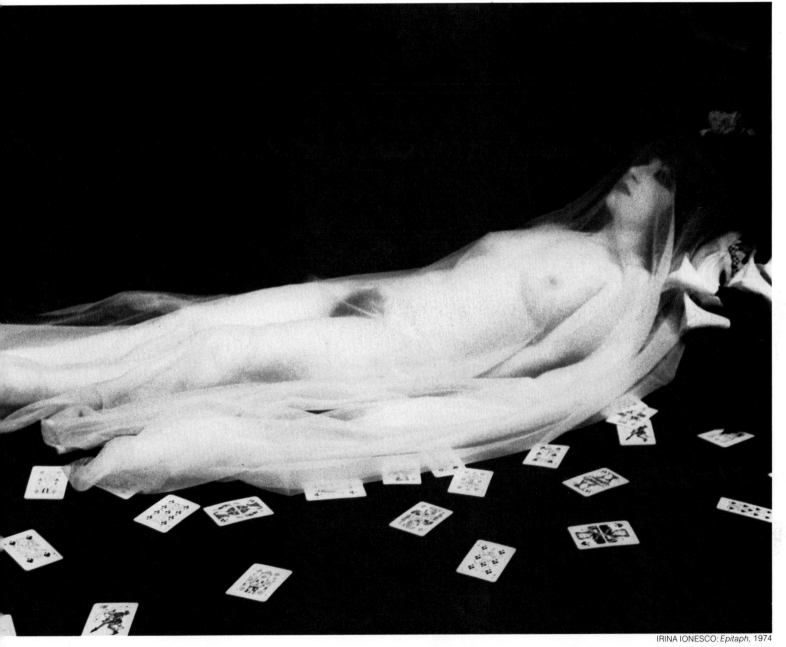

IRINA IONESCO: *Epitaph,* 1974

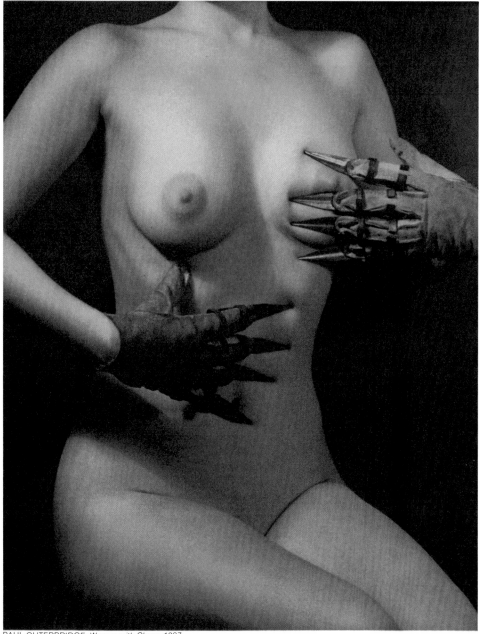

PAUL OUTERBRIDGE: *Woman with Claws, 1937*

Paul Outerbridge grew up in material luxury, but in an atmosphere of emotional bankruptcy caused, he suggested in his autobiography, by his parents' mismatched marriage. A sister "went quite completely out of her mind, brooding about conditions of her family." Outerbridge himself curtailed a brilliant international photographic career to spend 20 years on an erotic obsession with the nude and fetishism. Now that taboos have been lifted, this work can be studied and appraised. It is technically flawless. Following his dictum of contrasts — "large with small, hard with soft, shiny with dull" — this example startles the viewer with its fetish of specially constructed gloves pressing cruelly into the flesh of a nude torso.

The fantasies of Joan Myers spring from dreams ▶ of a lost Hollywood of the 1920s that survives today only in a neighborhood of old driveways, abandoned mansions and choked gardens that once belonged to motion-picture royalty. Here she has found a crumbling wall and posed her model against it, trying to recapture a ghostlike past by making the living figure seem to recede into the wall, becoming part of it and thus bringing it back to life. She does this by subtly manipulating her toned and hand-colored print to a deliberate blur: The head is gone, one hand has six or seven fingers. The title comes from the "S" scribbled on the upper right corner of the wall — the remains of old graffitti.

JOAN MYERS: ''S,'' 1978

Making All the Elements Work

The photographs in the preceding section, though they represent only the tip of the iceberg of potential that exists in nude studies, still display an astonishing variety. In fact, so great is that variety that it may obscure the most important fact of all: the one thing that they have in common. Each sets out to realize an idea—intellectual, esthetic or personal, but usually a combination of the three—that the photographer had, probably *before* he went to work. Furthermore, those ideas were not born out of thin air. They resulted from long hours of thought and labor, long familiarity with their subject matter, many failures—but, in the end, they led to photographs that say something.

This complicated creative process depends on an understanding of the special object that is the nude. Photographers, confronted for the first time with this highly complex subject, simply cannot know how they will be able to exploit it photographically until they have tried —by examining it in detail from many angles, first with the eye, then with the camera through many different lenses in varying light combinations, and finally in their own thoughts. Only in this way can they learn to make the most of their subject.

It is this experimental approach that has been used in the following specially prepared section. William G. Larson, who teaches photography at Temple University in Philadelphia, was invited to spend a couple of sessions photographing a nude model without having any preconceived picture in mind—a freewheeling, get-acquainted exercise.

Some of the results appear on the next two pages—they constitute a composite contact sheet, to indicate the range of options available and the kind of open-minded approach that contributes to an understanding of the nude. On succeeding pages Larson shows how the ideas that appeared during his shooting sessions can be developed, altered and perfected by a number of variations in technique, such as camera angle, lighting, lens choice, focus and, finally, color.

In preparing this lesson, Larson deliberately chose someone who had never posed in the nude before. He did this in order to explode the widely held view that only professional models should be used for nude photography. Their stereotyped poses, learned from long experience in meeting professional photographers' requirements—the twisted torso, the pointed toe—can get in the way of the beginner. He will not understand how to use or correct them, and will end up making banal pictures. Naturalness, not posing experience, is essential for a worthwhile study of the nude.

A seemingly twisted pose becomes a graceful study of a young model in the picture that William G. Larson selected as the best among the 384 he made to demonstrate techniques for photographing the nude. He achieved this quiet mood with bright but softly diffused lighting, the pensive expression of his model, and artful arrangement of the lines of her body.

WILLIAM G. LARSON: *Seated Figure*, 1970

The Effects of Pose

These examples make no attempt to lay down rules about how a figure should be turned to its best advantage, or how to build vertical or pyramidal compositions. These things are not learned from rules but by trial and error, constant practice, studying and profiting from the work of others.

Larson's pictures have deliberately been made as varied as possible to get the eye and the imagination moving freely. They exploit both light and dark backgrounds, different lenses, a wide variety of camera angles and lighting effects. Poses vary from the utterly casual to the highly contrived. Some are full figures, some show only details. Some are highly personalized, others detached. But all are worth careful study for they contain many ideas.

Two are distorted: The second from left in the top row enlarges the model's face, emphasizing its wistful expression, the more so because of the fragile body behind it. The other, last in the bottom row, has an entirely opposite effect— with its exaggerated leg length, it produces a stiff and monumental figure that stresses bone and muscle.

At least two of the 18 were taken from floor level or near it, some from straight on, several looking down on the model from above. Compare the second picture in the middle row with the third picture in the bottom row. One was taken from about six feet in the air, the other from within inches of the floor.

Larson's pictures were all taken indoors without any props. Accessories, whether they be background surf, driftwood or blowing grasses, simply distract the photographer from the primary purpose: an understanding of the artistic potential of the nude.

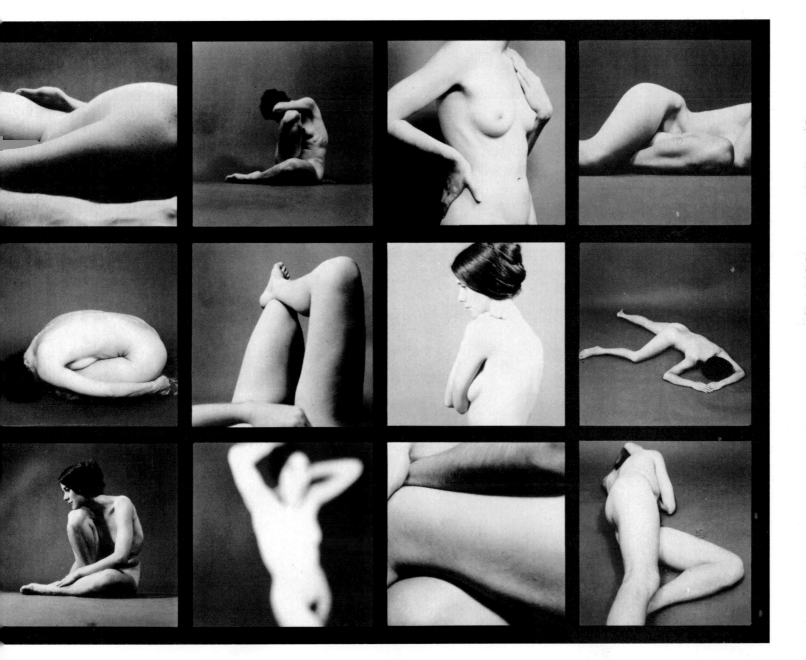

Creating Distortion

Distortion, when used with artistry as in the pictures on pages 148 and 149, can be a potent emotional weapon in photography of the nude. But artistry is essential. Exaggerated distortion, unless it has a valid intellectual or emotional idea behind it, is merely an eye catcher, and can quickly become tiresome. (Of the 18 pictures on pages 166-167 only two are strongly distorted.)

Legitimate distortion calls for a careful choice of the method by which it is achieved. The principal tool is the lens, the kind and amount of distortion depending on its focal length: A focal length shorter than that considered normal for the film size makes whatever is close to the camera seem abnormally large; a focal length longer than normal has the opposite effect. As a simple illustration of the possibilities inherent in lens choice, William G. Larson placed his model in a relaxed position on the floor *(right)* with one arm outstretched and the other arm cradling her head. He made three shots with different lenses and achieved three images with remarkable differences in emotional content.

The lens is not the only factor influencing distortion, however. How close the camera is to the subject is equally important. In the first of the pictures at right the extreme distortion is achieved not only by the wide angle of the lens but by positioning the camera within two feet of the model's fingertips. Had the camera been farther away, the effect would not have been nearly so pronounced. By blending both the lens choice and the camera distance, the photographer is able to produce any degree of distortion he wants, and the amount of distortion remains under his precise control.

wide-angle lens

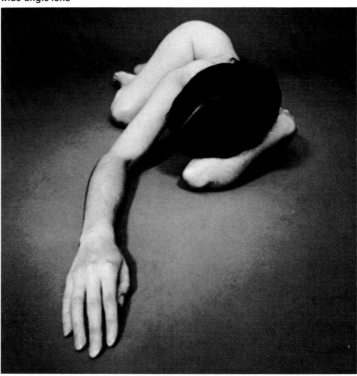

Using a 38mm lens—shorter than normal (i.e., wide-angle) for the 2¼ x 2¼ Hasselblad camera—and bringing it very close to the model's outstretched fingers, Larson creates a picture of considerable tension. The oversized hand, with its long emaciated arm and disappearing body, suggests not only deprivation of some sort, but also a kind of supplication; the viewer is being asked to relieve the woman's suffering. Here distortion has disturbing emotional impact.

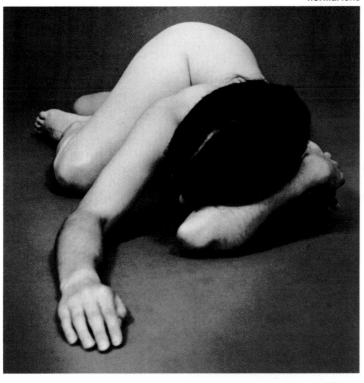

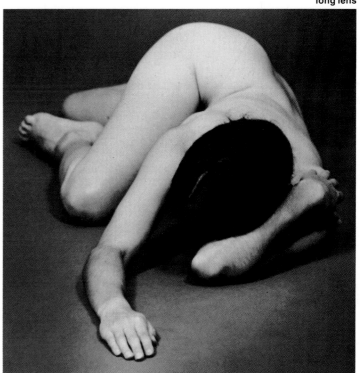

With a normal lens for his Hasselblad (80mm), Larson achieves a view of his model almost identical with that observed by the human eye looking at it from floor level and only a few feet away. This picture has its own distortion — as does every photograph — but it is the kind that the eye itself produces and hence looks natural. The result: a tranquil picture of someone drowsing.

With its ability to foreshorten, the long-focal-length lens (250mm in this case) produces an entirely different effect. The model's leg and foot seem thickened. Her hip has not changed in actual size from the picture to the left, yet it appears swollen because her head has become smaller. Considering the slender girlishness of this model, so apparent in other pictures throughout the essay, it is quite extraordinary what a change the long lens has wrought.

The Many Moods of Light

The best studio lighting is usually the simplest. The more lights used, the more difficult it becomes to keep them in balance. Each introduces problems such as intersecting shadows and awkward highlights in the wrong places. And movement of one light affects the others. Limiting the number of lights need not limit the artistic possibilities, for the number of lights may influence the result less than does their type.

There are two main types of studio lights: diffuse and direct. Diffuse light, created by placing a thin sheet of spun-glass fibers (available in camera stores) over the lamp, distributes itself fairly evenly over the figure, flattening and softening contours and smoothing skin by reducing shadows to a minimum. The direct light from an unscreened lamp does just the opposite; it emphasizes contours and skin texture by creating powerful shadows and highlights. By playing these two contrasting characteristics against one another, the photographer can achieve virtually any pictorial effect he desires.

Light placement has a powerful effect. The closer a direct light is, the more concentrated its highlight will be. In the fourth picture at right, for example, a close light would have succeeded in heightening the shadow along the breast, and the light down the thigh would have been lessened. A combination of setups one and five will produce the effect shown on page 165—a white-on-white, or "high-key," picture.

Each of the examples shown is a straightforward picture, employing only one or two lights to illustrate the five basic setups shown in the diagrams. Within them is enough variety to keep most photographers busy for a lifetime.

With two diffuse lights set at the same distance from the model, and at a 45° angle (diagram below), the effect is a soft overall lighting of the entire figure, with no point of emphasis and scarcely any shadows. The evenness and flatness of this lighting can be varied by moving one light farther away from the model.

By substituting a direct light for the diffuse light at the camera's right, a more sculptured effect is achieved. The direct light casts shadows, making visible many subtleties of bone and tissue that the totally flat lighting could not bring out. The direct light also creates a point of emphasis with a highlight on the shoulder blade.

Removing the diffuse light at the camera's left and leaving the direct one at the camera's right produces a figure of light and dark contrast. There is no "fill-in" illumination on the back. The details there are lost, and the picture derives its effect from the highlights and the suggestion of shape made by the irregularity of the shadow running down the model's side.

By aiming a single direct light at the model, as shown in the diagram below, an edge-lit effect is obtained. The sharpness of the shadow line can be controlled by the position of the light. The farther the light is moved around behind the model, the harder the shadow edge will become.

When the direct light is taken off the figure entirely and aimed at a white background, a strong silhouette effect results. However, enough light bounces from the background to highlight the breast. If the model were to move farther away from the white background, less bounce light would reach her to illuminate her contours, and a pure silhouette would result.

The Importance of Camera Angle

Startling differences in the impact of a picture can be achieved simply by raising or lowering the camera. A figure can be made to appear monumental or insignificant, pathetic or exuberant, natural or artificial, the effect depending on the choice of angle.

Shown here for contrast's sake are two extremes in camera angle: a very high one on this page and a floor-level one opposite. High angles most easily exploit the prone full figure when it is posed in depth, while low angles make possible the building up of compositions — like the bodily triangle in the picture at right — that are firmly anchored on a single dominant element.

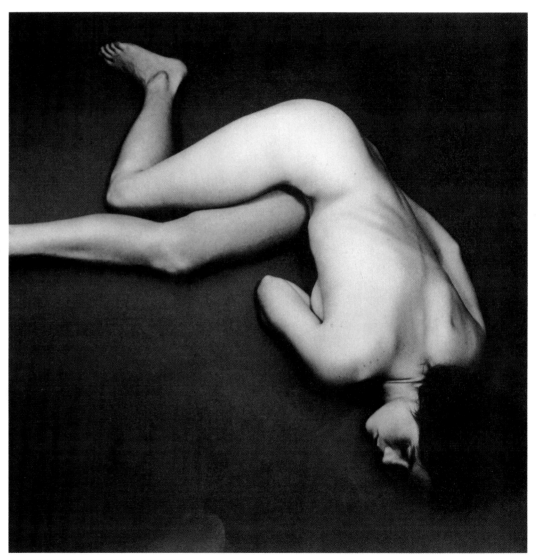

A conventional pose is turned into a much more interesting one by high camera angle aiming straight down on the sprawled nude figure. In such shots, care must be taken to guard against unwanted distortion of a figure as it stretches away from the camera. The cure: back away.

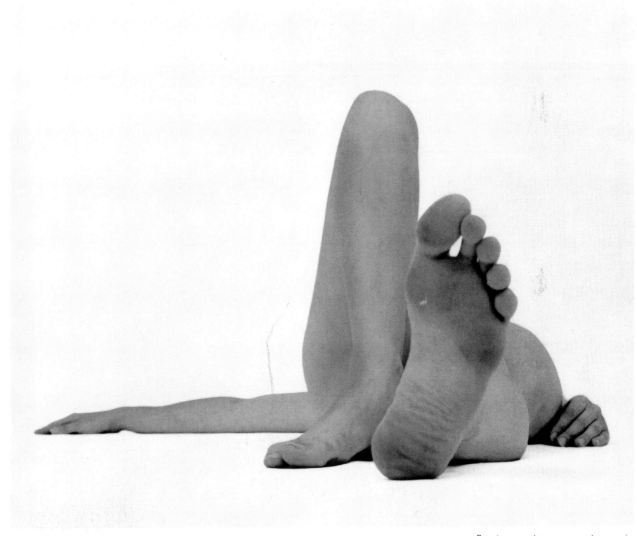

By using a very low camera angle, a precise arrangement of knee, foot, hip and hand is assembled to form a triangle — with arm extended to one side for balance. The camera is high enough from the floor to give depth, separating the outstretched arm from the foot.

Focusing for Emphasis

In any picture the eye is immediately drawn to the point of sharpest focus. This opens up wide opportunities for composition and emphasis, since the photographer can control the relative sharpness of the picture areas by varying his depth of field through his choice of lens focal length and aperture setting. He can push this use of focus to an extreme, as in the picture above, which gives only the vaguest suggestion of the body forms attached to the sharply focused fingers in the foreground. Or he can use focus more subtly, as in the picture opposite. There the hazy focus of most of the body works with the composition itself to lead the eye to the nipple, which is the central pictorial element. Blurring of other elements is kept to a minimum—and manipulated just enough to soften and enrich the entire photograph.

A disembodied figure stretches out behind the hand that so strongly dominates this picture, whose entire effect would be destroyed if it were all more sharply focused. How else suggest that anonymous head, the semblances of an upthrust knee and an outstretched leg?

Excessive blurring would only have hurt this ▶ picture. The softness of the foreground goes almost unnoticed, while the slight fuzziness of the thigh and the arm contrasts in the gentlest way with the more sharply focused breast.

The Difference Created by Color

The addition of color to photography of the nude introduces qualities and dimensions that can be a source of difficulty as well as a creative tool. Along with the play of light and shadow that define form in black and white, color hue and saturation must now be considered.

To get accurate color, the film must be balanced for the light source being used. Negative films can be used both indoors and out, but slide films should be daylight type for outdoors or strobe, and tungsten type when household lamps or floodlights are used.

Properly balanced film will not assure pure skin tones, however. Outdoors, foliage can give a greenish tinge to the skin; indoors, a model lighted by skylight without direct sunlight will have a bluish cast; color casts are also created by light reflected from walls or furnishings. Professionals frequently use gold-colored foil reflector sheets or a warm-toned filter to correct these effects. Bluish filters will correct the overly warm tones that can result in early morning or late afternoon, when the sun's rays are reddened by the atmosphere.

Despite the caveats, color—when it is used carefully—can greatly enhance the nude study. It can be used simply to separate a figure from the background, or to create a particular mood: Vibrancy can be evoked by having a background of contrasting and saturated colors, while pastel or harmonizing colors can create a mood of calm. Color can be used boldly or in small accents, in simple shapes or in complex patterns. In the study on this page, William Larson has taken complementary colors of different strengths and direct, nearly frontal lighting to produce a subtle interplay of engaging patterns and dimensions. □

The varied patterns and contrasting colors of the background materials set off the more subtle variations of skin tones in this studio study. The rhythm in the backdrop, echoed by the arch of the model's back and head, unifies the whole.

Nature **5**

ANSEL ADAMS: *Moon and Mount McKinley, 1948*

The Difficult Drama of Nature

Nature photography is an act of both devotion and submission. When Ansel Adams depicts a mountain range *(preceding page),* he celebrates earth-lifting forces far greater than anything humans have yet attained. When a photographer seeks to show the ferocity of a lion, the flight of a wood duck or the life style of rabbits in his own back yard, he meets these creatures not on his terms but on theirs, deferring to their requirements of safety and secrecy. Even trees and flowers impose stern demands for patience on a photographer, for they live according to the inexorable clock of the seasons. The great photographer Edward Steichen has set an example of marathon patience by devoting 15 years to documenting the slowly changing appearance of a single tree at his home in Connecticut.

The best photographers of wildlife catch their elusive images in much the same way that trappers or hunters get their prey. Stealth is usually essential for success. They wear drab clothing, move quietly and slowly, stay downwind so that an animal cannot detect their scent, and spend long hours hidden in brush or a blind waiting for the moment for action. They become intimately acquainted with the habits of their subjects: where animals come to drink, which berries a particular type of bird prefers, how alarm signals are communicated among the animal population. The best pictures of wildlife may be obtained if a photographer finds a natural salt lick where deer supplement their diet, or if foxes and bobcats can be enticed into the open with a bait of meat. The over-eager photographer who tromps noisily through the woods and fields, knowing little about the animal inhabitants but hoping for a lucky break, is almost certain to come back empty-handed.

Even the wiliest photographer finds that animal pictures must generally be taken from a distance. The telephoto lens—200mm or longer—is indispensable in wildlife photography. Even for such giant-sized subjects as elephants *(center),* Peter Beard, who specializes in photographing African animals, had to use a 200mm lens; the herd was wary because of the calves. A sturdy tripod is a prerequisite for good pictures with a telephoto lens, because any camera vibration will produce blurred images; a rock or branch may serve to support the camera in an emergency. Many photographers use shoulder braces to steady the camera while following birds in flight.

In other matters of equipment, wildlife photographers can choose almost any level of sophistication. A good zoom lens will allow a quick change of focal length if the subject appears nearer or farther away than expected. A motorized camera attachment that automatically advances the film will allow a rapid series of exposures of swift-moving creatures. And a trip wire, linked mechanically or electronically to the shutter, will let the animal take its own picture while the photographer stays well out of the way. A more advanced version of the trip wire is a photoelectric-cell arrangement *(pages 186-187)* that triggers the shut-

PETER BEARD: *Elephants,* 1960

ter when an animal breaks a beam of light. The photographer may combine trip wires or photoelectric devices with electronic flash to shoot nocturnal animals. There are even gyroscopic camera mounts that will hold the camera amazingly steady in a boat or on a moving truck. As for film, color emulsion has the great advantage of realism, but many animal photographers like to work in black and white, because its great speed and exposure latitude simplify the lighting problems that often occur in the wild. Also, black-and-white film makes it especially easy for the photographer to compensate for minor exposure errors when the negative is printed.

In landscape photography the equipment tends to be less complex. A normal lens and a 35mm camera are suitable for most purposes, though a larger-format camera will yield better detail, and wide-angle and long lenses prove useful for some subjects. Since light is generally plentiful and the subject more or less stationary, color film is less troublesome than in wildlife photography. Yet many landscape photographers today use black-and-white film—partly following the example of Edward Weston.

Weston's legendary series of pictures taken at Point Lobos, California—beginning in 1929 and covering two decades—demonstrated the impact that can be achieved with black-and-white film. He revolted against a long photographic tradition of imitating the idyllic, almost mawkish visions of nature that had been the stock in trade of many 19th Century painters. He would be bound by none of the compositional rules that had inhibited many earlier photographers of landscapes. (At the turn of the century one rulemongering photographic manual stated that a complete landscape consists of foreground, middleground, background and sky, and that one or two of these "may sometimes be suppressed.")

Weston and the talented photographers who followed him to Point Lobos (pages 189-200) saw nature with the eye of true artistry. They did not limit their response to an accepted style, but instead bore witness to the countless moods of nature, using close-ups, distance shots, time exposures, special lighting effects and numerous other techniques. Through patient observation, they found prodigal beauty and mystery in a weatherworn tree, a leaping wave or a single rock. In the process they set their own excellent example for every photographer of ocean or mountain, of bird or baboon. □

Stalking Animals with a Camera

The first rule of animal photography is to stay out of sight. Photographers can do this in a number of ways: They can operate the camera while hiding in a blind, whether it is wrapped camouflaged netting or an elaborate tent; they can rig up a "camera trap" that causes an animal to take its own picture; or they can operate the camera by remote control, using a cable, air pressure, or even a radio signal to release the shutter.

The choice of method is dictated, at least in part, by the skittishness of the subject, which varies widely among different species. A tern, for example, will tolerate a six-foot-high blind set up only 10 feet from its nest, but a golden eagle may become alarmed when human beings approach to within a half mile of the nest. And if the subject is a grizzly bear, the photographer will not want to come close, even if that were possible.

No matter how ingenious the equipment, success will ultimately depend on the photographer's skill in locating nests, game trails, water holes and other likely sites. Patience, thorough preparation and the knack of thinking as animals do are also helpful traits for the photographic game hunter. And a bait of seeds or meat gives animals an added incentive to present themselves to the camera.

nest

camera on tripod with 600mm lens

camouflage-cloth blind

To photograph a skittish trio of baby great blue herons 100 feet above ground in a pine tree, Jim Brandenburg worked from behind a simple blind made of camouflage-patterned, green-and-black cloth. Brandenburg climbed up a steep cliff to reach his own perch 100 feet from the birds. With him was an assistant, who helped drape the cloth around the photographer and his tripod-mounted camera. When the assistant left, the birds relaxed and Brandenburg made his candid baby pictures.

Three young blue herons scan the forest around their lofty nest in New Mexico's Gila Wilderness. By selecting a vantage point at about the same height as the nest and by using an extreme telephoto lens, photographer Jim Brandenburg captured an intimate portrait of these aloof and wary birds. His 600mm lens, with its shallow depth of field, served to isolate the herons, revealing them in sharp focus with just enough of the pine boughs around them to establish their airy locale.

JIM BRANDENBURG: *Great Blue Herons*, 1980

To create an outdoor studio for his studies of kingfishers in their natural habitat, Japanese photographer Tadashi Shimada built this pool near a stream and stocked it with fish. About three feet from the pond he set up a motor-driven camera with a 50mm lens. To freeze the split-second action of a kingfisher catching a fish, Shimada used four self-adjusting strobes that emitted flashes of 1/12,000 second every 1/5 second. Shimada watched through binoculars from a tent some 60 yards away across the stream; when a kingfisher struck, he pressed an electronic cable release to trigger the shutter and strobes.

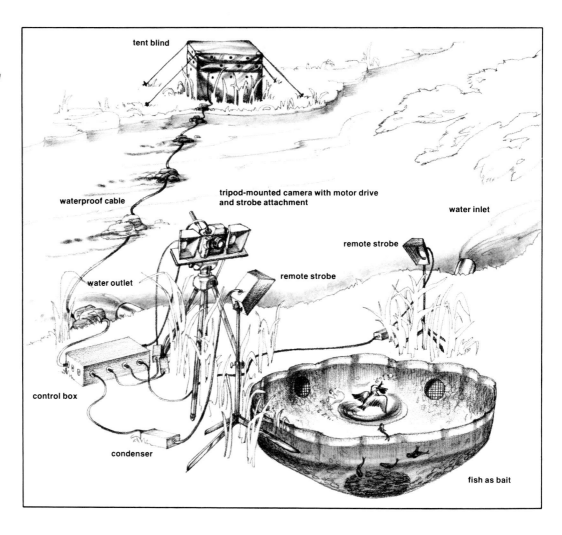

tent blind

waterproof cable

tripod-mounted camera with motor drive and strobe attachment

water inlet

remote strobe

remote strobe

water outlet

control box

condenser

fish as bait

A kingfisher makes a successful strike, emerging ▶ from Tadashi Shimada's specially built pool to eat one of the 20 to 30 fish it catches daily. Once plentiful in Japan, kingfishers are now called "dream birds," rarely seen because of pollution in their hunting streams. Shimada photographed the birds over a period of 10 years, eventually producing a prize-winning book about the life of the kingfisher.

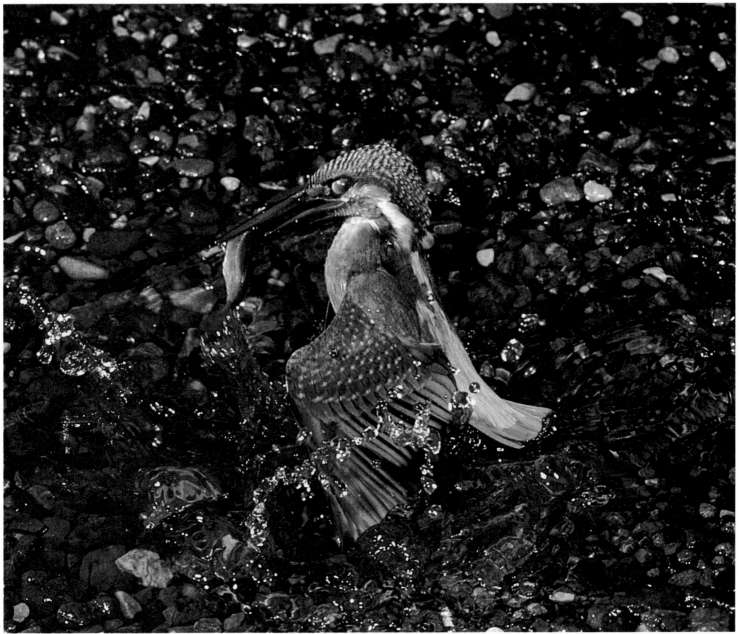

TADASHI SHIMADA: *Kingfisher*, 1978

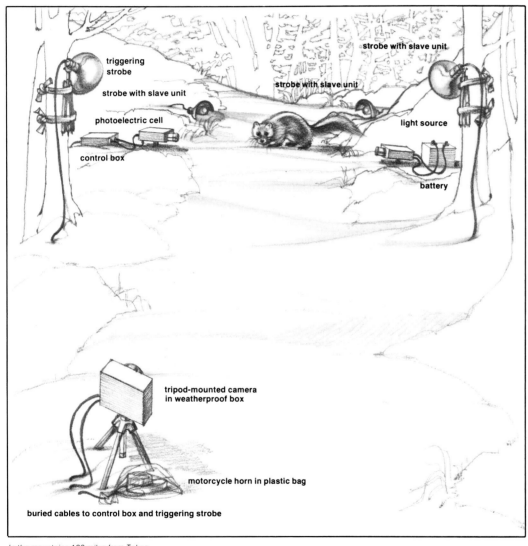

In the mountains 100 miles from Tokyo, photographer Manabu Miyazaki set up strobes and a motor-driven camera that were triggered whenever an animal interrupted an infrared beam aimed at a photoelectric cell across the trail. To get the animal to face the camera, Miyazaki connected a motorcycle horn to the control box. When the beam was broken, the horn went off and— after a 3/10-second delay to let the animal react— the strobes flashed as the camera took the portrait.

Every sense alert for danger, a Japanese marten ▶ turns to look at an interloper—the camera of Manabu Miyazaki. The marten—here richly backlit by concealed strobes—is a distant relative of the weasel, badger, skunk and otter. It hunts squirrels in the trees, but also has a lusty appetite for mice, which may have prompted it to cross this mountain trail—and break Miyazaki's infrared beam.

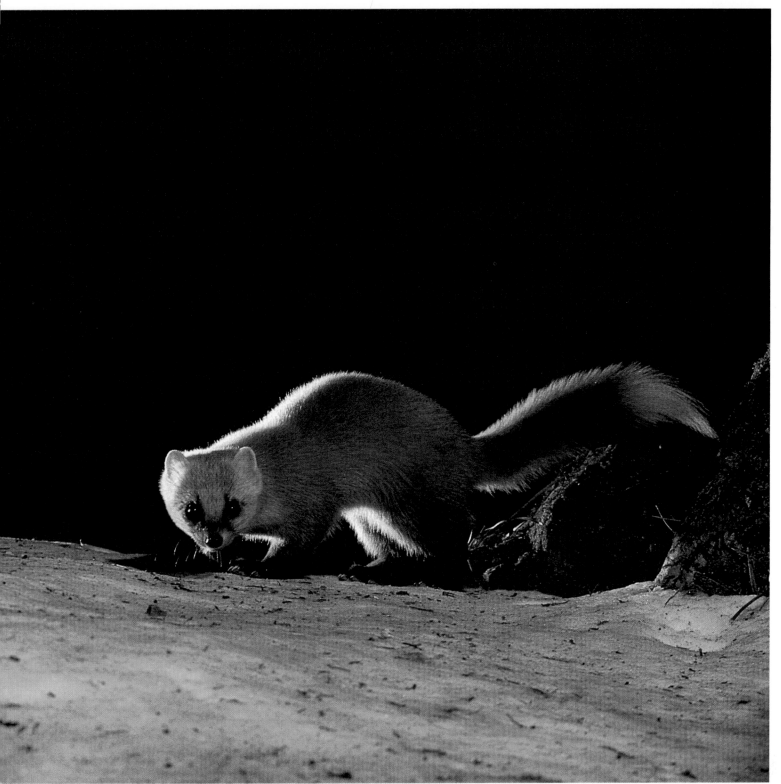

MANABU MIYAZAKI: *The Marten*, 1979

A Mecca for Landscape Photographers

For many photographers, Point Lobos, California, is a shrine, consecrated by Edward Weston. Ranging across those few hundred acres of seacoast in the 1930s and 1940s, the noted photographer, already famous for his portraits, nude studies *(page 137)* and still lifes *(page 76),* lent new vigor to landscape photography. "I never tire of that wonder spot," he wrote after he took his first pictures of Point Lobos, "nor could I ever forget it, no matter where I go from here." Nor could the photographers who followed him to record, each in his own particular style, the rugged beauty of this unspoiled headland.

When Weston began his lengthy exploration of Point Lobos at the age of 43, he found himself challenged as never before. This was nature at its most elemental—sometimes savage, sometimes serene, and ceaselessly changing. The force of wind and water was written into contorted cypress trees, jagged cliffs and sculpted masses of sandstone. Up on the hills, well away from the bludgeoning surf, were flowering meadows and stands of moss-hung pines. One moment the little peninsula would be bathed in brilliant sunshine, the next moment it would be veiled in fog or lashed by a violent storm.

Edward Weston's views of this protean bit of wilderness were soon hailed as masterpieces. He indulged in none of the romanticism that had often characterized previous landscape photography. Carefully composed, the pictures were taken with an 8 x 10 view camera and printed on glossy paper by the contact method to preserve maximum detail. They clearly fulfilled his desire to show "the thing itself"—the fundamental structures of nature rendered with almost sensuous sharpness.

So compelling was his approach to Point Lobos that Weston's own sons were somewhat hesitant to tackle the same subject when they were starting out in photography. Their father assured them that his studies were by no means definitive, and that a landscape can be seen in many different ways. As it turned out, Weston's work was only the overture—magnificent, to be sure—of a continuing series of photographic variations on the themes of nature at Point Lobos. His sons Cole and Brett Weston went on to create distinct interpretations of their own *(pages 193 and 199),* as did many other gifted photographers. Today thousands travel there each year to try to capture the spirit of the California coast with their cameras.

Thrusting out into the Pacific, the 560 acres of Point Lobos possess such natural grandeur that in 1933 California designated them a state reserve, never to be altered. Edward Weston, who made the view opposite encompassing Point Lobos' trees, rocks and a kelp-clogged cove, lived nearby until his death in 1958.

EDWARD WESTON: *China Cove*, 1941

The Many Guises of the Shore

PETER McARTHUR: *Surf at Sunset,* 1967

Along the shore, the sea and land confront each other in ways so complex that the encounter seems to be almost animate. In places, the surf lashes the cliffs, spitting spray high into the air and coiling for yet another onslaught. Only a few feet away, gentle wavelets wash beaches of fine sand.

The moods of the sea at Point Lobos, diverse to begin with, have been vastly multiplied by the moods of its observers. Edward Weston, who photographed the shore under every conceivable circumstance—at high noon, in the evening, standing close or far away—always attempted to capture the essential texture of a subject. Other photographers, like Peter McArthur, have preferred the mysterious softness created by mists *(above)* or time-exposures, or have sacrificed detail in order to suggest a foreboding atmosphere. Thus, Point Lobos continues to appear in new guises, endlessly shifting like the sea itself.

Metronomically stroking the shore, the sea has a gentle, eternal quality in Peter McArthur's picture of Point Lobos (above). The setting sun, hidden in mist, provides the softest sort of light. He blurred the motion of the waves by making a ½-second exposure with his Leica.

Like the sea, the plant life along the shore of ▶ Point Lobos suggests many moods. Minor White's lyrical picture opposite shows kelp floating fanlike in a tidal pool. The leaves seem to flow up out of a region of darkness, which actually is the looming shadow of a rocky cliff.

MINOR WHITE: *Floating Kelp*, 1950

COLE WESTON: *Storm, Point Lobos, 1977*

Driven by a winter storm offshore, the Pacific Ocean crashes onto sun-drenched rocks in a spray of surf. Cole Weston discovered color film's landscape potential while assisting his father — who experimented with color but preferred black and white. Through color, Cole found his own way of interpreting the rigorous beauty of Point Lobos.

The surface is nearly still and the damp strand ▶ *lies exposed at low water as day turns into dusk on a tranquil inlet. Renowned for his black-and-white landscapes, photographer Ansel Adams here experimented with Polaroid color film to portray the range of hues at Point Lobos, from sunny evergreens to deepening shadow.*

ANSEL ADAMS: *Point Lobos, Late Evening, California*, 1977

The Rocks' Patterned Tale of Time

In the rocks of Point Lobos, whole eons lie bared to the eye of the camera. The granite cliffs along the north shore of the peninsula were formed during the Mesozoic Era, at a time when dinosaurs roamed the earth. Elsewhere along the shoreline are glittering masses of rock containing smooth pebbles that were locked up in a natural cement of quartz, feldspar and mica during some long-ago upheaval. Most remarkable of all are the formations of shale and sandstone, folded over the underlying granite, deeply gouged by glaciers and eroded by wind and sea into fantastic whorls, ripples and projections.

When Edward Weston photographed these subjects, he attempted, as he put it, to "have it look like a rock, but be *more* than a rock." Powerful form and almost palpable texture played equally important roles in Weston's monumental pictures. Subsequent photographers of the rocks have often allowed their emotions to show more clearly, using unusual lighting or mist to generate mood, sometimes obliterating detail in the process. Yet in all their diverse pictures, the rocks of Point Lobos—like the turning seasons and the tireless motions of the sea—speak of stretches of time that dwarf any human concerns.

EDWARD WESTON: *Sandstone Erosion*, 1942

Weston's views of the rocks at Point Lobos, such as the sandstone above, rendered texture with the most painstaking fidelity (he often expressed a desire to work with a microscope). And striking patterns—in this case, a water-hewn maze of ridges—were always present.

To Wolf von dem Bussche, Point Lobos is such ▶ a stark and forbidding place that he says he "wouldn't want to spend the night there"—a response that is communicated by his picture of the rock opposite. His 4 x 5 view camera, aimed upward, was equipped with a wide-angle lens.

WOLF von dem BUSSCHE: *Massive Rock,* 1970

Two rocks in a pool seem to be performing an unearthly balancing act in the picture at left, taken with a 4 x 5 view camera by Steve Crouch. The even illumination gives the rocks a range of subtle gray tones, and the water, untroubled by any wind, looks like a bath of mercury.

Although they are about five feet high, the fog- ▶ swathed boulders in Peter McArthur's picture, opposite, look like a haunted mountain range. A faint mist was coming in with the rising tide at the time, but he made it seem much heavier by blurring its motion with a five-minute exposure.

STEVE CROUCH: *Pool and Rocks*, 1967

PETER McARTHUR: *Boulders in Mist*, 1969

Trees That Clutch at the Land

ERNST HAAS: *Pines and Cliff,* 1967

*Standing beneath outstretched pine branches,
Ernst Haas shot across a chasm to sunlit cliffs in
the distance, creating a subtly colored dialogue
of rocks and trees. The picture was taken
late on a fall day, with a Leica and normal lens.*

Brett Weston, in an approach decidedly unlike ▶
*his father's detailed textural renditions, created
an almost ethereal atmosphere in the picture
opposite. Photographed with an 11 x 14 view
camera, the pine trees quickly fade and blur as
they recede into the dense fog of a summer day.*

BRETT WESTON: *Monterey Pines,* 1964

Even in winter, Point Lobos displays lovely
colors. On a rainy day in December, Steve
Crouch photographed the muted hues and
water-freshened greenery of a glade located
well away from the shore. Dead ferns give
a rusty color to the forest floor, and pale moss
swathes the green branches of the pines.

STEVE CROUCH: *Forest in Rain,* 1969

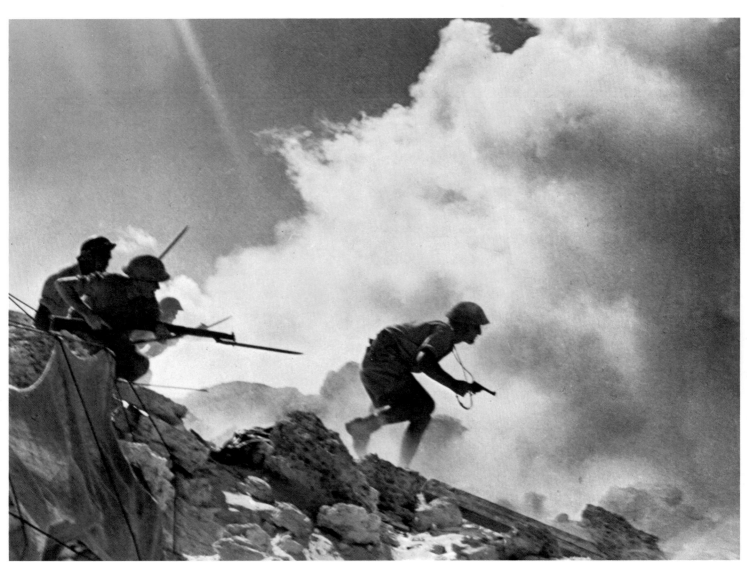

SERGEANT L. CHETWYN: *Australian Troops Advancing on a German Strongpoint at El Alamein,* 1942

The Camera in the Front Lines

The names of the first men to take cameras to war were, sadly, lost. All that is known are the results: some daguerreotypes of the American war against Mexico and also of an ill-fated Hungarian rebellion. They show no action, merely officers and men posing. An Englishman named Roger Fenton is the first war photographer about whom something is known—and from his account of his efforts to cover the Crimean War, it is not difficult to see why he and his contemporaries took only pictures of men who would stand still.

Fenton made pictures of trenches, battered forts, camps and generals. "If I refuse to take them," he wrote of the generals, "I get no facilities for conveying my van from one locality to another." And it is the van that emphasizes the enormous difficulties under which pioneer war photographers worked. Fenton had 36 cases of equipment, including 700 unsensitized glass plates. Before pointing his camera at a subject, Fenton was obliged to go through the following routine: First, he cleaned and polished the plates and coated them with assorted chemicals mixed in collodion, which dried into a tough film. Then he made the plates light-sensitive by immersing them in a solution of silver nitrate until they achieved an auspicious yellow color. Thereupon, he clapped them, still damp, into lightproof holders and went out to take some pictures. That done, he rushed back to his darkened van, sloshed the plates in tanks of other chemicals to develop and fix the images, wafted them over a flame until they were dry and, finally, varnished them. During the process it was his hope that no cannon balls would crash through the van, admitting light at the wrong moment, and he had great luck. Only one did.

A decade later, in America's Civil War, the photographer's equipment was still as cumbersome and the process nearly as tedious. The men who covered that conflict under the direction of the famous Mathew Brady were handicapped by the same obstacles that had hampered Fenton and his unknown predecessors. They, too, had to concentrate on men who would hold still. Dead men hold quite still, and so well did Brady and his fellow photographers record the aftermath of battle that their pictures are recognized today as the first true photographs of war.

It was not until World War I that equipment improved sufficiently to make possible a broadening of subject matter to include pictures of living men in the action of combat. And not until the 1920s and 1930s did the advent of 35mm and 2¼ x 2¼ cameras—light in weight, quick-acting, able to take pictures in dim light and freeze fast motion—provide war photographers with the recording instruments that made them superlative chroniclers of the cataclysms of the mid-20th Century. Some of their pictures have, through a combination of genius and happenstance, turned out to be works of art —photographs that by any measure of composition, lighting and posing

must be ranked with noteworthy pictures taken under far less severe conditions (for a portfolio of great war photographs, see pages 210-240). But artistry can never be the principal goal of the war photographer; he seeks simply to capture on film, in the most effective way possible, a record of man's organized violence.

Among the many modern war photographers who have written descriptions of their experiences, one who set down a good deal of explicit information about his techniques was Eliot Elisofon. During World War II, Elisofon frequently carried two Zeiss Contax 35mm cameras, one on a very short strap at about the level of his collarbone, the other hanging lower down on his chest. He could snatch either camera instantly and, since one was fitted and set for short-range work while the second had a long lens, he was, as a rule, prepared for whatever came along.

With modern equipment, Elisofon was able to photograph more of a war than earlier photographers could. His composition, he explained, was mostly "determined by the action. . . . Pictures which you might spend two hours composing in a ground glass on a tripod have to be settled in one second or perhaps two." But Elisofon's compositions were seldom accidental. "In battle photography, which is so often distant, the foreground is perhaps the greatest single aid in composition and the full use of the negative area," he pointed out, remarking, "a burning object in the distance . . . will never fill a negative, but adding three digging soldiers helps considerably."

This emphasis on people was an ingredient even before World War II in the work of the photographer whose extraordinary career is more closely associated with war pictures than that of anyone else in this century. He was Robert Capa. Capa knew that war is fought by individuals and that it can be recorded as well in a single human face as in a horizon full of flame. The idea would be carried further by David Douglas Duncan in the Korean War, and further still by Horst Faas and Larry Burrows in Vietnam.

Novelist John Hersey once called Capa "the man who invented himself," and with good reason. Born André Friedmann in Hungary in 1913, Capa fled the country at the age of 18 to escape the dictatorship of Admiral Nicholas von Horthy. As a stateless person, he made his way to Paris, where he found that no one wanted to buy pictures from an unknown Hungarian. Accordingly, he created in his fancy "a rich, talented American photographer" whom he called Robert Capa and for whom he, Friedmann, acted as agent. He sold pictures briskly until the day he was introduced as Capa to an editor who knew him as Friedmann. With a shrug, the talented American killed off the poor Hungarian, and Friedmann became Capa permanently.

In 1936, aged 23, Capa went to Spain with a single 35mm camera to photograph the Spanish Civil War. Among his Spanish pictures, that of a Loyalist

soldier falling at the instant he is killed by machine-gun fire *(pages 226-227)* has often been cited as the most dramatic action photograph ever made. During World War II, Capa became perhaps the best-known of photographers, thanks in part to his knack for turning up at critical times and places — Salerno, Anzio, Omaha Beach, Bastogne. In 1943, Capa had just been laid off by *Colliers* and was about to lose his Army press credentials when he picked up a rumor of the impending Allied invasion of Sicily. He hopped a plane from London to Algiers and, with the help of a friendly PR officer, wangled an interview with Major General Matthew B. Ridgway of the 82nd Airborne Division. Capa's passport and press credentials were dubious at best, but Ridgway was intrigued. "As long as you're willing to jump and take pictures of my division in combat," he said, "I don't care whether you're Hungarian or Chinese or anything else." Capa had never jumped before, but he soon parachuted into Sicily — and he stayed on the move long enough to be hired by *Life* before the Army could ship him back to the States.

At the end of World War II, Capa said, "I hope to stay unemployed as a war photographer until the end of my life." He thought war was "like an aging actress: more and more dangerous and less and less photogenic." But in 1948 he went to photograph the fighting in Israel and in 1954 to cover the French troops then embattled in Vietnam. There, despite all his combat savvy, Capa stepped on a land mine and was killed. A year later, *Life* established the Robert Capa Gold Medal for photography requiring "exceptional courage and enterprise abroad."

As the fighting in Vietnam escalated, American forces having replaced the French, literally hundreds of photojournalists followed the combat troops. A minority of them exploited the horror for their own profit and advancement, but the best of the photographers developed along the lines that earlier had emerged in Capa's work: a focus on individuals and an increasing hatred of war. A cooler breed of photographers appeared, possessed of no less courage and no less appreciation of luck, but very much in tune with their times. They took risks, but seldom gladly and never rashly. Perhaps the outstanding example of the cool school is West German photographer Horst Faas, who went to Vietnam for the Associated Press in 1962 and remained until 1973.

Born in Berlin in 1933, Faas covered the fighting in the Congo and Algeria in the early 1960s. His concept of photojournalism, formed in Africa, was sharpened in Vietnam. "In battle I look at things first in terms of people, second in terms of strategies or casualties," he has said. "To tell a story, you don't photograph 100 dead civilians to prove there were 100 dead civilians. You photograph one dead civilian with an expression on his face that says, 'This is what it's like if you're a dead civilian in Vietnam.' "

In getting to his picture, Faas was as resourceful as Capa ever was, but

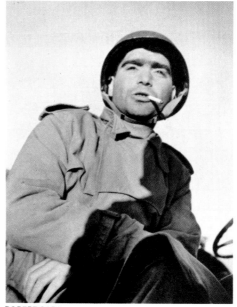

ROBERT CAPA

In his two decades as a war photographer, Robert Capa's casual bravado and unerring eye for the dramatic shot became legend. After he was killed in Indochina in 1954, Capa's brand of photography was memorialized in an award given to photographers who demonstrate their skill under extremely dangerous conditions.

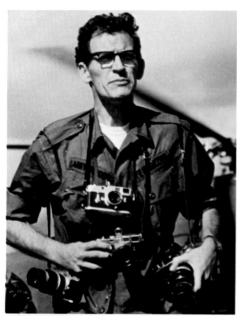

LARRY BURROWS

Life photographer Larry Burrows, the only three-time winner of the Robert Capa Gold Medal, spent his eight years in Vietnam taking pictures, as he once said, "to show the interested people and shock the uninterested into realizing and facing the horrors of the Vietnam war." His last Capa Medal was awarded posthumously in 1972.

somewhat more analytical. Once, before a mission, he was shown aerial reconnaissance photographs that revealed the presence of Viet Cong foxholes all over the area. "I knew what would happen," Faas said. "The troops would land in the clearing where the helicopters could put down, and machine guns would cut them to pieces." He was right. "Three Americans were killed in the first minute of that one. I wasn't with them." Faas's canny approach served him well. Although he was twice wounded, he survived more combat missions, very likely, than anyone who served in Vietnam — and he is the only person to have been awarded both the Capa Medal and the Pulitzer Prize for photography for the same year, 1964.

Other winners of the Capa Medal whose photographs appear on the following pages include John Olson (1968), Dirck Halstead (1975) and Susan Meiselas (1978). But only one person has ever won the Capa three times: Larry Burrows, esteemed by many as the best war photographer in the history of the profession, won the award for 1963, 1965 and, posthumously, for 1971.

A lean, bespectacled Englishman who began his photographic career at *Life* making copies of great paintings, Burrows first went to Vietnam in 1962 — the same year as Horst Faas — and covered the war for more than eight years. "Vietnam was really put on the map by Larry," Faas has said. "He was a jack of all trades. He could do anything." Certainly Burrows' meticulous study of master painters had taught him enough about color and composition to make him an artist with the camera. His Vietnam pictures, in tones of green and gray with occasional splashes of fire, are the most beautiful ever made of man's ugliest activity.

This paradox was typical of Burrows, a modest, gentle man who was at the same time, in the words of *Life* Managing Editor Ralph Graves, "the single bravest and most dedicated war photographer I know of." At the outset of his tour in Vietnam, Burrows was, as he put it, "rather a hawk." But as the years passed, he became increasingly disillusioned; the role of war photographer — compelled by profession to record the wretchedness of others — weighed more and more heavily on him. "It's not easy to take a shot of a man crying," he said, "as though you have no thoughts, no feelings as to his sufferings." Yet he continued to photograph the war, both on the ground and in the air, at close range. He slogged for hundreds of miles through the jungle, and he flew hundreds of helicopter and fighter-bomber missions.

"The depth of his commitment, his concentration, was frightening," wrote *Life* correspondent John Saar, who worked with Burrows for nearly two years. "He could have been a surgeon or a soldier or almost anything else, but he chose photography and was so dedicated that he saw the whole world in 35mm exposures." This dedication was fully matched by Burrows' zeal for perfection. "As a photographer he began where most others stopped," Saar

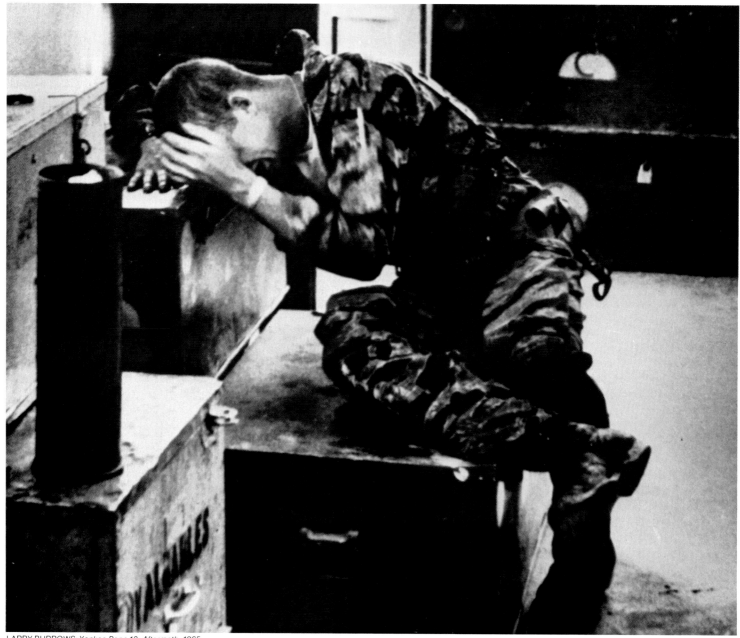

LARRY BURROWS: *Yankee Papa 13, Aftermath,* 1965

The young crew chief of Yankee Papa 13, a U.S. Marine helicopter in Vietnam, breaks down after a failed attempt to rescue a wounded comrade. Larry Burrows almost turned away from the sight as being too painful and private to photograph, but ultimately included this shot in a photo essay that earned him his second Capa award, for 1965. The Marine also appears on pages 220-221 in another picture from the same essay.

wrote. "Technically perfect—exposure, speed, focus were always reflexively correct—he worried constantly for composition and, most of all, meaning. He ran terrible risks because he was a perfectionist and he had to take risks to get perfect pictures—the only kind he found satisfactory."

Among the last stories Burrows shot in Vietnam was one about a 10-year-old boy named Lau who had been paralyzed from the waist down by a mortar fragment. Lau spent two years receiving medical treatment in the United States; when he returned home, he could speak only English, walked on crutches—and was rejected by his family and friends. "Lau's is not the greatest tragedy in Vietnam," Burrows said at the time, "but as one looks at the pictures of this courageous little chap, one has to wonder whether the ultimate agony of this war is not to be seen in his eyes."

Burrows often said that the one story he wanted to do in Vietnam would be *after* the war, when he could return and show the country at peace. But it was not to be. On February 10, 1971, he climbed into a helicopter to cover the South Vietnamese incursion into Laos. Above the jungle near the border, the helicopter was hit by antiaircraft fire. There were no survivors of the crash. Larry Burrows had lived longer in his profession than Robert Capa, who died at 41. Burrows was 44. □

Robert Wallace

From the Tragedy of War, Great Photographs

Even in war, when picture taking must compete with the need for survival, the art of photography flourishes, as the pictures on these and the following pages demonstrate. They were chosen, not because they so eloquently convey the grand spectacle of war with its terrifying action and its bitter aftermath —although they indeed do that—but rather because they are, by any standard, outstanding pictures in their own right. Purely as photographs, they transcend their subject.

Photographs of war have been made almost since the camera came into use. But it was not until the 20th Century that fast films and lenses combined with portable cameras enabled daring men and women to photograph troops in action. Their records of fighting on the battlefield have given the world an unprecedented view of the meaning of war.

Some war photographs owe their quality to the acknowledged talents of famous men—Edward Steichen, Robert Capa, David Douglas Duncan, W. Eugene Smith. But many of the best pictures were taken by soldiers and sailors who were assigned to photographic duty but whose names are now unknown, lost in the archives of the great powers. Only their photographs remain, enduring testimony to the artist's genius for isolating beauty from the most tragic of subjects.

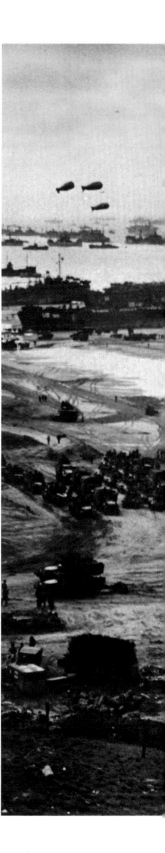

Aiming for a panorama of the armada that invaded Normandy in World War II, U.S. Coast Guard photographer Vernon Brown climbed to a hill above Omaha Beach and recorded the epic scale of modern warfare. Ships clog the English Channel and barrage balloons—dangling cables from their underbellies to protect ships and men from low-level strafing—dot the sky as troops and matériel are disgorged onto the beach. The land in the foreground is cut with German trenches that had been taken during the first assault.

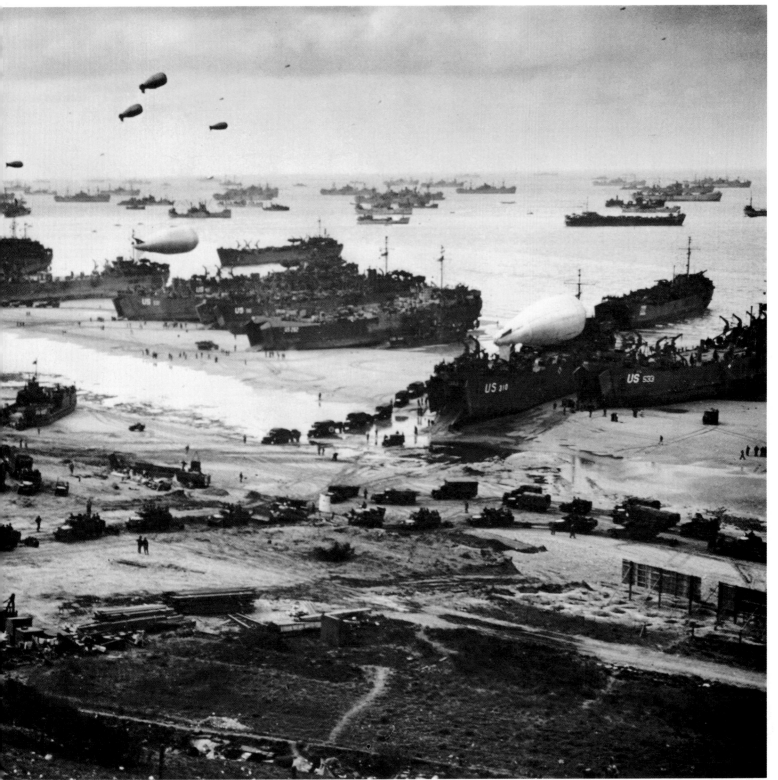

VERNON BROWN, U.S. COAST GUARD: *Omaha Beach*, 1944

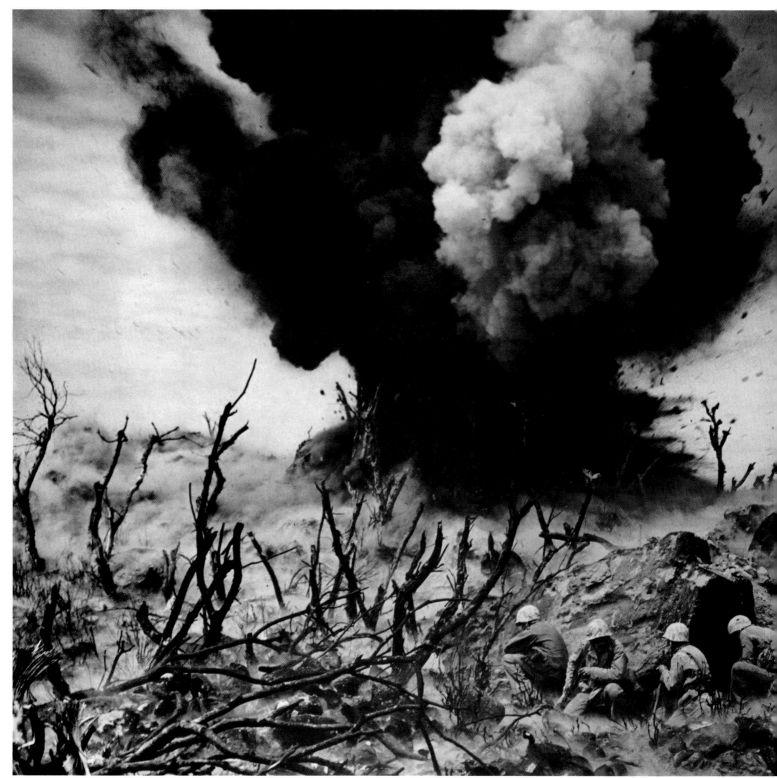

W. EUGENE SMITH: *Sticks and Stones/Bits of Human Bones*, 1945

212

"Sticks and stones/bits of human bones/a blasting out on Iwo Jima." This macabre nursery rhyme accompanied the caption that W. Eugene Smith sent back to Life with his picture of a Marine demolition crew crouching behind a boulder as the charge they have set blows up a fortified cave. The blast was one of many Smith witnessed during 26 days of seemingly endless demolitions that, cave by cave, destroyed the deeply entrenched defenders in one of the last campaigns of World War II.

U.S. ARMY, PHOTOGRAPHER UNKNOWN: *Contrails over Germany, 1944*

Silhouetting the men of a U.S. Army antiaircraft battery against the German sky over Puffendorf, an Army photographer captured the abstract pattern (above) made by American and German planes circling each other for position late in 1944, as the Battle of the Bulge raged far to the south.

Slashing into Poland in September 1939, the ▶ tight formation of a squadron of Stukas is recorded in this shot taken by the wingmate of the plane in the immediate foreground. The Stuka, a dive-bomber strafer flying in close support of ground troops, played a major part in the masterfully organized blitzkrieg tactics that enabled Hitler's Wehrmacht to defeat Poland in 35 days in the opening round of World War II.

PHOTOGRAPHER UNKNOWN: *Stukas over Poland*, 1939

A CH-54 helicopter drops ammunition into the U.S. Marine base at Khe Sanh. Located some 15 miles south of the demilitarized zone and 10 miles east of the Laotian border, the base straddled a North Vietnamese infiltration route into South Vietnam. In early 1968, the North Vietnamese laid siege to it for 11 weeks, forcing U.S. military commanders to airlift reinforcements and equipment. Shooting with underexposed Ektachrome, which he prized for its greens and browns, Larry Burrows brought to this view of the Khe Sanh airlift the care for color and composition that is characteristic of his photography.

LARRY BURROWS: *An Ammunition Airlift into Besieged Khe Sanh*, 1968

U.S. NAVY, PHOTOGRAPHER UNKNOWN: *Shelling Guam,* 1944

Against a background of a calm Pacific and a softly clouded sky, billowing smoke creates a scene of destructive power as the guns of a U.S. battleship blast at the island of Guam before it was retaken from the Japanese in 1944. The 14-inch at center has just recoiled, while the gun at bottom has been run out to fire another round.

Edward Steichen used infrared film to capture ▶ this classic image of a great warship, the U.S.S. Lexington, and its men. Steichen, then a World War II Navy photographic officer, employed infrared film's transformation of natural tones to make the sky almost black, the ship deep gray and the figures of the men a contrasting white.

LIEUTENANT COMMANDER EDWARD STEICHEN, U.S.N.R.: *Getting Set for the Big Strike on Kwajalein,* 1943

This shot of a Marine opening fire as his helicopter descends into Viet Cong territory was taken with a camera mounted outside the helicopter. The camera was on a special rig that swiveled with the barrel of the M-60 machine gun, allowing the lens to point constantly at the gunner. Photographer Larry Burrows used a remote cable to trigger the shutter while he hunkered down out of sight behind his subject.

LARRY BURROWS: *Yankee Papa 13, Gunner,* 1965

DMITRI BALTERMANTS: *An Attack*, 1941

*Counterattacking the Nazi troops outside Moscow
in the winter of 1941, Russian infantrymen
leap a trench in the desperately fought defense of
the Soviet capital — these men became famous
because they won back from the invaders
only a bit more than 200 yards of land. The picture
is one of many outstanding photographs of
World War II (for another, see page 239) that were
made by Dmitri Baltermants, who was then a
correspondent for Izvestia and who covered the
action by commuting daily 50 miles from the
newspaper's offices to the front lines.*

Minutes after the first wave of troops had landed ▶
*at Omaha Beach on the morning of D-Day, June
6, 1944, Life photographer Robert Capa
turned his back on the German defenders' fire,
flung himself down on the sand just above the
low-water mark and aimed his Zeiss Contax at
the incoming troops of Company Easy, U.S. 16th
Infantry, as they momentarily took refuge behind
the enormous steel, jacklike tank traps that
had been set out in the water by the Germans to
disable invading landing craft (background).
While the battle for Omaha Beach still raged,
Capa took 106 pictures; a nervous darkroom
technician later ruined all but eight. This is one.*

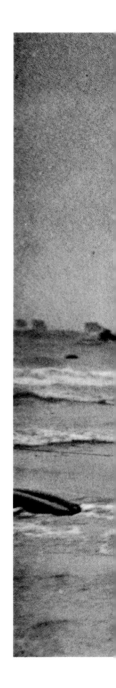

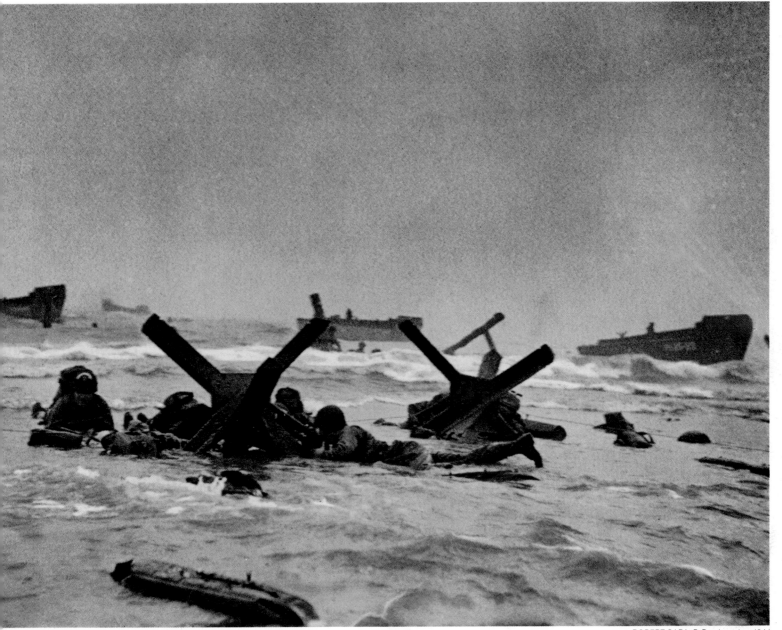

ROBERT CAPA: *D-Day Invasion,* 1944

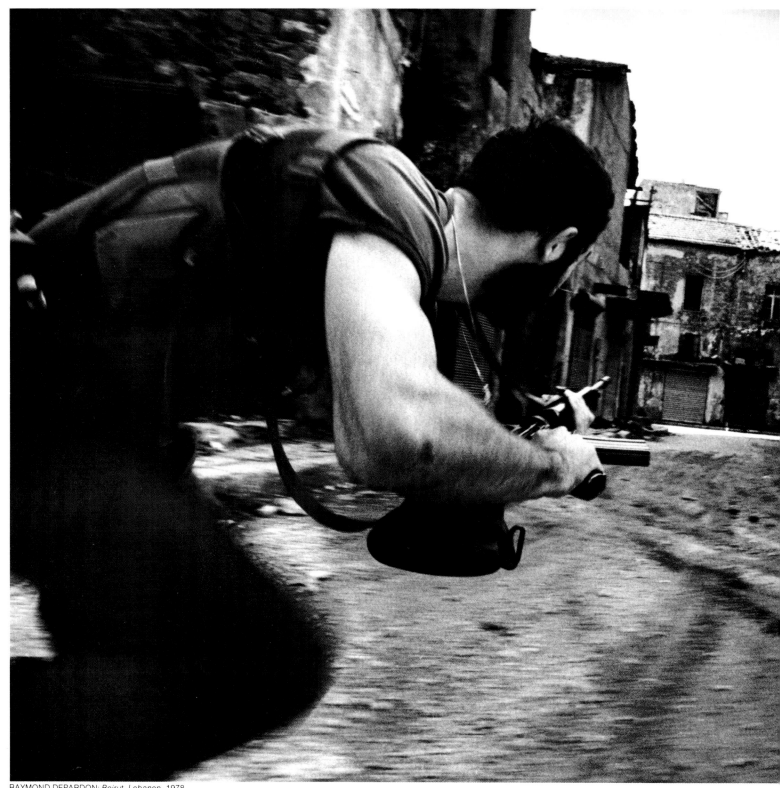

RAYMOND DEPARDON: *Beirut, Lebanon,* 1978

A Christian Phalangist militiaman fires to cover himself as he races for a new position in the shattered streets of Beirut. In the fighting between Christian and Moslem factions in the Lebanese capital, with any street corner liable to become the front line, French photographer Raymond Depardon had to shoot from the hip with his camera while on the run himself.

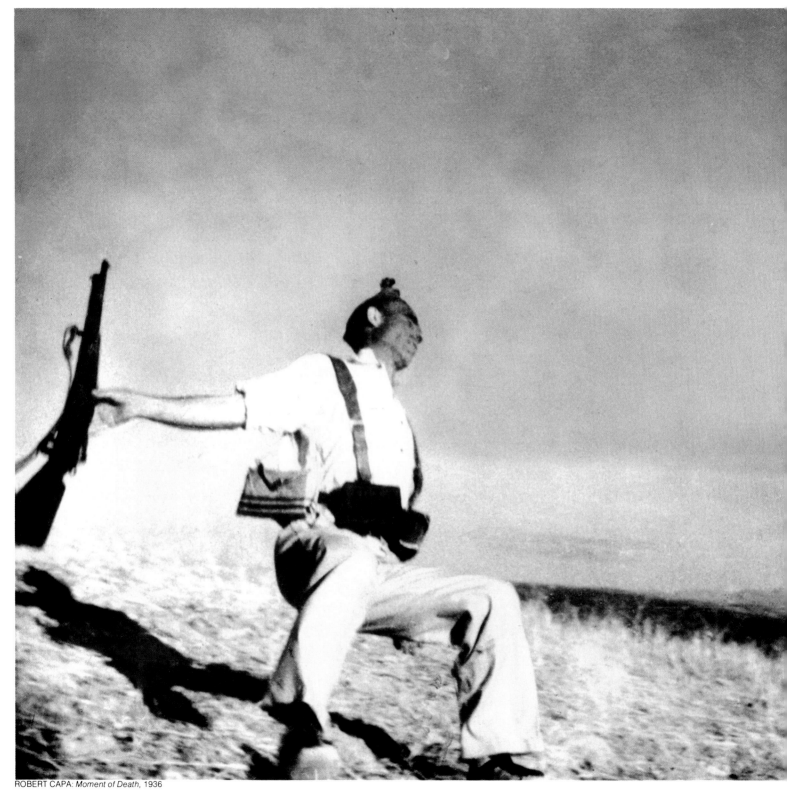

ROBERT CAPA: *Moment of Death,* 1936

The moment of truth comes to a Loyalist soldier of the Spanish Civil War in this memorable picture by Robert Capa. To take it, Capa—an iron-nerved photographer who survived virtually every campaign from North Africa to Germany while covering World War II for Life, only to be killed photographing the French war in Indochina—waited at the top of a parapet for the troops to charge. It was no accident that he was there; Capa had deliberately placed himself where he knew he would be able to capture the instant when a man was killed in action.

PHOTOGRAPHER UNKNOWN: *Wounded in Flanders*, 1917

*Though himself wounded, a German soldier
helps his more seriously hurt comrade up the
steep slope of their trench in Flanders during
World War I. Both had taken part in an assault
across No Man's Land, trying to penetrate
the trenches, tunnels and barbed wire
that separated them from the British forces.*

Photographing the last moments of World War II in Europe, Robert Capa got a tragic picture of one of the last Americans to die. The soldier was manning a machine gun as routine protection for troops entering Leipzig when he was killed by a sniper on April 19, 1945, only 18 days before the Germans surrendered. Capa wrote sadly of the soldier's death in his book, Images of War: "The last day, some of the best ones die. But those alive will fast forget."

ROBERT CAPA: *Germany, 1945*

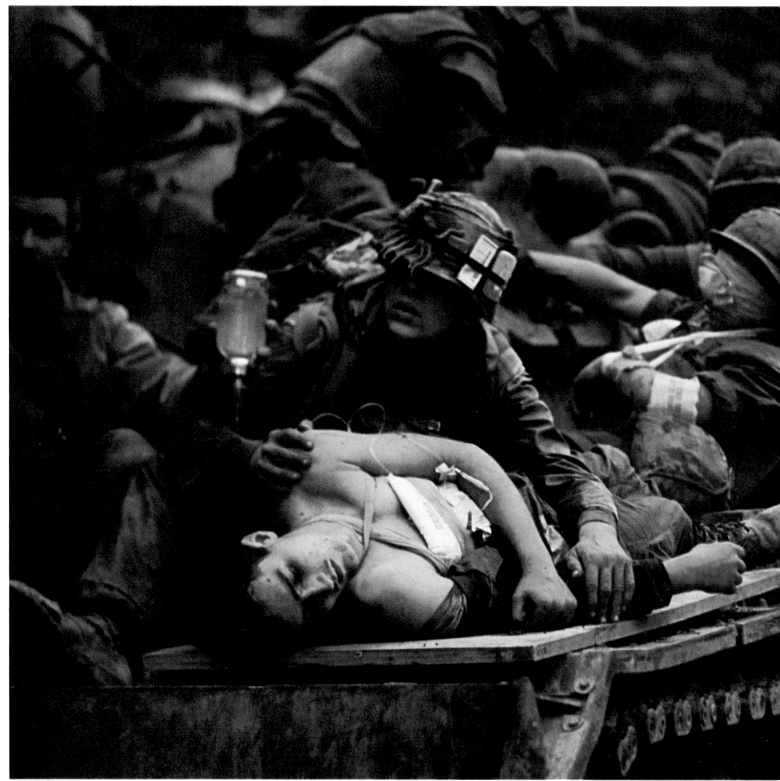

JOHN OLSON: *Hue*, 1968

A tank becomes an ambulance to evacuate
wounded Marines during the bloody 25-day battle
that destroyed the ancient Vietnamese city of
Hue, a former royal capital, in some of the bitterest
fighting of the 1968 Tet offensive. John Olson, the
youngest photographer ever to win the Capa award,
was just short of his 21st birthday when he took
this picture. As a photographer for Stars and Stripes,
he covered some of the hardest-fought battles of
the war and was wounded twice.

DIRCK HALSTEAD: *Vietnam Retreat*, 1975

Smoke obscures the background of the scene as giant U.S.-made helicopters hover to evacuate South Vietnamese refugees fleeing the devastation of Xuanloc, a provincial capital just 40 miles east of Saigon. Dirck Halstead, another Capa award winner, shot this image for Time during the frantic last days of American involvement in Vietnam.

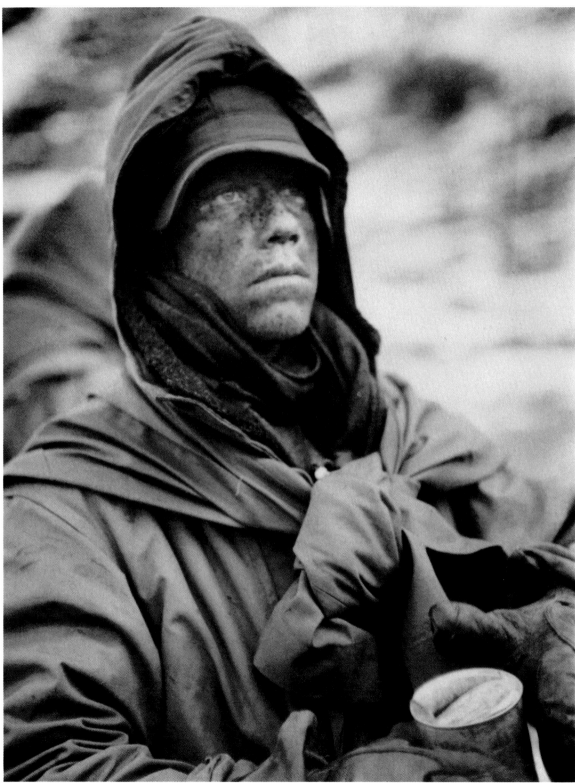

DAVID DOUGLAS DUNCAN: *Marine in Korea*, 1950

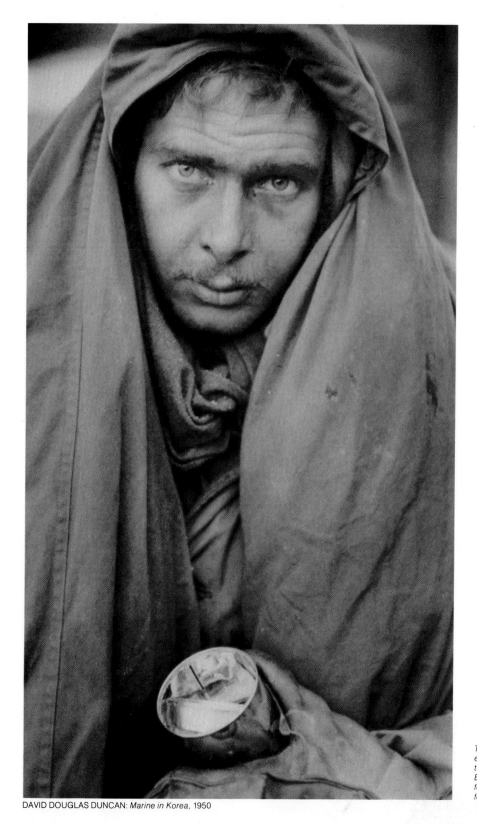

DAVID DOUGLAS DUNCAN: *Marine in Korea, 1950*

The exhaustion and horror of war stare from the eyes of two Marines during the fighting near the Changjin Reservoir in Korea in 1950. Both of these pictures were taken on assignment for Life by David Douglas Duncan, who focused sharply on the men's expressive eyes.

Ignoring the burning building of Vitebsk, Russia, exhausted German infantrymen of Hitler's Operation Barbarossa take a break for food during the Nazi lunge into the Soviet Union in the summer of 1941. The men in this picture, taken by a Nazi combat photographer, were later repulsed as they approached Moscow.

PHOTOGRAPHER UNKNOWN: *Pause at Vitebsk,* 1941

In one of a set of pictures that won him the
Pulitzer Prize for news photography, Horst Faas
captured the bitter futility of the Vietnam
war as a peasant, holding the body of his child,
confronts Rangers of the Vietnamese army.

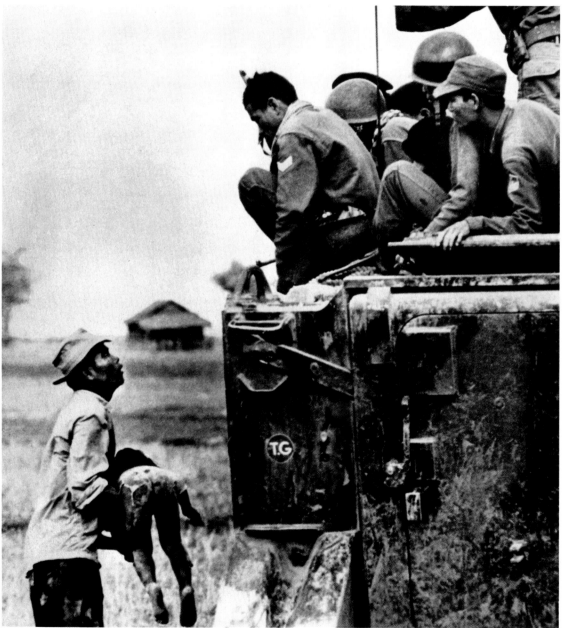

HORST FAAS: *Father and Child, Vietnam, 1964*

DMITRI BALTERMANTS: Sorrow, 1942

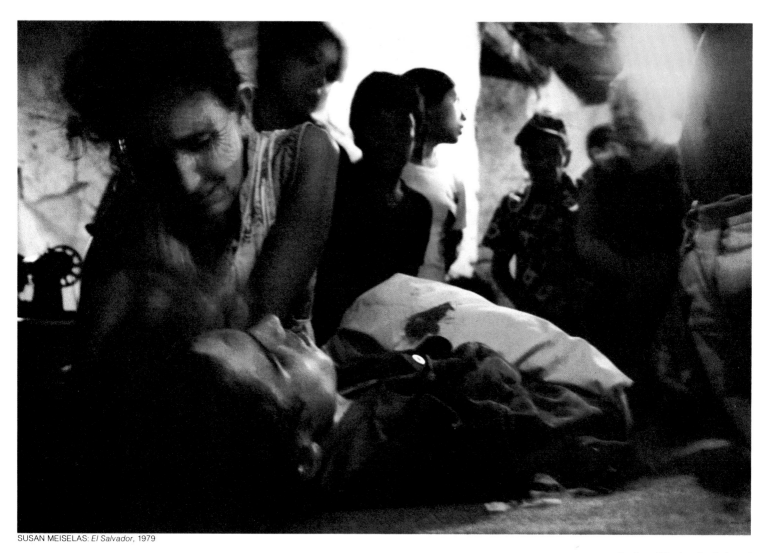

SUSAN MEISELAS: *El Salvador,* 1979

*Family and friends gather for funeral
preparations as a Salvadoran mother grieves over
the body of her teenage son, believed to have
been shot while distributing leaflets opposing El
Salvador's government. Susan Meiselas took this
picture in 1979, the year she won the Capa Medal for
her 1978 coverage of Nicaragua's revolution
against the dictatorship of Anastasio Somoza.*

Bibliography

History

Capa, Robert, *Slightly Out of Focus*. Henry Holt and Company, Inc., 1947.
Editors of LIFE, *LIFE's Picture History of World War II*. Time Inc., 1950.
Garland, Lieutenant Colonel Albert N., and Howard McGraw Smyth, *United States Army in World War II: Sicily and the Surrender of Italy*. Office of the Chief of Military History, United States Army, 1965.
Gernsheim, Helmut:
 Creative Photography: Aesthetic Trends 1839-1960. Faber and Faber, 1962.
 The History of Photography. Oxford University Press, 1955.
Hood, Robert E., *12 at War*. F. P. Putnam's Sons, 1967.
*Lacey, Peter, and A. La Rotonda, *The History of the Nude in Photography*. Bantam, 1964.
Lewinski, Jorge, *The Camera at War*. Simon and Schuster, 1978.
†Marshall, S.L.A., *The American Heritage History of World War I*. American Heritage, 1964.
Newhall, Beaumont, *The History of Photography from 1839 to the Present Day, Revised Edition*. The Museum of Modern Art, 1964.
Stettner, Louis, *History of the Nude in American Photography*. Whitestone, 1966.
Sulzberger, C. L., *The American Heritage Picture History of World War II*. Simon and Schuster, 1966.

Biography

Fellig, Arthur, *Weegee by Weegee*. Da Capo Press Inc., 1975.
†Karsh, Yousuf, *In Search of Greatness*. Knopf, 1962.
Newhall, Nancy, ed., *The Daybooks of Edward Weston*. George Eastman House, 1961.
Steichen, Edward, *A Life in Photography*. Doubleday, 1963.

Photographic Art

Avedon, Richard, and Truman Capote, *Observations*. Simon and Schuster, 1959.
Brandt, Bill:
 Perspective of Nudes. Amphoto, 1961.
 Shadow of Light. Viking, 1966.
†Brower, David, ed., *Not Man Apart*. Sierra Club, Ballantine, 1965.
Callahan, Harry, *Photographs*. Van Raper and Thompson, 1964.

†Capa, Robert, *Images of War*. Grossman, 1964.
Cartier-Bresson, Henri:
 †*Photographs by Henri Cartier-Bresson*. Grossman, 1963.
 The Decisive Moment. Simon and Schuster, 1952.
 The World of Henri Cartier-Bresson. Viking, 1968.
Cosindas, Marie, *Color Photographs*. New York Graphic Society, 1978.
Editors of LIFE, *Larry Burrows*. Time Inc., 1972.
†Friedlander, Lee, *Self Portrait*. Haywire Press, 1970.
Howe, Graham, and G. Ray Hawkins, eds., *Paul Outerbridge Jr.: Photographs*. Rizolli International Publications, Inc., 1980.
Karsh, Yousuf, *Karsh Portfolio*. University of Toronto Press, 1967.
Meiselas, Susan, *Nicaragua June 1978-July 1979*. Pantheon Books, 1981.
Meyerowitz, Joel, *Cape Light*. New York Graphic Society, 1978.
Minkkinen, Arno Rafael, *New American Nudes*. Morgan & Morgan, Inc., 1981.
Miyazaki, Manabu, *Animal Paths*. Kyohritsu Shuppan Co., 1979.
†Newhall, Nancy, ed., *Edward Weston: Photographer*. Aperture Inc., 1968.
†Ockenga, Starr, *Dressup*. Addison House Inc., 1978.
Singh, Raghubir, *Rajasthan—India's Enchanted Land*. Thames and Hudson, Inc., 1981.
Smith, W. Eugene, *W. Eugene Smith, an Aperture Monograph*. Aperture Inc., 1969.
Stettner, Louis, ed., *Weegee*. Alfred A. Knopf, Inc., 1977.
Weston, Cole, *Cole Weston*. Peregrine Smith, Inc., 1981.
Weston, Edward, *My Camera on Point Lobos*. Da Capo, 1968.
White, Minor, *mirrors messages manifestations*. Aperture Inc., 1969.

Special Subjects

Beitler, Ethel J., and Bill Lockhart, *Design for You*. John Wiley and Sons, Inc., 1969.
*Clark, Kenneth, *The Nude: A Study of Ideal Form*. Doubleday, 1964.
Croy, O. R., *The Photographic Portrait*. Focal, 1968.
Duncan, David Douglas, *This Is War!* Harper and Brothers, 1951.
Everett, Thomas H., *Living Trees of the World*.

Doubleday & Company, Inc.
Falk, Edwin A., and Charles Abel, *Practical Portrait Photography*. Amphoto, 1967.
Feldman, Edmund Burke, *Art as Image and Idea*. Prentice-Hall, 1967.
Focal, *Focal Encyclopedia of Photography*. McGraw-Hill, 1959.
Freidel, Frank, *Over There: Story of America's First Great Overseas Crusade*. Little, Brown, 1964.
Garrett, Lillian, *Visual Design: A Problem-Solving Approach*. Van Nostrand Reinhold, 1967.
Gurney, Gene, *The War in the Air*. Bonanza, 1962.
Henderson, Harry B., and Herman G. Morris, *War in Our Time*. Doubleday, Doran and Co., Inc., 1942.
Hicks, Wilson, *Words and Pictures*. Harper and Brothers, 1952.
Karsten, Kenneth, *Science of Electronic Flash Photography*. Amphoto, 1968.
Kinne, Russ, *The Complete Book of Nature Photography*. A. S. Barnes, 1962.
Leathart, Scott, *Trees of the World*. A & W Publishers, Inc., 1977.
*Legg, Ken, *Point Lobos Wildflowers*. State of California, Department of Natural Resources, 1954.
Nurnberg, Walter:
 Lighting for Photography. Focal, 1968.
 Lighting for Portraiture. Focal, 1969.
Scott, Robert G., *Design Fundamentals*. McGraw-Hill, 1951.
Sullivan, Constance, *Nude*. Harper & Row, 1980.
Weismann, Donald L., *The Visual Arts as Human Experience*. Prentice-Hall, 1970.

Magazine Articles

"The Battle That Regained and Ruined Hue." *Life*, March, 1968.
Burrows, Larry, "One Ride with Yankee Papa 13." *Life*, April, 1965.
Gibbons, Boyd, "A Durable Scale of Values." *National Geographic*, November, 1981.
Krawczyk, Jack, "Yesterday's Glorious Gas Guzzlers." *Popular Photography*, August, 1981.
Moffett, Hugh, "The Pros." *Life*, December, 1966.
Schofield, Jack, "Ian McKinnell." *Zoom*, May, 1981.
Wolf, Eelco, "Olivia Parker." *Photoshow #3*, July/August, 1980.

*Available only in paperback.
†Also available in paperback.

Acknowledgments

The index for this book was prepared by Karla J. Knight. For the assistance given in the preparation of this volume, the editors would like to express their gratitude to the following individuals and institutions: Acme Printing Co., Medford, Massachusetts; Wynn Bullock, Monterey, California; Walter Clark, Rochester, New York; Steve Crouch, Carmel, California; Tomas D. W. Friedmann, New York City; Professor L. Fritz Gruber, Cologne, Germany; Therese Heyman, Associate Curator for Prints and Photography, The Oakland Museum, Oakland, California; Tamarra Kaida, School of Art, Arizona State University, Tempe, Arizona; Joyce Large, Ottawa, Ontario, Canada; Grace Mayer, Curator, The Edward Steichen Archive, The Museum of Modern Art, New York City; Duane Michals, New York City; Arno Rafael Minkkinen, Creative Photography Gallery, Massachusetts Institute of Technology, Boston, Massachusetts; Zelma L. Mitchell, Navy Photographic Center, U.S. Naval Station, Washington, D.C.; Beaumont Newhall, Director, George Eastman House, Rochester, New York; Richard Noble, New York City; Marion Patterson, Menlo Park, California; Polaroid Corporation, Cambridge, Massachusetts; Bettie Sprigg, Audio-Visual Division, Office of Assistant Secretary of Defense, the Pentagon, Washington, D.C.; Joanna Steichen, New York City; Cole Weston, Carmel, California; Minor White, Arlington, Massachusetts.

Picture Credits

Credits from left to right are separated by semicolons, from top to bottom by dashes.

COVER: William Larson; Manabu Miyazaki, from Nature Production, Tokyo; David Austen from Black Star © 1980—Larry Burrows for *Life*; Olivia Parker © 1979; Joel Meyerowitz.

Chapter 1: 11: Henri Cartier-Bresson from Magnum. 14: Joanne Leonard. 15: K. Matsuzaki, courtesy Nikkor Camera Club. 16: © Marcia Keegan from The Image Bank. 17: David Austen from Black Star © 1980. 18: Marcia Keegan. 19: Laurence Fink. 20: © Charles Harbutt from Archive Pictures. 21: © Stephen Shames, 1980, from Woodfin Camp & Associates. 22, 23: Michael Semak; © Mary Ellen Mark. 24: Leonard Freed from Magnum. 25: John Benton Harris. 26: © Lutz Dille. 27: Leonard Freed from Magnum. 28, 29: Mary Ellen Mark; Alen MacWeeney. 30, 31: Ken Heyman. 32: Marcia Keegan. 33: Ron James. 34, 35: Frances McLaughlin-Gill for *House & Garden,* Copyright © 1956 by The Condé Nast Publications, Inc. 36: Ernst Haas. 37: Joel Meyerowitz. 38, 39: © David Alan Harvey, 1978, from Woodfin Camp & Associates. 40, 41: © Susan Meiselas from Magnum. 42: © 1981 Raghubir Singh, Paris.

Chapter 2: 45: Edward Steichen, courtesy The Museum of Modern Art, New York. 48-69: Photographs by Richard A. Steinberg. Drawings by Nicholas Fasciano. 71: © Martus Granirer. 72: Walker Evans. 73: Lilo Raymond © 1980, courtesy Marcuse Pfeifer Gallery. 74: Paul Outerbridge Jr., copied by Tom Tracy, courtesy G. Ray Hawkins Gallery. 75: Sheila Metzner. 76: Edward Weston, printed by Cole Weston. 77: © André Kertész. 78: Edward Steichen, courtesy The Museum of Modern Art, New York, from *The First Picture Book— Everyday Things for Babies,* Harcourt, Brace & Co., New York. 79: André Kertész. 80: © Pål-Nils Nilsson. 81: Hiromitsu Morimoto. 82: Ian McKinnell. 83: Jack Krawczyk. 84: Olivia Parker © 1979. 85: John Gruen. 86: Polacolor 8 x 10 by Marie Cosindas.

Chapter 3: 89: Edward Steichen for *Vanity Fair,* courtesy The Museum of Modern Art, New York. 92-101: Photographs by Richard Noble. Drawings by Nicholas Fasciano. 103: Richard Avedon. 104, 105: © Karsh of Ottawa from Rapho Guillumette. 106, 107: Polacolor 8 x 10 by Marie Cosindas. 108, 109: Helen Levitt. 110, 111: Mary Ellen Mark. 112, 113: © Arnold Newman. 114: Copyright © 1967 The Estate of Diane Arbus. 115: Copyright © 1969 The Estate of Diane Arbus. 116, 117: Duane Michals. 118, 119: Joel Meyerowitz. 121: Lee Friedlander, courtesy The Museum of Modern Art, New York. 122: Alfred Stieglitz, courtesy The Condé Nast Publications, Inc. 123: Edward Steichen, courtesy of the photographer and The Museum of Modern Art, New York. 124: Bill Brandt from Rapho Guillumette. 125: André Kertész. 126: Joyce Tenneson. 127: © Judith Golden, 1975. 128: Duane Michals.

Chapter 4: 131: Paulus Leeser, courtesy The Museum of Modern Art, New York. 132: Scala, Florence, courtesy Musei Vaticani, Rome; Städelsches Kunstinstitut und Städtische Galerie, Frankfurt, Foto Blauel, Munich. 133: National Museum, Stockholm. 134: Alvin Langdon Coburn, courtesy George Eastman House. 135: Edward Steichen, courtesy The Museum of Modern Art, New York. 136: Jeanloup Sieff. 137: Edward Weston, printed by Cole Weston. 138: Lucien Clergue, courtesy Pierre Belfond Editions, Paris. 139: © 1981 Robert Mapplethorpe, courtesy Robert Samuel Gallery, New York. 140: Harry Callahan. 141: © Gene Antisdel. 142: Lynn Davis. 143: Pascale Couderc, Marie-Joséphine Broc, Paris. 144, 145: Frantisek Drtikol, courtesy Alan Porter, Camera Magazine, Lucerne. 146, 147: Evergon, courtesy Robert Samuel Gallery, New York (4); George Krause. 148, 149: Arthur Fellig ("Weegee"), courtesy Janet Lehr Inc.; © André Kertész. 150, 151: Harry Callahan. 152: Starr Ockenga. 153: Joan Myers, courtesy Marcuse Pfeifer Gallery. 154: Joel Meyerowitz. 155: John Benson. 156: Michelle Bogre. 157: Kelly Kirkpatrick. 159: Joel-Peter Witkin, courtesy Robert Samuel Gallery, New York. 160, 161: Siegried Halus; Irina Ionesco, Paris. 162: Paul Outerbridge Jr., courtesy Robert Miller Gallery, New York. 163: © Joan Myers, 1976, courtesy Marcuse Pfeifer Gallery. 165-176: Photographs by William G. Larson. Drawings by Nicholas Fasciano.

Chapter 5: 179: Ansel Adams, from *The Eloquent Light,* courtesy Sierra Club. 180, 181: Peter Beard. 182: Drawing by Lois Sloan. 183: © Jim Brandenburg, 1981. 184: Drawing by Lois Sloan. 185: Tadashi Shimada, Chitose, Japan. 186, 187: Drawing by Lois Sloan; Manabu Miyazaki, from Nature Production, Tokyo. 188: Map by Walter H. Johnson. 189: Edward Weston, printed by Cole Weston. 190: Peter McArthur. 191: Minor White. 192, 193: Cole Weston; Ansel Adams. 194: Edward Weston, printed by Cole Weston. 195: Wolf von dem Bussche. 196: Steve Crouch. 197: Peter McArthur. 198: Ernst Haas. 199: Brett Weston. 200: Steve Crouch.

Chapter 6: 203: Sergeant L. Chetwyn, courtesy Imperial War Museum, London. 206: Pix, Inc. 207: Courtesy Russell Burrows. 208: Larry Burrows for *Life.* 210, 211: Vernon Brown for U.S. Coast Guard. 212, 213: W. Eugene Smith for *Life.* 214: U.S. Army Photo. 215: Wide World. 216, 217: Larry Burrows for *Life.* 218, 219: U.S. Navy Photo; Edward Steichen for U.S. Navy, courtesy The Museum of Modern Art, New York. 220, 221: Larry Burrows for *Life.* 222, 223: Dmitri Baltermants from Novosti; Robert Capa for *Life,* from *Images of War,* © 1964. 224, 225: © Raymond Depardon from Magnum. 226, 227: Robert Capa, from *Images of War,* © 1964. 228: Süddeutscher Verlag, Bilderdienst, Munich. 229: Robert Capa for *Life,* from *Images of War,* © 1964. 230, 231: John Olson for *Life.* 232, 233: Dirck Halstead from Time-Life Picture Agency. 234, 235: David Douglas Duncan for *Life.* 236, 237: Ullstein Bilderdienst, Berlin (West). 238: Horst Faas, courtesy Associated Press. 239: Dmitri Baltermants from Novosti. 240: © Susan Meiselas from Magnum.

Index Numerals in italics indicate a photograph, painting or drawing.

779
G

779 13680
G

The Great Themes

DATE DUE			
OCT 11 '84			
MAR 12 '85			
APR 16 '85			
OCT 15 '85			
DEC 18 '85			
MAY 28 '86			
FEB 18 '87			
OCT 2 7 2000 Fac			
2/10/10			